COYOTE
UGLY

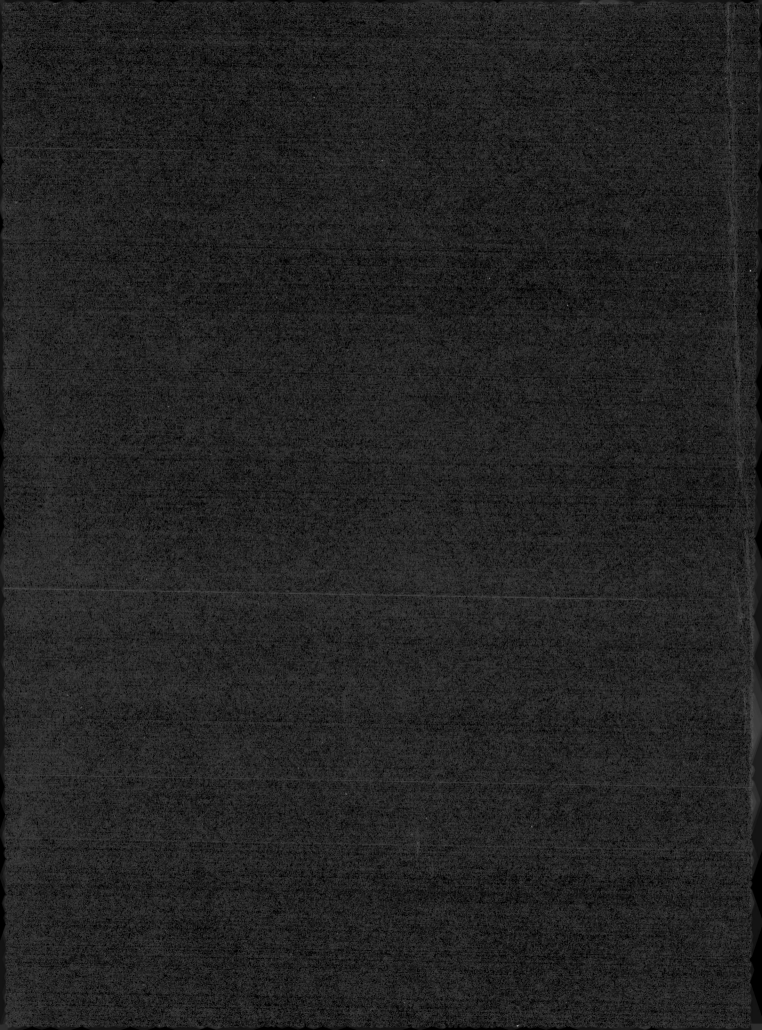

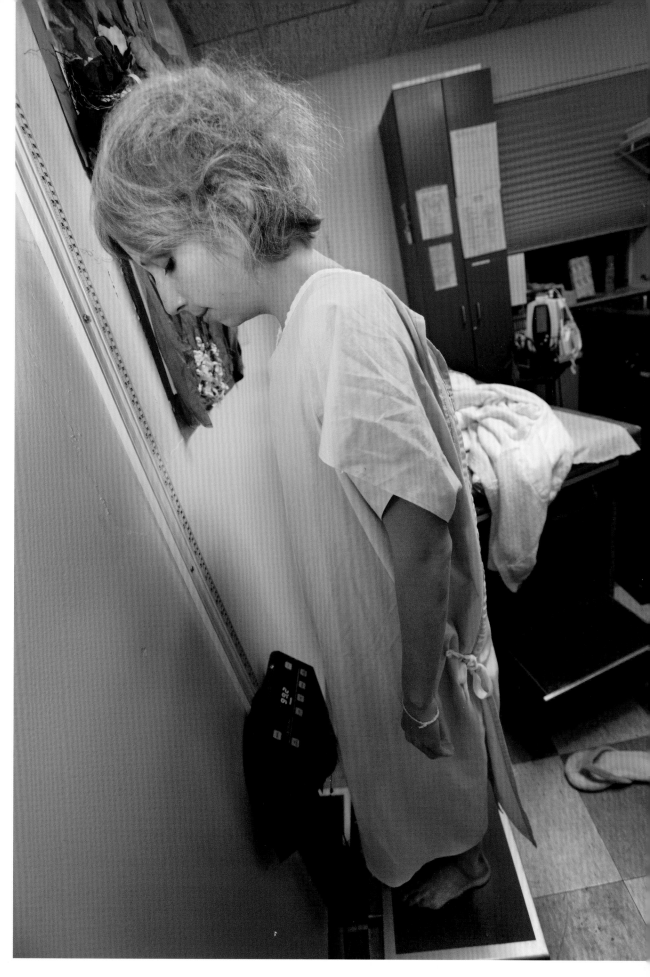

Melissa, 23, at daily weights. Prior to entering the Renfrew Center, Melissa weighed 52 pounds and was in a wheelchair.

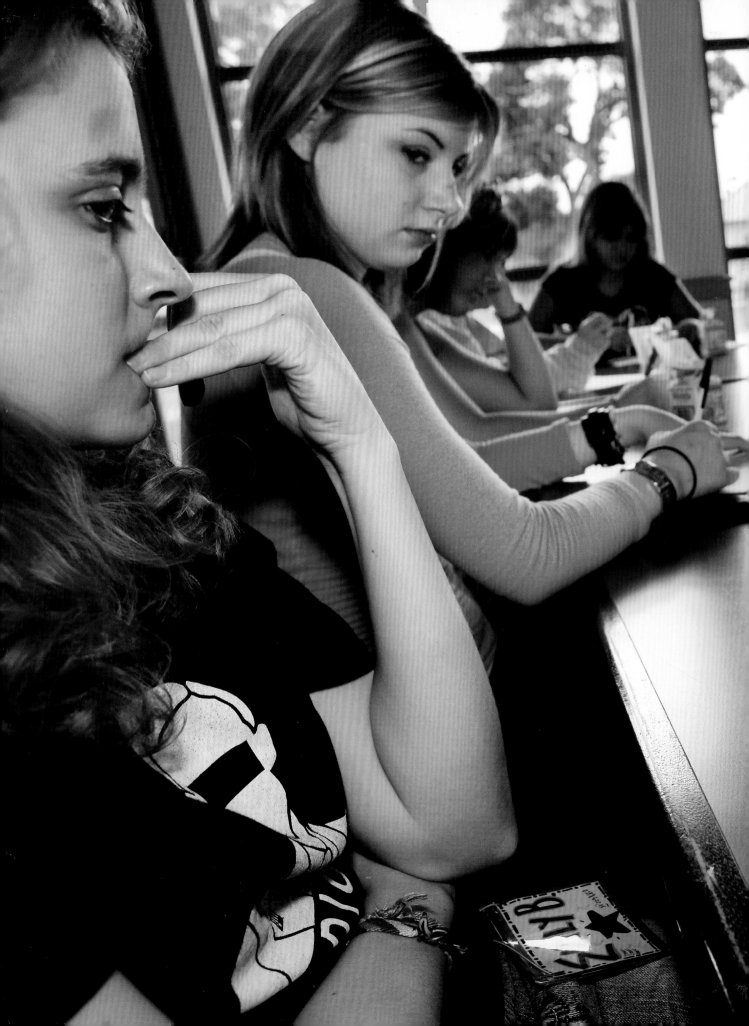

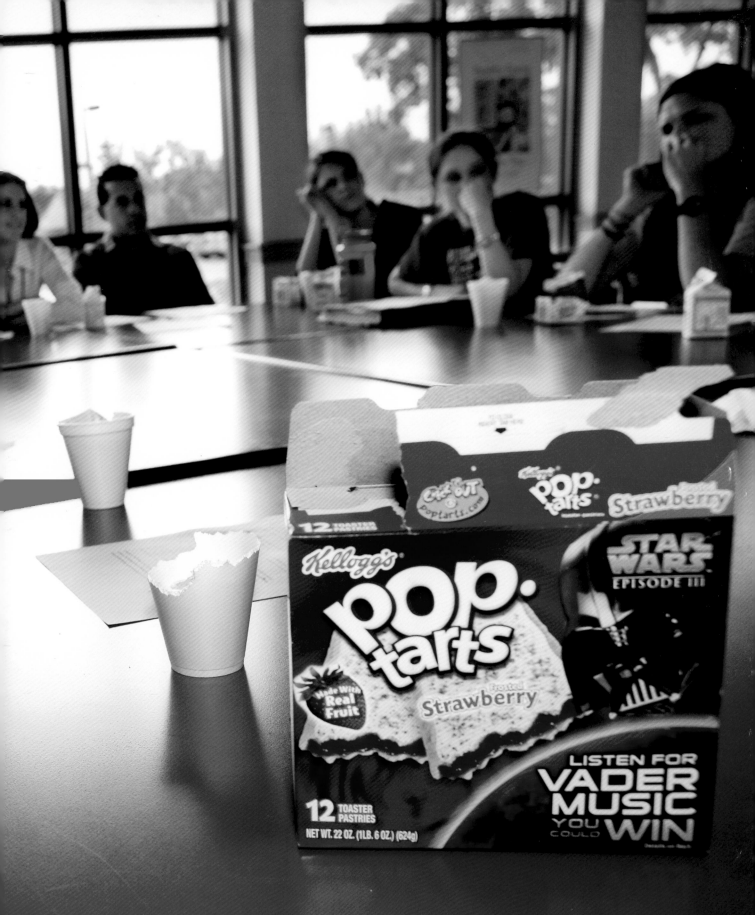

In a Mindful Eating therapy session, residents have to eat a "fear food" such as Pop-Tarts, doughnuts, or candy bars and then discuss their feelings.

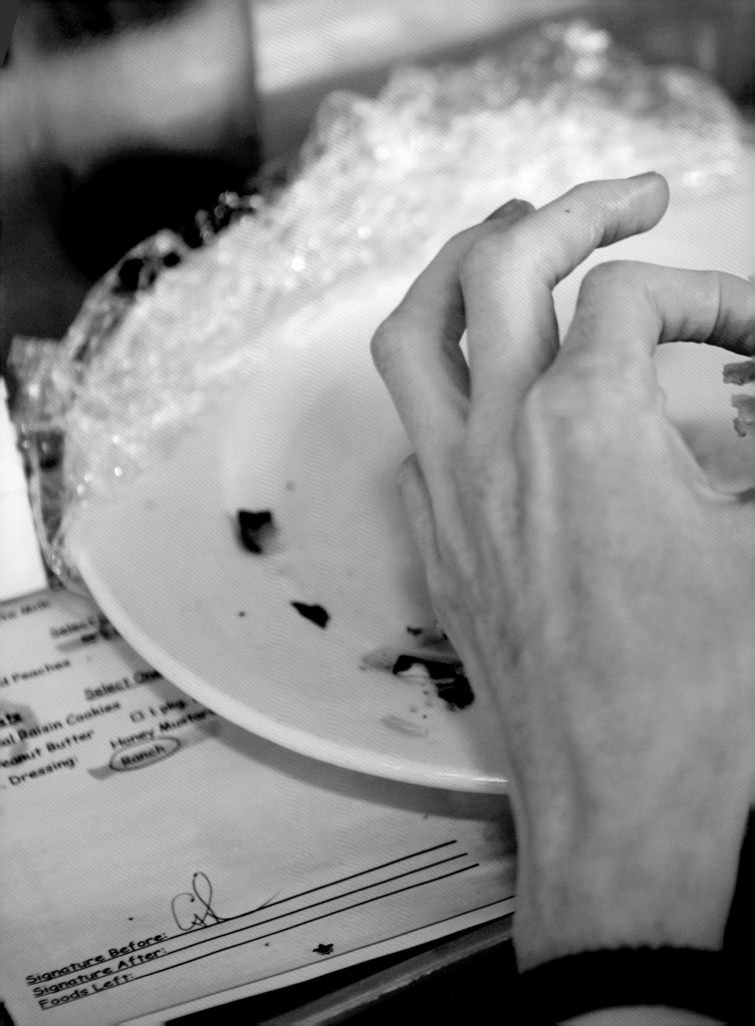

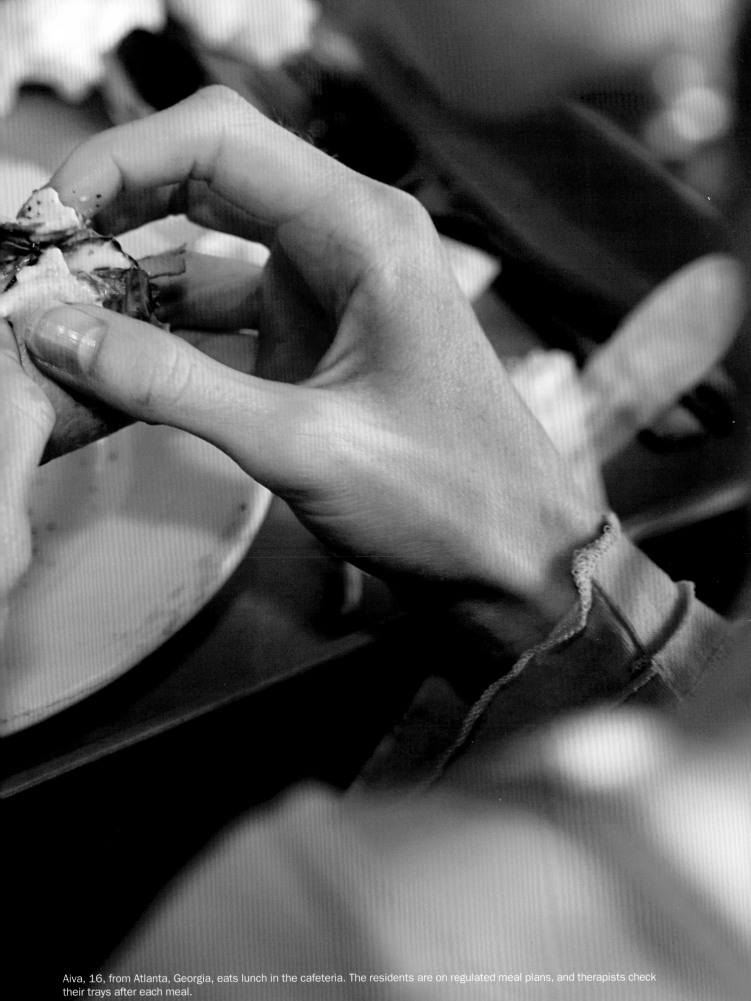

Aiva, 16, from Atlanta, Georgia, eats lunch in the cafeteria. The residents are on regulated meal plans, and therapists check their trays after each meal.

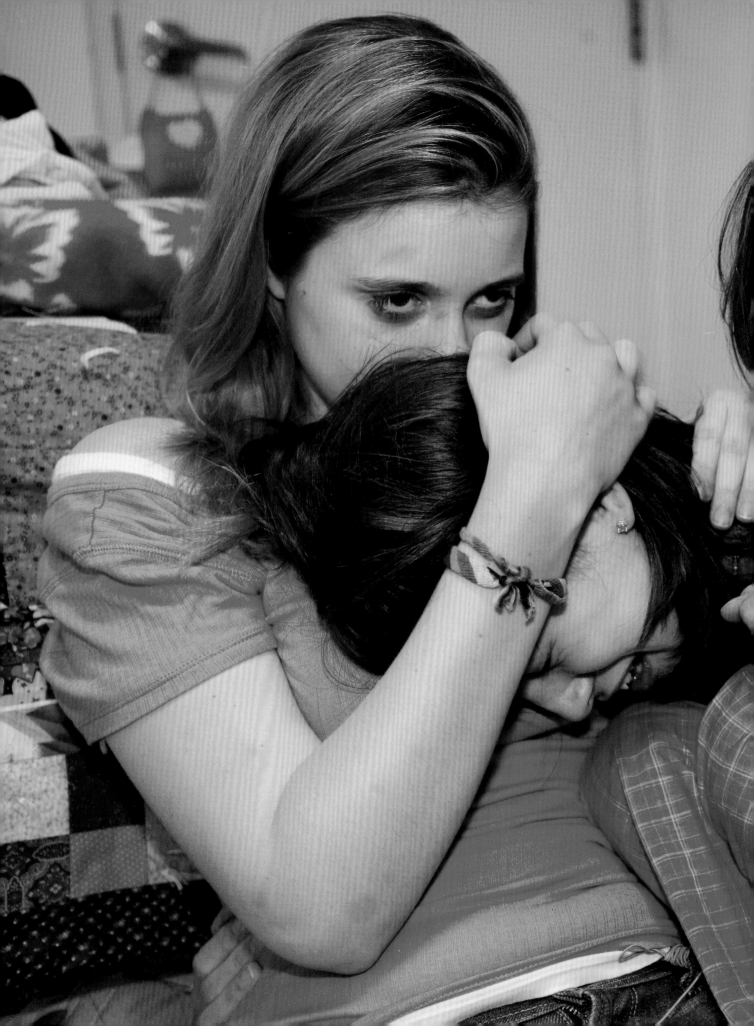

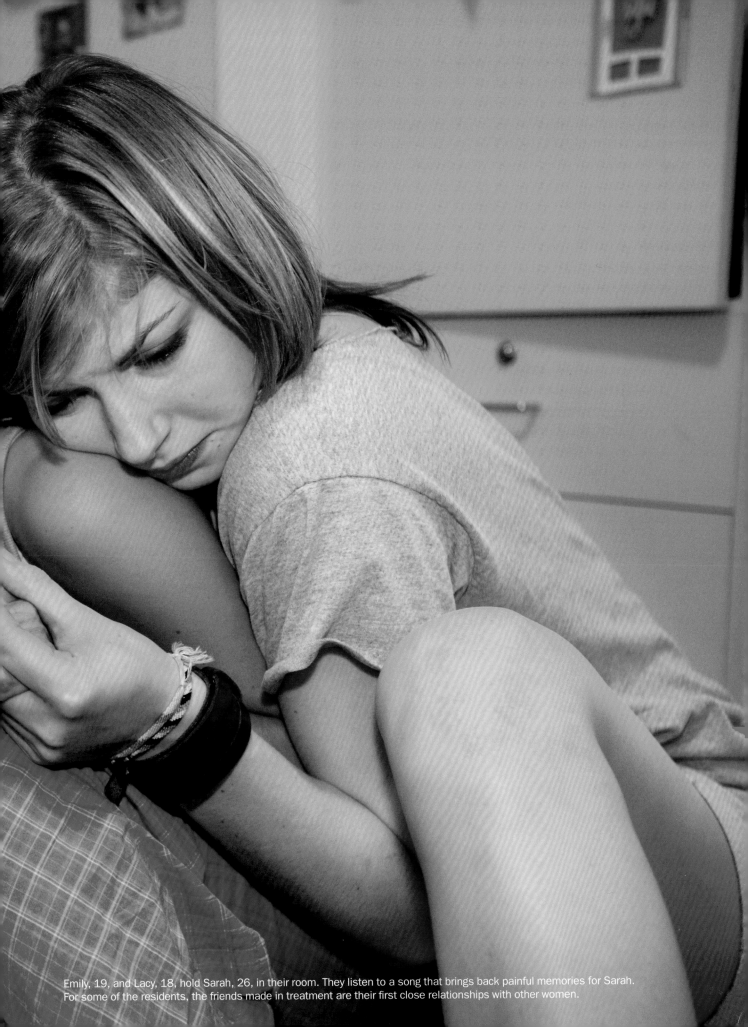

Emily, 19, and Lacy, 18, hold Sarah, 26, in their room. They listen to a song that brings back painful memories for Sarah. For some of the residents, the friends made in treatment are their first close relationships with other women.

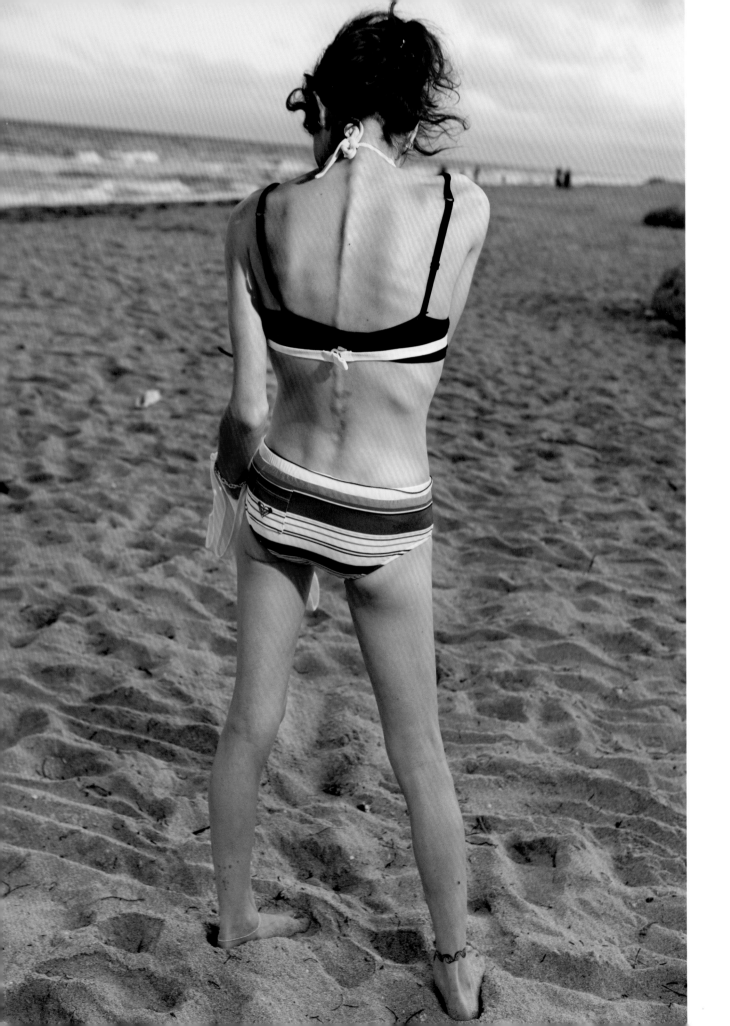

LAUREN GREENFIELD

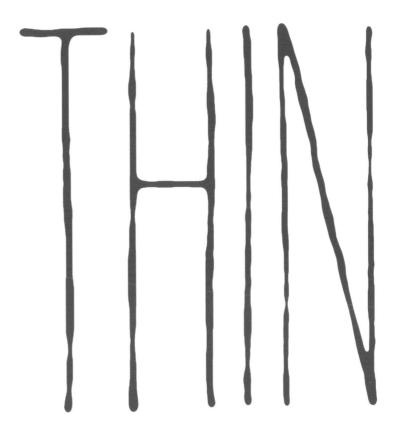

Introduction by Joan Jacobs Brumberg
Essays by Dr. David Herzog and Dr. Michael Strober

CHRONICLE BOOKS
SAN FRANCISCO

MELCHER
MEDIA

Contents

All photographs were taken at the Renfrew Center, a residential facility for the treatment of women with eating disorders in Coconut Creek, Florida, unless otherwise specified.

LAUREN GREENFIELD

Why Thin?

Every girl is affected by the desire to be thin. In the United States, we grow up feeling like our bodies are an expression of our inner selves. To be thin is to be beautiful, disciplined, and even moral. Fat is equated with laziness, slovenliness, a lack of regard for oneself, and a deficiency of self-control.

Perhaps it is due to the power of these ideas in our culture that the pathology of eating disorders has become so common and severe. Eating disorders now affect one in seven American women and have become a mental health epidemic. Though often glamorized or trivialized in popular culture, they are actually the deadliest of all psychiatric disorders.

The making of *Thin* was a continuation of my decade-long exploration of body image and the way the female body has become a primary expression of identity for girls and women. I spent five years photographing and interviewing girls and women around the country for a book and exhibition called *Girl Culture*. In that work, I explored the way the body is a medium for girls to express their identities, ambitions, insecurities, and struggles. I was interested in the fact that girls learn from an early age that a woman's power comes from her body and its display. The way girls present, decorate, reveal, and manipulate their bodies is a reflection of society's conflicting messages and expectations of women. The female body has become a tabula rasa on which one can view the interplay between society's imprint and the individual's voice and psychology.

In this context, the pathology of eating disorders is compelling, symbolic, and important to understand. It is extreme and atypical, but unlike most other mental illness, it has a visible relationship to the values of mainstream culture. Yet while the symptoms look strangely familiar, it is unfathomable to most of us how or why the common dieter crosses the abyss into irrational, self-destructive, and even suicidal behavior.

We live in a culture that supports obsessions with the body, food, self-improvement, and personal transformation of a physical nature. Perhaps this is why we are fascinated with eating disorders and why they have been glamorized by a media that highlights the rich and famous celebrities who have fallen in its wake. In the mainstream, we love to eat and focus on food, and yet we also condemn ourselves for engaging in this very act required for our survival. Any girl who has lost or gained

weight can provide evidence that people respond more positively to thin people than to fat (more friends, more boyfriends, the kindness of strangers, etc.). The "before" and "after" pictures used to sell diet products and plans, weight-loss camp, plastic surgery, and reality TV shows such as *The Swan* and *Extreme Makeover* rely on the shared assumption that our bodies are an extension of the "American Dream"—blank canvases of a meritocracy where we can paint our own dreams and achieve our goals if we devote enough hard work, money, and time to get the job done—the Puritan ethic interpreted within the culture of narcissism.

I began *Thin* with an interest in the most pathological and exaggerated manifestation of the "body project" that engages most of us to some lesser degree. Eating disorders seemed a cautionary tale about society's unhealthy emphasis on our physiques and the implied relationships between our inner and outer attributes. I have been a chronic dieter myself, especially during my teenage years, and can relate to obsession over calories and nutritional content. I can identify with Alisa, one of the women featured in the film and book, when she changes her clothes 10 times before going out the door and explains that her wardrobe choices are based on what is slenderizing rather than color or season. This is the kind of "insanity," "obsession," and "compulsion" that otherwise rational women experience every day. I have strictly dieted, religiously exercised, emotionally overeaten, and even tried purging a couple times with little success (the work of an amateur, as my Renfrew subjects would call it). And yet, even with that background, I was ignorant of the true nature of eating disorders and how difficult they are to overcome.

While the *Girl Culture* journey was very personal for me, inspired by my own body-image issues and memories from childhood, *Thin* was a crossing into the unknown. Though it began with a familiar departure point of the body project, it descended quickly into the heart of darkness of mental illness. The women in the film and book helped me navigate the deep, difficult places that I have never known firsthand. They allowed me to bear witness to their struggle and document the disease and its damage. I came to understand that the mental disorder is far removed from the world of popular culture, vanity, materialism, and self-esteem issues that have been the thematic preoccupations of my prior work. If anything, the superficial similarities

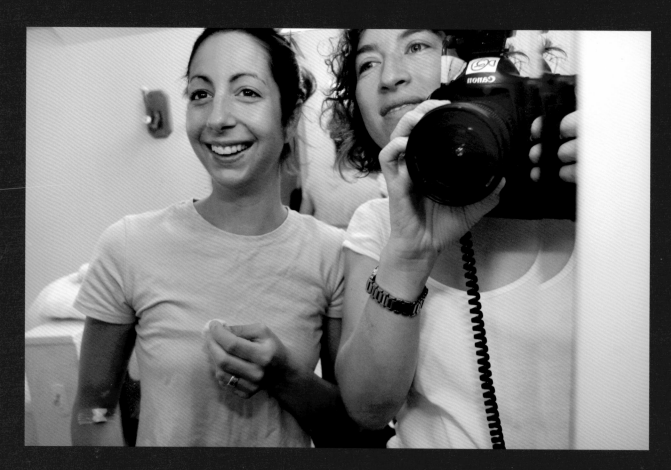

Photographer Lauren Greenfield with Shelly, 25, a patient at the Renfrew Center.

that eating disorders have to mainstream dieting has led to a misunderstanding of the sufferers by their peers, families, the media, and insurance companies.

Although the reasons people develop eating disorders are complex and individual, it is clear that they function as a coping mechanism, like drugs, alcohol, or cutting—used to numb out intolerable emotional pain and experience a sense of control. The fact that this particular coping strategy is so prevalent in our time is a logical consequence of a society obsessed with the concept of an ideal body. Perhaps the primacy of self-expression through one's body explains why there is an overlap between people who self-harm by cutting and those who engage in the slow suicide of an eating disorder.

This cultural focus on the female body that was the subject of my earlier work, *Girl Culture*, might well explain why that series of photographs hit a nerve that allowed them to travel and reverberate in ways I could never have imagined. The accompanying educational curriculum was used by young people and educators around the country, and the museums that showed the

exhibition created a broad range of outreach and community programs around it. From the e-mails I received, the art that people sent me, and the personal nature of the comments written in museum guest books, I understood that girls and women had made it their own. The grassroots response made me want to go deeper into the subject by harnessing the narrative potential of film. I brought the idea of a series of documentary films based on *Girl Culture* to producer R. J. Cutler, and to Sheila Nevins and Lisa Heller at HBO, and we decided that I would direct my first film on the subject of eating disorders.

I first visited the Renfrew Center in South Florida, one of the best-known residential facilities for the treatment of eating disorders, in 1997, as a photojournalist on assignment for *Time*. I returned there again to photograph for *Girl Culture*. As a photographer, I found it a challenging yet compelling place to work. The stories of the women were incredible and the atmosphere raw and honest. There was natural drama and tension that was emotional, narrative, and cinematic. Actually, the very things that stymied me as a still photographer—the repetition of the daily rituals; the claustrophobic nature of institutional life; the

monochromatic fluorescent color palette—were rich and communicative elements in the storytelling process of filmmaking.

Having made multiple trips to the facility, I was drawn to the familiarity of the place, but also to its structure. The fact that it was an all-female residential facility with 40 beds gave it the atmosphere of a college dorm. There was inherent "girl culture"—female bonding, competition, gossip, cliques, and the complex social dynamics between girls—that was both familiar and turbo-charged in comparison to the communities of girls I had photographed before.

The only remaining question was one of access. Would a treatment facility give me the access that I needed to tell this story, and would I be able to gain the trust and candor of a population that has deep-seated trust issues, a debilitating body image (which could be further activated by the presence of a camera), and whose modus operandi (as part of their illness) is trafficking in secrets, lies, and manipulation?

The Renfrew Center never wavered in their cooperation or enthusiasm for the project. They understood my need for journalistic independence free from editorial influence or conditions. The staff taught me about the illness and daily life within the institution and guided me in gaining the trust of the residents, each of whom could choose whether or not to participate. The residents came on board gradually and unpredictably—sometimes with enthusiasm, at other times with hesitation or apprehension, and at the best of times, unexpected openness and partnership. My work with them was an intense but fluid dance. For reasons practical and ethical, the subjects were my collaborators, and when we had obstacles, roadblocks, questions, concerns, we had to work them out together to move forward. A challenging situation for a documentarian, this dynamic required me to remain open and vulnerable to the residents' moods, issues, and changes of heart and mind toward the filming. I also continuously laid my own goals, process, and needs on the table with patients and staff in private meetings and community group-therapy sessions.

Once on board, the women were incredibly generous and honest with their stories and their lives. Their body-image struggles were so profound and their illness so all-encompassing that the image issues people often have in relation to cameras were comparatively insignificant. The women understood the importance of being documented in their highs and their lows to show the reality and the devastation of the disease. We worked through these ups and downs in a protracted, intimate way such that they related to me and my (all-female) crew as people rather than as cameras, or the "media."

The resulting film is a cinema-verité exploration that follows four women—Shelly, Polly, Brittany, and Alisa—in their daily lives at the Renfrew Center. While following their individual stories, the documentary investigates the process of treatment, the culture of rehab, the cycle of addiction, and the unique relationships, rules, and rituals that define everyday life within the institution that is their temporary home. What emerges is a portrait of an illness that is frustrating in its complexity and tenacity, and shattering in the pain it inflicts on its sufferers and their loved ones.

I decided to make this companion book because of the stories and information that could not be communicated in the film, and because photography with words is my first and most natural voice. I also wanted to tell a broader story about the diversity of the population affected—older women, women of color, adolescents, and obese women ("emotional eaters")—which I could do more effectively in photography. I wanted the film to be purely experiential so the viewer could understand the emotional reality of living with this illness. To that end, we deliberately stayed away from a didactic approach of lengthy interviews and "talking head" experts. For the book, however, there was an opportunity for me to conduct first-person interviews to flesh out the backstories that help to understand the origins of each woman's illness. There was also the possibility of a more longitudinal view of the central women from the film—seeing their transformations from early childhood pictures through the process of treatment at Renfrew to post-treatment interviews chronicling both recovery and relapse. After the film was complete, Shelly, Polly, Brittany, and Alisa entrusted me with their private diaries to first read and then include in this book. The journals give expression to the powerful internal voices of an eating disorder and the fierce struggle between that voice and the one of recovery. All of the handwritten passages that appear in the book are excerpts from their diaries and art.

The women in these photographs are incredibly brave to share their stories and the intimate details of their private struggles with a tragic illness. Eating disorders are fueled by secrets and lies. These women decided that by being honest with the camera and with me, they could possibly make a difference for themselves and for others. I am honored by their courage, trust, and collaboration, and I dedicate this book to them.

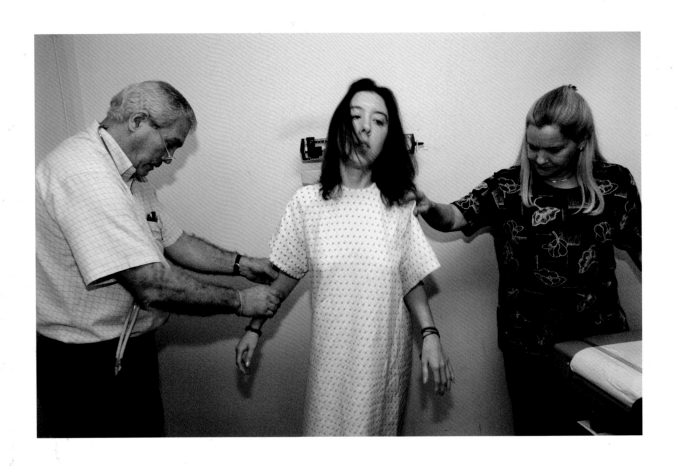

Erin, 24, from Lincoln, California, is "blind-weighed" at daily weights. She mounts the scale backward so as not to see her weight gain from treatment. (From *Girl Culture*)

JOAN JACOBS BRUMBERG

Introduction

In *Girl Culture*—a stunning exhibition that has traveled to museums and galleries across the United States and abroad since 2002—photographer Lauren Greenfield provided a provocative and memorable mirror to the social world of young American women. Now, in *Thin*, her first feature-length film and third book, she brings the same artistic talent and emotional sensibilities to the subject of eating disorders, specifically anorexia nervosa and bulimia, two well-known psychopathologies associated with contemporary young women.

Anorexia nervosa (severe food restriction) was actually named and identified in English-language medicine in the 1870s, long before late-20th-century mass media began peddling its waiflike icons. Sometimes it was called "hysterical anorexia" or lack of appetite from the emotional excess that Victorian medicine believed to be innate in all women. Anorexia nervosa actually remained a relatively rare disorder well into the mid-20th century when, after World War II, the numbers increased as a result of economic prosperity, better diagnosis, and psychosocial factors associated with modern female adolescence.

Bulimia (the binge-purge cycle) is a recent development suited to the pace and psychology of contemporary society. It seems to have emerged, in its modern form, among women dieters in the 1920s and then accelerated in the past thirty years, probably as a result of a mixed message we all recognize: Eat, but don't eat. To a large extent, bulimia also depends on women's personal freedom and autonomy, disposable income, an eating environment that is fast and highly individualistic, and the availability, at almost any time of the day or night, of highly processed food that is easy to consume and also easy to regurgitate. Anorexia nervosa and bulimia both flourish in cultures of plenty where food is abundant. In this kind of society, the appetite is not just about hunger. Instead, it becomes a voice, a way to say something about the self, especially among women.

Physician Hilde Bruch, author of *The Golden Cage: The Enigma of Anorexia Nervosa* in 1978, was the first to suggest that

JOAN JACOBS BRUMBERG, Ph.D., is a professor at Cornell University, where she has been teaching history, human development, and women's studies for more than 20 years. She is the author of *The Body Project: An Intimate History of American Girls* and *Fasting Girls: The History of Anorexia Nervosa*. She lives in Ithaca, New York.

there was a social contagion factor in eating disorders, which she called "me-too anorexia." After the death of 32-year-old pop singer Karen Carpenter in 1983, anorexia nervosa was "popularized" in women's magazines, novels, and made-for-TV movies. There were also published personal accounts and memoirs of bulimia (e.g., by Cherry Boone O'Neill and Jane Fonda), some acting as warnings, and others, inadvertently, as "how-to" guides. Today, many assert that the Internet plays a role in the "communicability" of eating disorders.

Both anorexia nervosa and bulimia have become part of American female experience in the generations born since World War II. Most young women these days can name a celebrity—or someone within their own peer group—who is or has been anorexic or bulimic. Many mothers and grandmothers have witnessed the protracted emotional struggles of eating-disordered adolescents whom they love. Contemporary men as well as women know what it means when someone says, "You look anorexic."

Given our personal experience and the nature of American popular culture and its unrelenting interest in bodies and weight, it's hard to ignore eating disorders. We are both fascinated and repelled by them because they represent the complexities of female experience in a culture that deeply reveres thin bodies. In fact, it's useful to recall the words of German philosopher Karl Jasper: "The neuroses in particular have a contemporary style—they flourish in certain situations and are almost invisible in others." In essence, psychopathologies—such as neurasthenia and nymphomania—may come and go, but they always tell us something about the historical time period in which they are experienced and produced.

While each case involves a mix of individual biology, psychology, and culture, eating disorders flourish whenever and wherever affluence combines with the idealization of a slim female body. Anthropologist Anne E. Becker has demonstrated that even on the remote island of Fiji, the arrival of television—and Western cultural values along with it—generated a sharp increase in eating disorders among adolescent girls. In the early 21st century, we are exporting eating disorders to the world along with McDonald's hamburgers and Disney movies.

However complex and tangled the cause of eating disorders, we must acknowledge that there is a powerful social reward in our

society for being thin. And while our preoccupation with flaw-
lessly slender bodies may not directly cause eating disorders, it
surely fuels the mindset of those who develop them. For that
reason, anorexia nervosa and bulimia are diseases that are
unlikely to go away easily. Today, eating disorders have a firm
hold on our psyches and they continue to be disproportionately
female, involving a wider age range of women than ever before.
Increasingly, eating disorders are linked to self-injurious be-
havior, such as cutting, and are also incorporated in the border-
line and bipolar character disorders. (Cutting, an increasingly
popular coping strategy among the young, mimics eating disor-
ders in terms of the social contagion factor.)

In *Thin*, the film and this book, Lauren Greenfield builds a com-
pelling narrative around the experiences of four young women—
ages 15 to 30, all with eating disorders—who are patients at
the Renfrew Center in Coconut Creek, Florida. Renfrew is a pri-
vate residential treatment facility where patients' bodies and
possessions are carefully monitored; access in and out is lim-
ited; and eating behavior is closely controlled as part of a larger
medical and psychological program. Each patient works with a
multi-disciplinary team of nurses, nutritionists, therapists, and
physicians. As a patient improves, she wins privileges that allow
reintegration into the outside world. Because Renfrew's inter-
vention is costly, we connect immediately to the issue of
insurance: In our flawed health care system, not everyone with
an eating disorder can afford this kind of treatment. In fact,
many Renfrew residents cut short their treatment when insur-
ance coverage runs out.

Because of the disease, eating-disordered patients can be dis-
honest and manipulative even when they have consented to
residential treatment, suggesting some striking parallels with
other substance abuse and addiction problems, such as
alcoholism and drug abuse. At Renfrew, hiding and secrecy are
often an issue, and we are privy to the customary staff checks
for contraband items that patients might use to sabotage the
therapeutic process, such as tape measures (to measure body
size), razors (to self-injure), and hidden food.

While some clinicians may debate Renfrew's highly structured,
reward-based approach, Greenfield makes no judgment about
the treatment modality, its assumptions, ethics, or success.
That's not the point of her work. Instead, the goal is to involve
herself and her viewers in the day-to-day experience of young
women doing battle with a life-threatening psychopathology.
Each of *Thin*'s protagonists—Shelly, Polly, Brittany, and Alisa—
entered Renfrew because her life had fallen apart as a result
of an eating disorder. Each brought with her a unique personal
and family history, as well as a set of problematic behaviors
that we get to know intimately as these four stories unfold over
a lengthy struggle. Through a focus on these women, *Thin* con-
firms that eating disorders are not simply illnesses of vanity.
They are disturbing, dangerous, and often demeaning.

In order to achieve this kind of unique visual ethnography,
Greenfield worked collaboratively with Renfrew's staff and
patients. Along with cinematographer Amanda Micheli, she
lived and worked at Renfrew over a six-month period, literally
hanging out with patients who were both subjects and inform-
ants. She had full access to intake and treatment sessions;
the four women central to the film were fully aware of the
filmmakers' mission and gave their consent. If and when they
felt discomfort with filming, they could opt out simply by asking
Greenfield or Micheli to stop the camera. After the filming was
complete, Greenfield spent an additional year photographing
and interviewing the four women, as well as a diverse group of
other Renfrew residents, for this book.

The result is a deep look into an eating disorders clinic. We
develop a sense of the daily therapeutic routine: early-morning
blind weigh-ins, periodic room checks, and required group
and individual therapy sessions, all structured around three
scheduled, nutritionally ample, sit-down meals. Along the
way, we experience many of the unhappy and sometimes
upsetting behaviors associated with eating disorders: emotional
outbursts against family and friends; hostile therapeutic
exchanges; bizarre reactions to food; excessive preoccupation
with weight. But it is in the girls' diary entries and their inter-
views that they most honestly detail their secret lives, including
their deep resistance to giving up their symptoms and the
ways they cheat the Renfrew system.

Clearly, Greenfield knows how to insinuate her camera into
some very troubled lives. (*Girl Culture* had the same revelatory
and sometimes shocking quality.) In the film, Greenfield
becomes so intimate with her subjects that we get to watch
Alisa purge for the camera without embarrassment, and we
collude with Polly as she violates house rules by smoking in
her bathroom and blowing the smoke into the air ducts, all
while talking to the camera. This is cinema verité at its best,
but it also provokes questions: How does Greenfield get so
close? And why would these women allow themselves to be
filmed at these painful private moments?

Renfrew patients obviously regarded Greenfield and Micheli
as neutral, even as allies. Perhaps, the patients were also
disarmed and/or seduced by the potential to tell their individual
stories to the world. Participation in a documentary project
could give meaning to their prolonged suffering, either as a
warning to others or as a way to legitimate their illness.
All of these motivations are possible in a culture like ours
where there is no longer any stigma attached to public narra-
tives of deep despair and recovery.

Greenfield's talent as photographer and documentarian is that
she manages to get up-close and personal in a sympathetic
way without romanticizing the pathological behavior that is cen-
tral to this story. Both the film and the photographs provide

extraordinary access and a sense of intimacy that allows us to see and feel the anguish and torment of four otherwise smart and attractive young women whose emotional lives are filled with misery, anger, and confusion. As we enter their claustrophobic lives, we experience their dramatic and obsessive relationship with food, scales, toilets, and feeding tubes. Most important, we go away remembering how harsh and destructive eating disorders can be.

The medical consequences of eating disorders are dire and sometimes fatal. People with anorexia nervosa develop amenorrhea and osteoporosis; many lose teeth and hair prematurely. A cure is not easily accomplished and recidivism rates are high. *Thin*, fittingly, has no happy ending because many women struggle with eating disorders for ten, twenty, even thirty years.

"Thin" is an apt title in many ways. It's the mantra of the eating disordered but also of our larger society. In the interviews, we hear patients repeat, over and over again, words that are commonplace in everyday conversation: "I want to be thin. I am overweight." Most of us feel the same way, so we work at this goal in a variety of ways. Some diet habitually, some episodically. Some of us lose weight; many do not. What distinguishes people with eating disorders from the larger community of American dieters is the degree of commitment to the ideal of slenderness, notably whether we adhere to severe food restriction, purging, or both. The patients we meet in *Thin* have embraced these symptoms *in extremis;* they make weight loss an obsession, if not their ultimate goal. Alisa, a professional woman and a mother of two, sadly but aptly sums up the mentality that left her addicted to purging: "I tried so hard to find satisfaction in other accomplishments. But nothing measured up to this one. . . . I just want to be thin. If it takes dying to get there, so be it."

In addition to the authentic voices of patients, *Thin* allows us entry into the atmosphere of high emotion that surrounds food and eating in the process of treatment. Patients at Renfrew matriculate with "dieting skills" in place—restricting, purging, laxative and exercise abuse—but they need to give them up for recovery, an outcome that we hope for but never really see. Learning to eat again in a more normal way is a frightening task because these patients are so deeply ambivalent about getting well, which, in their eyes, means getting "fat." Paranoid about the healthful diet that she must follow at Renfrew, Shelly accuses her nutritionist of wanting to make her "a big fatass." In their diaries, patients obsess about what they eat, count calories, and express a phobic reaction to most food. Over and over, they collaborate in the same expository chorus: "I am dying to restrict." "I want to puke!" "I want to be less than 100 again." "I am afraid I will look like a big old cow by the time I leave." Polly's artwork proclaims the ideal: "An exquisite complement to any meal: Nothing."

The emotion food engenders is palpable. No one seems to be hungry at meals, but everyone seems to be anxious. Frequently, girls reach out to support one another in the effort to get something down or complete a meal. Food is something to commiserate about, not enjoy.

"It's so dramatic and chaotic here," says another patient, capturing a reality that provides Greenfield with an intrinsically interesting canvas of raw emotion and anguish, some of which feels familiar and distinctly adolescent. Within the community of sufferers, some girls compete for attention just as they did in their families. In a therapy session, Polly says to 15-year-old Brittany: "You want to be the sickest one here."

All of this honesty about resistance makes a viewer wonder: Why is it so hard to overcome eating disorders? And what do these young women have to give up to get well? *Thin* suggests that each of the four central characters has used her obsessive behaviors as a source of identity, as a way to define who she is. For that reason, change is extremely difficult, something to be feared. Sadly, none of these young women are able to find a way to be more than a visual object—a thin person. And all of them express their life goals in terms of the number on the scale.

Although "Thin" is the perfect name for Greenfield's arresting film and edgy photographs, the two together could be subtitled "Empty." This unsettling collection ultimately makes a powerful case for the ways in which eating disorders contribute to arrested development in women. We hear almost no talk of boys, sex, or relationships. There is not a word about careers, artistic or expressive goals, politics, religion, or humanitarian ideals. These patients are not only small and light; they also seem hollow, unfulfilled, and without substance. "I used to have a personality," Shelly observes in a review of her eating-disordered life.

More so than any other cinematic or journalistic effort to date, Greenfield has created a disquieting exposé that records an obsessive adherence to a pathological body project. In an era of expanded female opportunity, in a society with enormous material resources, it would be nice to think that women would move away from the idea that their primary power is in appearance, but this has not been the case at all. In fact, the pressure for perfect bodies has escalated over the past few decades, affecting all of us, male as well as female. Today, there is both a medical and an aesthetic imperative for slenderness that provides powerful cultural fodder for the genesis of eating disorders. *Thin* is a stunning and important contribution to our understanding of a desperate, misguided search for perfection that will continue to perplex our affluent society for some time to come.

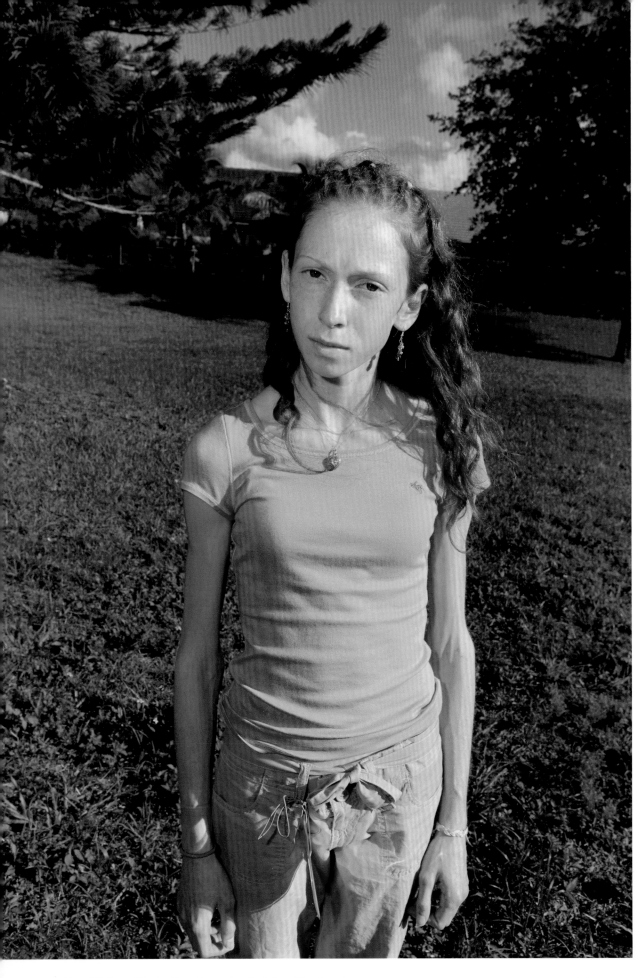

Aiva, 16, from Atlanta, Georgia, on her first day of treatment.

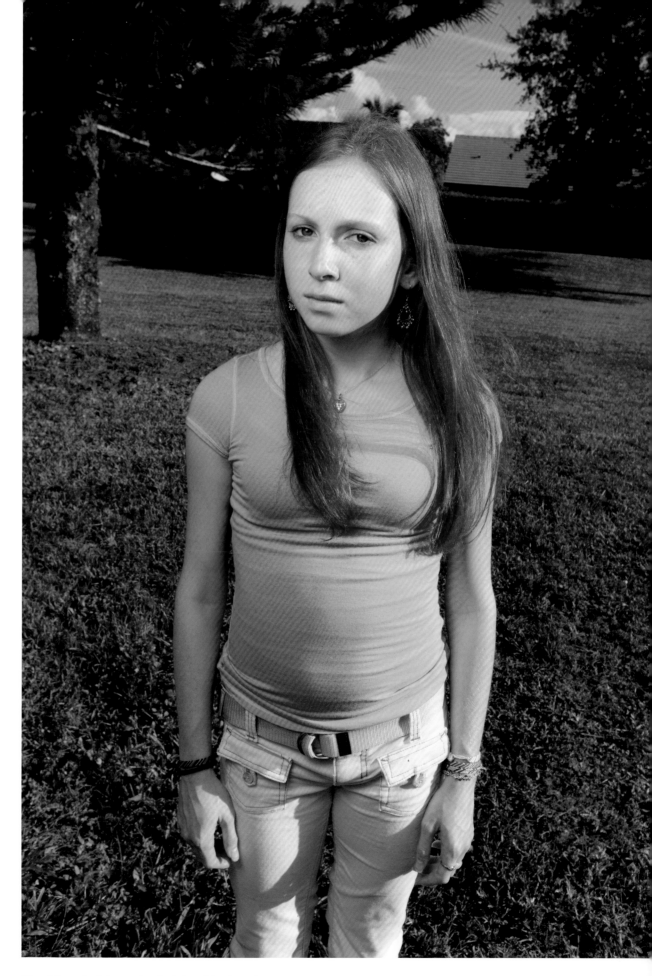

Aiva, 10 weeks later, on her last day of treatment.

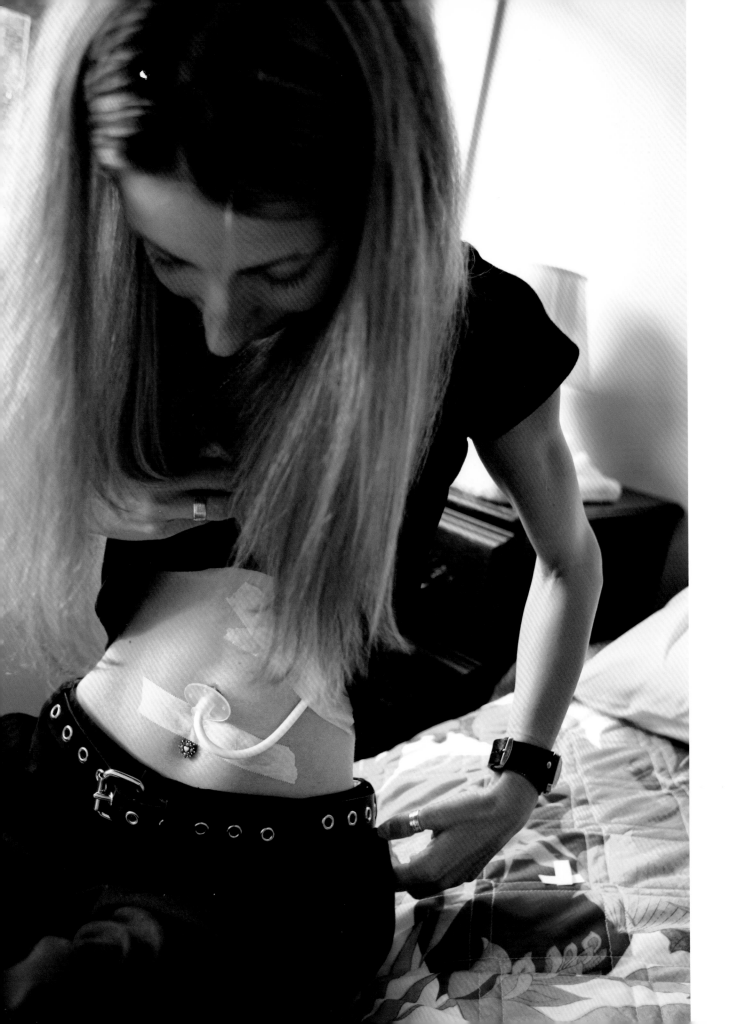

SHELLY

Everybody wants to be thin. I've been here for almost three weeks, and I'm gaining weight way too fast. When I was thin, I had all this control. I'm really big right now and I want to get thin, but I know it's not healthy.

When I came to Renfrew, I was so gone I didn't know what a normal meal looked like. I had a tube in my nose for five years. It's kind of embarrassing to have a tube in your nose and go to school and to work. I was getting formula through it. I was supposed to get three cans of 500 calories a night, but I'd only do one can and run it really slowly in case people would come to check on me, like Hoyt. Hoyt is my ex-boyfriend and we live together.

In the hospital, I would manipulate my tube. They started watching me because I wasn't gaining weight. I was glad I was losing weight. I would dump out most of the formula and replace it with water. No one even noticed. I mean, it was a totally different color. You had to be stupid not to realize it. They finally figured out that I was diluting the formula with water or running it into a cup. Running it into my bed. Running it into plants. Running it anywhere but inside me.

Every picture that I have from the past five years, I have a tube in my nose. My dad was like, "My child can't have a tube in her nose," and so he took me to the doctor. I got put under, and I woke up with a tube in my stomach. It was horrible. It was the worst pain I've ever, ever felt. When I first got it in I was like, This is easy access to my stomach. I could just flex my muscles in a certain way and stuff would come out, or I would just take a syringe and suck things out, which is totally disgusting, I know. But I had to get it out of me. And it wasn't even like I binged, just anything I ate. If I ate, like, a couple of bites of bread I would get it out. I loved it. It was a good feeling, 'cause I didn't have to throw up. I just had to suck it out with a syringe.

Since I've been at Renfrew, I've purged twice through the tube. I was on escorts, but I would just walk out of the community room and do what I had to do and then run back. Getting it removed was really hard because it had become a part of me. I flushed and cleaned it all the time. I took really good care of it. One girl was saying yesterday that getting a tube is a status symbol that you are really anorexic. And that's how I viewed my PEG Tube. I didn't have to eat. It didn't show, but I just knew it was there. I got a lot of attention for it, and it was a lot easier to not eat and just put in however many calories I needed.

LEFT Shelly, 25, from Salt Lake City, Utah, on her first day of treatment. A psychiatric nurse, she admitted herself to Renfrew after 10 hospitalizations. She arrived with a PEG feeding tube that had been surgically implanted in her stomach.

because if I stop they'll get m
want to do even though
I cant cay stop...

❀ I HATE MY

- My stomach was all spill
over the Elastic in YOGA.
subject... I think I am losing
will have to dive into this int
really talked about it so what
whole lot... I want a fucking

CAMEL

Phew - what a day. Today
I went to therapy and I t
and told Adam all kind of sh

or not pleasing that person
–So I do things I don't
ings negative feelings .

98.1 lbs

BODY ! ! !

ed together and hanging
uck . . .stop changing the
mind . . . I think that I
am because I havent ever
I have to lose . . . Not ^
jarette . . . So Does
Kaulee

⫿⫿⫿

98.4 lbs 7/18/04
pr Today

i've
ied and

I would calculate it so well before I worked that I'd have just the energy to make it through an eight-hour shift. I would give myself maybe 750 or 900 calories. Getting it removed was really upsetting because it meant that I was giving up my eating disorder because I didn't have that backup. It meant that I really had to take responsibility. That I was giving up everything this time, giving up restricting, giving up purging. It's like a big piece of my identity gone.

I am a registered nurse, and I graduated from the University of Utah. I worked in oncology for a year and a half and then did psychiatric nursing. I like psychiatric nursing because I feel like I really fit in with the patients. I really understand them and have a lot of empathy for them. I wanted to go into that field because I knew what people were going through who couldn't get out of bed because they were so depressed.

When I was hospitalized, I went under an assumed name, because I knew my boss would see the list of patients. I saw her one day when I was at Starbucks with my pole and the pump and the flush bag. I was like, Oh my God. I was trying to duck. I had this huge fucking IV pole. It was so embarrassing, and I tried to run and was squeaking all the way down the fucking hall. I kept having to resign from all these jobs. After a few months, I would get too sick and I'd be like, "Yeah, I have to go to a treatment center again." I've had 10 hospitalizations. I felt like an idiot every time.

When I came to Renfrew, I thought I was doing fine on my meds. I was on Effexor, Neurontin, Klonopin, Trazadone, and Seroquel. Okay, I realize that's a lot. I probably could have done without the Neurontin and the Seroquel. Klonopin is a controlled substance, a tranquilizer. I've taken it for four years and I've tried to get off of it but I've gone completely insane. I ended up in the hospital every time. So I got here and the psychiatrist took me off of everything. He said, "You have a history of stockpiling medications and that's how you're going to kill yourself." Then he told me I was bipolar. I mean, I am not bipolar at all. That really upset me.

I've worked with bipolar people. We were fighting over this because the psychiatrist wanted me to go on Lithium and I said no, because it makes you gain weight. It really increases your appetite. So he took me off the medications and put me on a Librium taper, and I am having major anxiety. I am freaking out. I can't feel my arms or my legs. I feel like I'm drunk, the horrible drunk where after you stop spinning you want to throw up but you can't.

I think if Renfrew didn't use any meds, many people would walk out the front door. I know I would; I was even threatening it. You throw somebody in a place, you take everything away from them, and then you make them eat and talk about their issues on top of that. Of course somebody's going to have major anxiety.

RIGHT, ABOVE Shelly holds her nephew in between her identical twin, Kelly (left), and her boyfriend, Hoyt, at a family gathering, two years before entering treatment at Renfrew. RIGHT, BELOW An entry from Shelly's journal. She has kept a journal since the onset of her eating disorder.

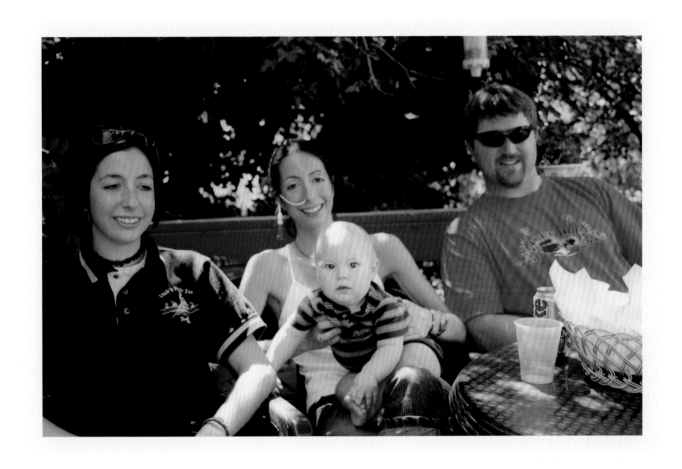

I can't believe I wieghed 82 lbs. That's way too fucking much. 84 isn't even that low. I'll get there again, but they'll never know. OK- can I say one thing... I am quite possibly a fat cow. Why cant I stop eating? I feel so out of Control!!! I feel Like

SHIT

We're always like, "What can I get tonight to get high? What kind of medication do I want to take today to knock myself out?" We were out on the smoke porch and a girl said to me, "I feel like I'm stoned." I'm like, "Well, how much Seroquel did you take?" and she tells me, "300 milligrams." I'm like, "Shit— 25 milligrams of Seroquel knocks me out. Puts me to sleep." We talk about what we're taking, and Polly's even shared some of her Neurontin with me because I wasn't getting enough and I needed more because I was having major anxiety. So she stole a whole bunch and we shared.

Being stuck in a place with a bunch of anorexics, you want to do something and not get caught just so you have that satisfaction of doing something against the rules. Drink some water before you get weighed. Lie about anxiety to get more drugs. Give each other drugs, smoke in bathrooms, share food, hide food. Anything you can do to break the rules. One girl purposely spilled half her food on the table and then wiped it up—and there went 50 calories. I don't like butter, so I hid it for the first three days so I could have coffee, because you can't have your coffee until you eat 100 percent of your food. I hid it in cereal boxes or I'd get Kleenex and put it in my pocket. I feel really guilty when I break rules, so I usually tell on myself.

I've gained a lot of weight. I felt like I was at a good weight and then all of a sudden I'm 90 pounds and I'm freaking out because it was so fast. I know that's not a lot because I came in at 84, but 6 pounds in three weeks? That's a lot for somebody who's not used to eating so much. I don't feel comfortable. My clothes aren't fitting like before. My arms feel a lot bigger. My legs feel bigger. All I do is sit, eat, and sleep. I just feel big and gross. I feel like my stomach has just gotten huge. It's always been flat or concave. I look at it and I'm like, Oh my God. I just want to turn off the lights when I take a shower.

I would die if I didn't know my weight every day. I'm supposed to be on blind weights while I'm here, but I want to know what my fucking weight is. You're supposed to get on the scale backward, but I just stand on the motherfucker and say, "Okay, let's weigh me." If they're too stupid to tell me to turn around, I'll just stand. At home, I would usually judge my weight by the way my clothes were fitting, what I looked like, and how I felt. I knew if I felt really crappy and hungry and dizzy then that was a good day.

In my head, I'm conflicted. I love the eating disorder so much and then I hate it so much. I hope I can look back and say how stupid it was and how much time I wasted and what I did to my family. But it just consumes me. I really want to give it up, but I don't see myself without it. I don't ever see myself not thinking, Fuck, I just ate this, let me go work out, let me throw up, I am not going to eat tomorrow. It makes me sad. If I can just quiet it down a little bit maybe I can eventually forget about it.

I'm scared of the fucking world and I don't know how to live in it. I'm anxious, so I'm just going to stay in my house and not eat. A lot of shit happened in my life, but I think I'm over it. I talk about it all the time in therapy, and I'm just tired of talking about it because I don't think it affects me. That's what scares me. I don't know why I do this. Maybe I just want to be thin.

RIGHT From Shelly's journal, prior to entering Renfrew.

A funny thing happened the other day - I was cleaning out my closet and I reached to the very back to grab some shoes. Under this old blanket I forgot that I had deposited a really big plastic box filled with puke. I had left it there before I went to the center. I thought I had thrown away the all of the containers and Ziploc bags before I had left - anyway I had just eaten so I opened the box and purged into the container. A few weeks ago I would have been disgusted but I wasnt. Just another part of my shitty days. The fact that it didnt gross me out is scary to me because I really dont want to start that cycle all over again.

What Do I get from my ED...
1.) Control
2.) Less anxiety
3.) Death
4.)

Might I say a few words on HBB. OK — This is probably one of the biggest stressers in my life. Ho Without a doubt I love the boy. Its just that right now I cant put the time and commitment into relationship. I think its because I am so scared. I'm scared of what he thinks about me. I wish I could read his mind and see if he really loves me as much as he says he does or if it's just all a game. I have a hard time listening to people him tell me how much he loves me.

Why he loves me. Im scared of being tied down to a relationship. I just dont see the point of investing so much time & energy if it might doesnt work out.

The intimacy part was the hardest part of a relationship. I dont know why I find it so awkward. I dont know if it's a trust thing or what. It could be a combination of not trusting him as well as not feeling comfortable with my body and who I am. I could live without any intimacy because that where I feel most vulnerable.

ABOVE An entry from Shelly's journal in which she writes about her relationship with Hoyt (whom she refers to as HBB).
RIGHT Four months before entering treatment at Renfrew, Shelly stockpiled prescription medication as part of a suicide plan. She arranged the pills into words as a suicide note, which she photographed and pasted into her journal.

Lonely · Rebellious · Lost · Afraid · Failure · Undeserving

Apathetic · screw-up · Weak · Abandoned · Terrified

Tired · Fat · Sorry

dependent · Psychotic

not Perfect · Remorseful

Failure · UnReliable

Useless · NUMB · Uncertain

SUICIDAL

Frustrated · Unbalanced · lifeless

Idiotic · BORING · UNFORGIVABLE · UNlovable · DEad · STUBBORN

LiaR · Flaky

humorless · Resentful

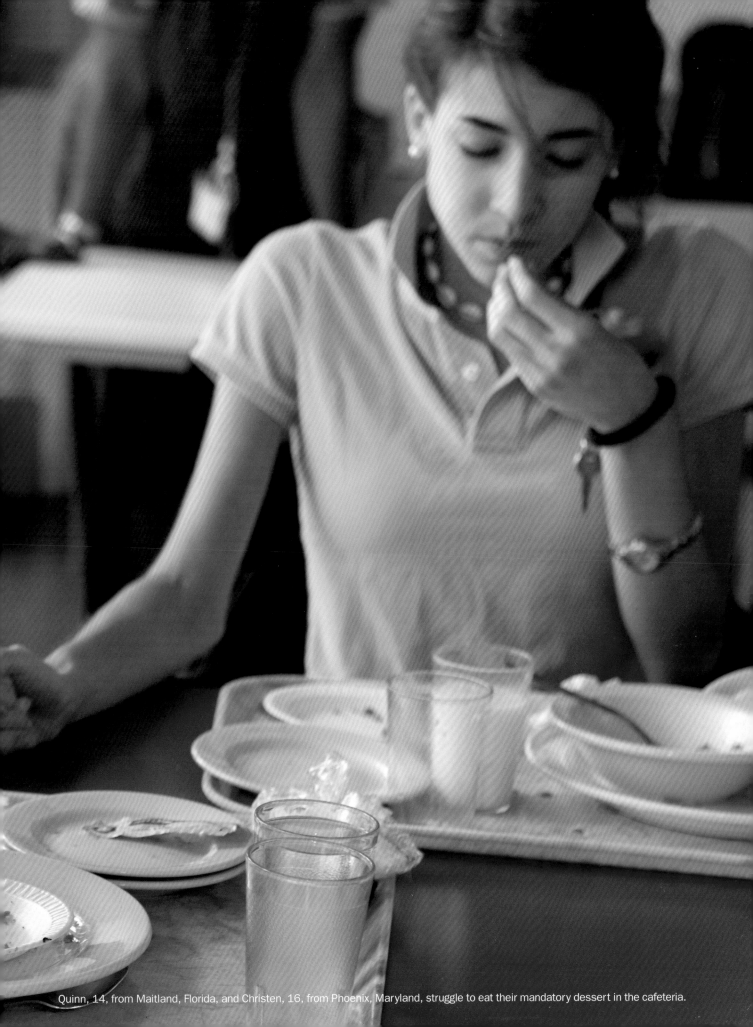

Quinn, 14, from Maitland, Florida, and Christen, 16, from Phoenix, Maryland, struggle to eat their mandatory dessert in the cafeteria.

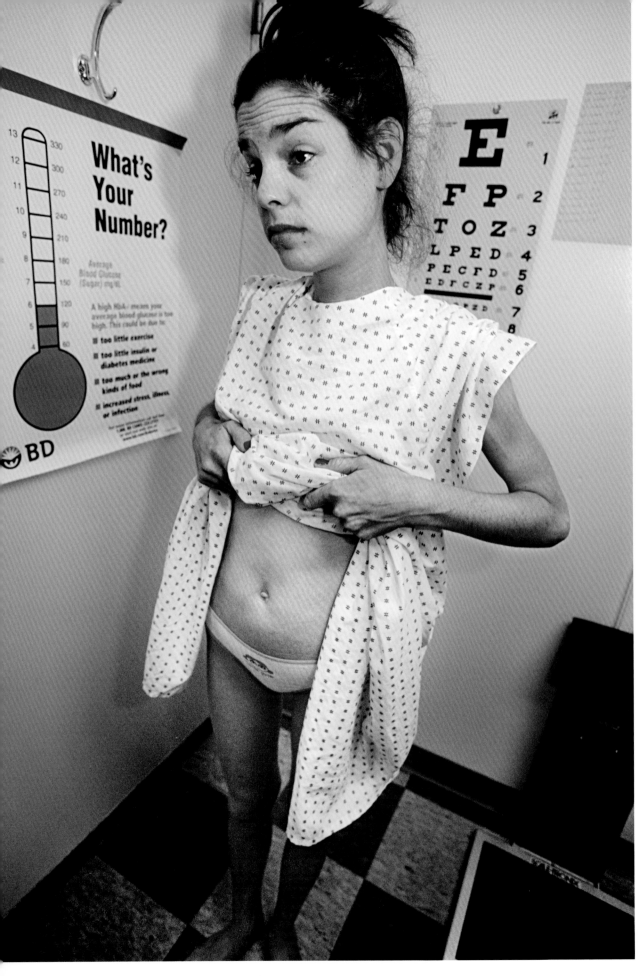

Jennifer, 28, from Miami, Florida, gets a "body-check" during daily weights. Residents with a history of self-harm are regularly examined by nurses for new scars, bruises, or cuts.

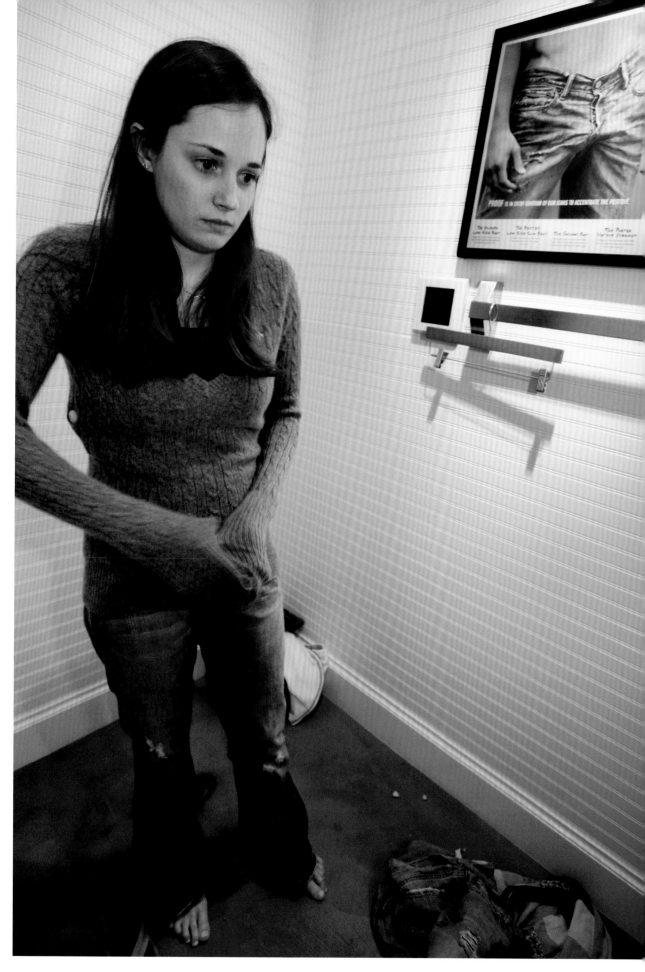

Mary, 24, from Atlanta, Georgia, tries on clothes at a local mall. As residents progress in their treatment, they go on supervised therapeutic excursions in the "real world" to confront the challenges of daily life.

STEPHANIE

14, FROM BROWNSVILLE, TEXAS

I hate myself so much. I came in at 89 pounds, and now I'm 97. It's only been two weeks. Some of my pants don't fit anymore. I can't even look at myself. I see fat, disgusting thighs and legs and arms. I'm just gross. I feel trapped in this body. When I came here I had decided I was skinny, but I gained 8 pounds, and now I see a huge whale.

It's too much food. I memorize every calorie under the sun, so I kind of estimate the meals here. A piece of toast, 100 calories. Cream cheese, 200 calories. Cereal, 140 calories. Milk, 90 calories. I'm going to leave here like a rhinoceros. I hate myself. Is that what they want? Do they want me to hate myself more and more every day as my weight goes up?

My ballet instructor would always say things like, "Stephanie, we're going to have to make you a special costume because nothing fits you. Suck in your stomach." There was a boy who I was in love with who said he didn't want anything to do with me because I was too fat. I wasn't fat. I was 5'5" and 125 pounds. My friends would make comments like, "I love the blob, Stephanie." I don't want to hear those things ever again. I want to be so skinny that no one can ever, ever say anything to me again about my weight.

I made a bet with my friend Leslie that I could be 110 by the end of the summer. It just kind of spiraled out of control. What started off as cutting calories and eating more fruit turned into eating only fruit and nothing else. I would only eat foods I knew exactly the amount of calories of. I would never ever eat food my mom made. I would only eat about 400 calories a day. Sometimes nothing. I was thinking about food all the time. And about chewing. I would buy pack after pack of gum, just to feel that chewing sensation.

Leslie used to be my best friend. She went the other way and became bulimic. When school started, it turned into this competition. She would monitor every-thing I ate and I would monitor everything she ate. She would call me and say, "I ran 5 miles today." Then I would say, "I've got to go and run 10 miles." Or I would see her run up the stairs and then go to class, and then I would use the hall pass so I could run up the stairs and burn those calories also.

We were obsessed with being skinnier than each other. On my birthday she said to me, "I fasted on my birthday." And then she brought me a cake and presented it to the whole class and cut me a piece and said, "Stephanie, eat the cake." We ended up hating each other. I can't stand her even now. She's home and still purging and losing weight and I'm here getting fat. When I come back, she's gonna be really skinny and I'm gonna be heavier and she wins.

My goal is to be happier, and the only way to be happier is to be skinny. Like Gisele Bündchen. She is a beautiful model and so skinny and just perfect. And Nicole Richie. Everything would be easier if I was as skinny as them. My whole life would be different.

I'm not ready to let go. I still want to be skinny more than anything else in the world. But I want to be happy again. I want to be invited to sleepovers and eat cake and eat chips and have pizza. I want to be a normal teenager again, but I want to be skinny so bad. I don't know which one I want more.

I don't want to be in a place where they make me eat 3,500 calories a day. I don't even know why I'm here. I don't want to gain weight. They're ruining all my hard work. This masterpiece that I painted, they're just ruining it and I can't do anything about it. I just want to go home.

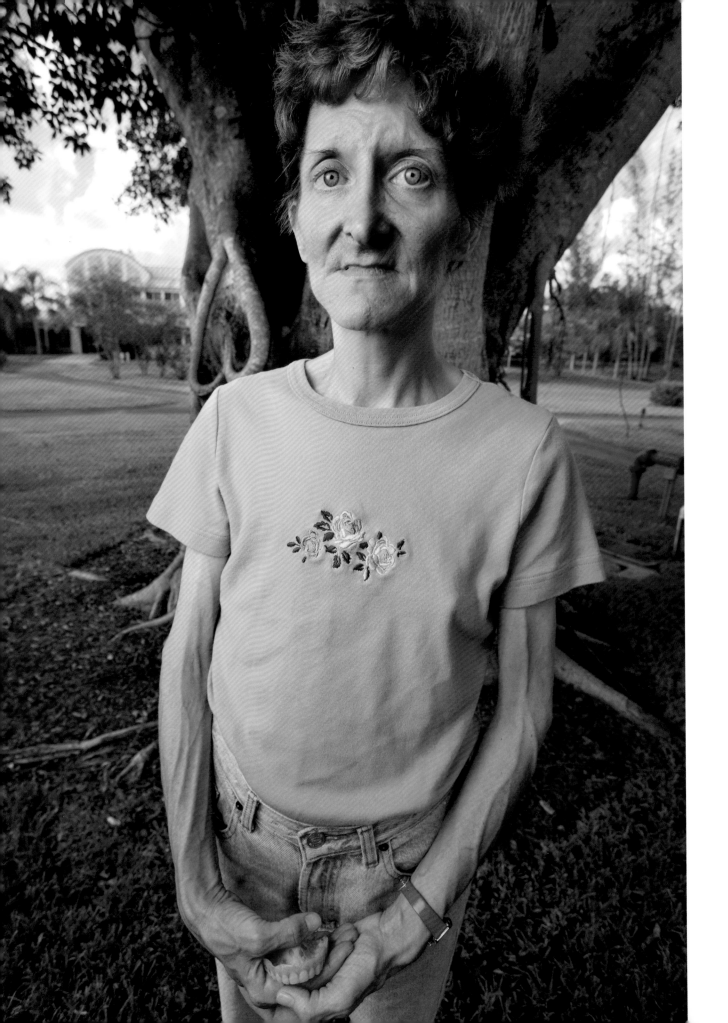

KATHY

I have a broken body. I have no teeth, I have no good leg. When I take my teeth out to wash them, I look at my face and my face looks old. My hair is thinned. I have nothing good on me anymore.

When I was 15 years old, I was raped by a neighborhood boy. It resulted in a pregnancy, and the pregnancy was terminated. My mother made sure that happened. I was date-raped at 18, and that resulted in another pregnancy and termination. I always felt like the outcast. I felt so terribly ugly.

I met my husband 21 years ago. He had two children in their 40s and grandchildren and great-grandchildren. I knew this was a man who was not going to want any more kids. I would have loved to have had children, especially after the two that I lost. I think I would have been the best mother in the world.

My relationship with my husband has suffered a lot from the eating disorder. Financially it's drained us, and physically it's hurt us. He's not been my husband, he's been my caretaker. Two years ago, I was sleeping in a chair in the living room with a nutrition bag plugged into my arm for 12 hours a night. I couldn't go into the bedroom because I couldn't roll the IV around our house. We're still very good friends, but intimacy is the hard part. We haven't had that since we've been married because that's when I really got into the eating disorder. You always hear about people who get married and let themselves go, and I was determined I wasn't going to do that. I went totally the opposite way. My

husband and I argued through everything. If we weren't talking about food we weren't talking about anything at all. It got to the point where it was just the food dance.

I have a hard time eating in front of other people at Renfrew. I feel other people looking at me. I hold my napkin up to my face because everything gets under my dentures. We have monitors in the dining room to make sure you're not cutting your food the wrong way or eating the wrong way. And even though a couple of the monitors knew that I have false teeth, that I can't just bite and chew a sandwich, one came up to me and said, "Can you eat your sandwich the normal way without picking it off?" And I said, "No, I can't, because I have dentures." And she was fine with that, and then I was almost finished and another monitor came up and said the same thing. And I had to remind her about the dentures too, and it was embarrassing to say it in front of the group of girls that were sitting at the table. I feel that they're looking at me because I chew funny. It's a very paranoid thing for me.

I used to have very strange rituals. I liked to heat my food up to boiling hot. I would go back and forth from my dining table to my microwave three, four times during dinner just to reheat and reheat until it got so desiccated that it was unappetizing. I'd end up just throwing it out and going, Oh, I can't eat this now. I'd have my favorite fork and my favorite spoon and my favorite knife, God forbid something happens to them. I couldn't find them one time and I went nuts.

I thought, I can't eat dinner now. I would cut my food up into tiny little pieces. I'd have to place my fork and knife and spoon in certain places on my plate. I'd constantly have to clean up the table. I'd shake my hands while chewing. I'd tap my fork to keep me from having to cut up my meat all the time. I can cut a piece of meat up to where it's microscopic, and I'd eat it that way, one little piece at a time.

I thought of 10 million reasons why I couldn't eat. I would wait for the phone to ring in my house because if I got up to answer the phone, I couldn't eat. Or I'd go out and check the mail or do something in the garden until the stuff on my plate got ice cold. And then I thought, Well, I'm not hungry now, so I might as well wait until dinner.

I've had my eating disorder for 33 years, and I know that's exasperating for the young girls. They can't figure it out: "You're like my mother, why would you be doing a teenage thing?" But I didn't get help and I denied it my whole life. I just thought it was the thing to do, part of the whole hype of, you've got to stay thin to look good. And now I look like hell. Right now, I'm a 15-year-old girl trying to grow up to be a 48-year-old woman, and I'm not there by a long shot. I'm not even 20 years old yet.

My body suffered a lot from my eating disorder. I have no teeth because they rotted from lack of nutrition. Two years ago, I broke my femur bone and now I've got a pin in my leg for life. I have severe osteoporosis, so I have to pretty much

walk in bubble wrap. I literally came out of the hospital with the pin in my leg, and that night I had to go back in because I started leaking fluid through my skin. I didn't know what was going on. I thought we had a leak in our ceiling. The fluid was literally coming out of my legs. The emergency room doctor said, "Lady, you're killing yourself." He said my body was eating itself.

When I came here, I had not eaten food in a long time. When I actually had to sit down and eat three meals a day, I started getting sores in my mouth. It's probably because my dentures are ill-fitting because of the weight loss. The osteo is very painful, and I have to carry a doughnut pillow around with me in case I have a hard seat to sit on.

I went through menopause when I was 36 years old. I didn't even equate it with my eating disorder; I thought maybe that it was in my family genes. A lot of girls here are fighting that, too, because their cycles are goofed up. They're worried that if they don't get their period it's going to be the end of their life forever. They are only 14, and I can't comprehend why they have the disorder because I think that they have the world by the shorts. And they probably can't comprehend why I have the disorder at 48. I wish I could take a film of my whole life from the time I was 15 and just let the young girls here watch it, because actions speak louder than words.

I don't feel that my life is in danger. It's a fight for my sanity more than anything. I hear the medical consequences that could happen but I don't see them. This isn't a physical thing, it's something in your brain. Unless they open me up and show me, I can't see it.

The eating disorder is making me sick, and I'm ready to give it up, but I have nothing else in my life right now. I'm afraid to figure out what else I'm going to replace it with. I want to gain control over something else. I lost control over my body twice very badly, and I think that's my problem now. When I was younger, somebody else told me, "You have to go to the doctor and have this taken care of," because the family would never accept what happened. Finally I retaliated and said, "No, the only one who's going to control my body is me." They violated me, and they weren't going to do it anymore.

RIGHT Kathy does a body tracing in art therapy. After she makes a drawing of herself, the therapist traces Kathy's actual body so she can see her distorted body image.

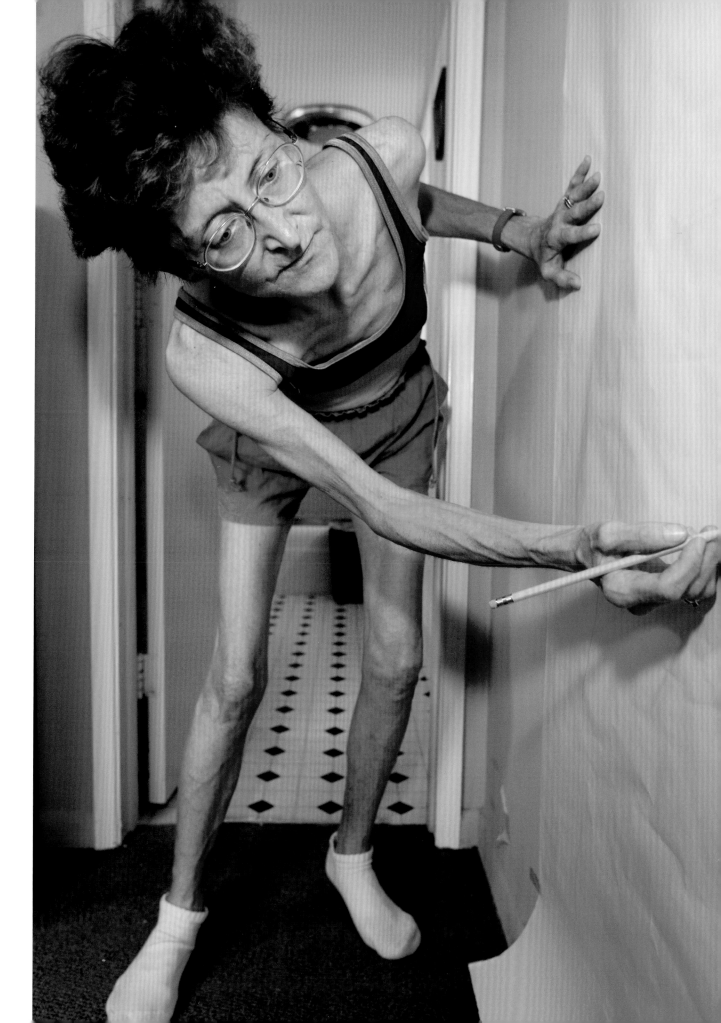

MELISSA

23, FROM ANN ARBOR, MICHIGAN

When I was little, I used to want to be the Little Mermaid on the float at Disney World. I still love the magical feeling when I go to Disney World that nothing matters. I think the Little Mermaid felt trapped in her world and wanted to get out and prove to people that she could believe in her dreams and defy what was holding her back. I like to think that kind of represents me and my eating disorder.

My eating disorder started when I was about 10 years old. I had been really sick the previous year, and with my sickness came depression. I started not wanting to eat and not wanting to go out. I wouldn't eat what the family ate for dinner. I couldn't go out to friends' houses because I had to eat my own food. I remember skipping lunch at school when I was little, throwing it away. It's how I lived life.

The height of my eating disorder was in college. I lived alone in a dorm room and didn't have any friends. The only thing I could think about was food. I wouldn't let myself eat until I finished all my schoolwork for the day. I would eat one meal spread out throughout the whole day. I'd work slowly on a bowl of cereal and milk and sugar-free juice. And when I felt weak, I'd let myself have one sugar-free Breath Saver.

I was really, really weak and my parents noticed. They made me go to the hospital, and when I got there, my tests were so bad that they wouldn't let me leave. I was on a feeding tube because I wasn't eating enough. My body started crashing. It was eating my muscles and I just kept deteriorating. The nurses didn't want me getting up because that would burn calories. So my muscles just atrophied. After a month, I couldn't even turn my head. I thought I was paralyzed. I could barely talk. Most of my hair fell out.

The staff at the hospital wanted to put me in a nursing home because they felt I was wasting a bed. There were questions of whether I would ever learn to walk again, whether my muscles would ever get back to normal. I remember being in physical therapy, and everyone else was really old. I felt like an old lady. I wanted to get better so bad. I said, "I'm ready. I can't do this on my own. I want to go to Renfrew."

I've been here seven months. When I entered the hospital, my weight was 52 pounds, and by the time I got to Renfrew three and a half months later, it was 60. I now fluctuate between 99 and 100 pounds. I still struggle, but I remember what I felt like in the hospital, and anything's better than that. I've learned a lot about why I had an eating disorder. A lot of it is genetic. I have a sister who had bulimia. A lot of my mom's side of the family has binge-eating disorder. I also got used to being in the sick role, and I felt like the only way I could get love and attention was to be sick.

My family is really proud of me and they tell me that. When they first saw me here when I was able to walk without a walker, they were crying. I can't imagine what it was like for them. When I was in the hospital, they were worried. They would go to the chapel at the hospital and pray. When I leave this time, I can't start doing things my way again. I have to follow the same meal plan, the same therapy appointments. I don't want to isolate. I'm going to be around my family and hopefully out in the community more.

I've never had a boyfriend. I feel about 14 years old because I've never had any experiences that other people my age have had, with boys and friends and puberty and everything like that. I just feel like since I was 10, my eating disorder kept me from life.

I would love to be a wedding planner. I have always loved weddings since I was little, with my Barbies and everything. I'd love to move to Orlando and be in the Disney area. I'll always love Disney. I love the happy endings, the concept that dreams can come true. My dream would be to just not worry about anything anymore. To live life like everything was good and everybody was healthy and happy. To just take a wand and make everything better.

POLLY

PART 1

I came to Renfrew after a suicide attempt over two pieces of pizza. That was obviously not the whole reason why I tried to kill myself. That was just kind of the straw that broke the camel's back.

Dieting has always been a huge part of my life. I remember all the things that are symptoms of eating disorders being taught by my family: to cut my food into really small pieces, and chew very slowly and take your time, and always drink water in between so that your stomach fills up faster. I was counting calories and counting fat by the time I was 11.

I had diet pills packed in my lunch when I was in elementary school. When I was 10 years old, my mother and aunt paid me $100 each to lose 10 pounds. I always thought I was fat. It wasn't until recently when I pulled out an old photo album that I was like, Oh my gosh. I really wasn't fat. I've had a distorted view of myself pretty much most of my life.

I remember being a kid and not having an eating disorder, but I don't remember a time ever in my life when food and dieting weren't an issue. It was always low-fat this, low-fat that. At the pool, you had a Popsicle instead of a candy bar because the Popsicle had less fat. The message was, when you're thin, you're prettier. You'll get boyfriends faster. You'll get married faster.

I'm from a small town. I grew up in a Southern home: going to the country club for dinners and summer swimming and the whole social circle. My sisters did beauty contests. We participated in every activity known to man: gymnastics, dance, music. I was always living with the pressure of being told I was the smartest one, that I could go far, and then putting those high expectations on myself and feeling like I wasn't reaching those. My oldest sister played the flute beautifully. My other sister played the piano beautifully. I was not perfect at anything. And then I found dieting, and I could be perfect at that. I remember thinking, This is something I'm good at.

My parents' divorce probably had a lot to do with the onset of the eating disorder. It was a very long, drawn-out, bitter divorce. Life was turned upside-down when I was 13. I just remember until I graduated, life being pretty much hell. I've still not forgiven my father for leaving.

RIGHT, ABOVE Polly, 30, from Johnson City, Tennessee, shows her scarred wrists from a suicide attempt, after which she admitted herself to Renfrew. RIGHT, BELOW Polly's journal entry, two weeks into her treatment at Renfrew.

5-21-04
11:40 pm

I am so not ok with my body right now. I feel like a big fat fucking pig. My belly is starting to bulge!

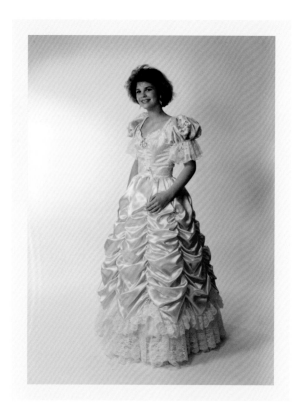

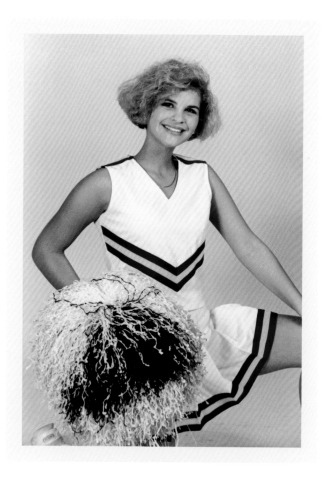

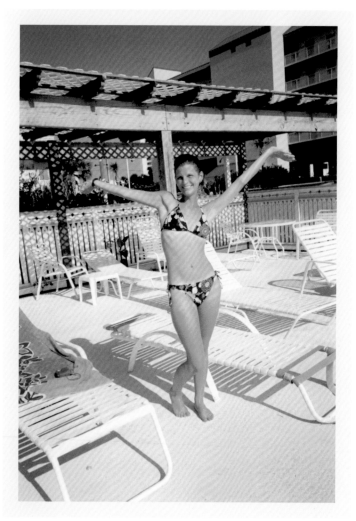

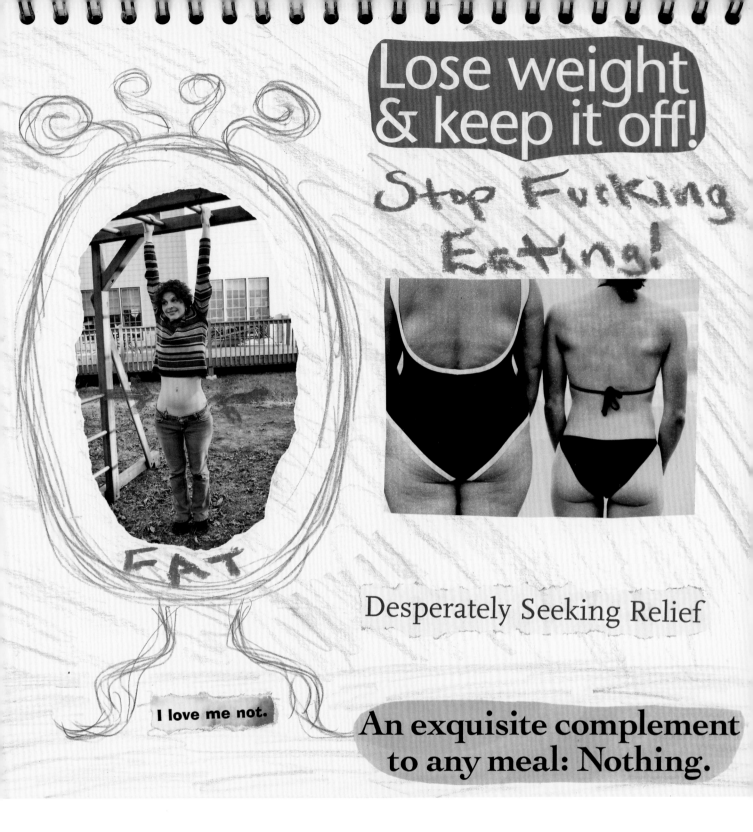

Lose weight & keep it off!

Stop Fucking Eating!

FAT

I love me not.

Desperately Seeking Relief

An exquisite complement to any meal: Nothing.

LEFT, CLOCKWISE FROM TOP LEFT Polly, 12, models a wedding gown for a Johnson City, Tennessee, modeling agency; Polly, 15, in her cheerleading picture; Polly, 18, in her senior yearbook picture; Polly, 27, on a family vacation. ABOVE Polly made this collage to express her anger with the picture (left), taken by her niece, that shows what she calls her "Buddha belly."

Everyone has asked me if I am excited about going to Florida, and I usually just smile and say "yes". Little do they know, I am completely freaking out. Now that I am on the plane, I wish I was going anywhere but to Renfrew. What was I thinking? Do I really want to be doing this? Am I ready to take this step? I do want to stop throwing up, desparately so, but I don't want to gain any weight. None! If I get fat, I'll just die. What if the clothes I brought get too small for me? How horrible would that be?
And, the smoking policy. That worries me to death.

I'm having trouble breathing. My God. Please help me survive this next month. What if I am the oldest girl there? What if I am the fattest? Shit, what if I am the oldest and the fattest? Renfrew will probably weigh me tomorrow and wonder why my fat-ass is even there. The insecure part of me wishes that I had packed a few laxatives just for tonight.
Damn, why didn't I plan ahead.

From when I was 14 until I was 17, I was bulimic. I would binge and purge, eat and throw up. In my late teens, I was raped. It was a bad relationship I was stuck in. I blame myself a lot because I didn't get out. For a long time, I didn't see it as rape because he was my boyfriend. There were horrible things that happened. It got to the point where I was afraid for my life. I think being in an abusive relationship with a man who told me I was fat had a lot to do with my eating disorder.

When I graduated from college, I went on a diet that lasted seven years. I tried to eat as little as possible. I would get on a broccoli kick and only eat broccoli for three weeks. Then I would get on a cereal bar kick and that's all I would eat. My fridge never really had much in it. Food was the enemy.

I started having heart problems. The doctors said that every time I purged, I was risking a heart attack. I ignored them, because I was at that point where I was like, Maybe this will be the time it'll all be over. And I was okay with that.

The night I tried to kill myself, I had been with my friends playing cards. Everything was okay until I had to eat the pizza. They kept pressuring me, so the whole thought process was to eat the pizza, leave early, go home, and throw up. But I got held up, and by the time I got home I couldn't throw up. I tried to and couldn't get anything out, so I went to the refrigerator, chugged a bunch of beers, and went and threw all the beer up but couldn't find any pizza. And I just panicked.

I cut my wrists, but that wasn't happening fast enough, so I grabbed a bottle of sleeping pills and took those because I didn't want to look at all the blood. I made a bunch of phone calls to family members in the process, which saved my life. I woke up in the ICU. And one of the first things out of my mouth when my mother came into the room was, "I want to go to Renfrew."

It's so expensive. Insurance is covering 80 percent and the rest is being pulled from the whole family. If I came to Renfrew and had to pay out of pocket, I would pay $1,500 a day to stay here. Even with insurance, it's still $300 a day.

Being at Renfrew is almost like being in college again. I feel like I'm in a freshman dorm. It is good to be with other girls who are suffering from an eating disorder. For the first time in my life, I don't feel like I am alone. But when you're sitting next to somebody who's not eating her meal, it makes it harder to eat. Everybody affects everybody else.

Renfrew is not a lockdown facility, which makes it different from the average psychiatric ward. When I came in, they searched my baggage. They take all your sharps away. Anything that includes alcohol in the first three ingredients they take away. So you can check your hairspray out between seven and eight in the morning and that's it. If you have mouthwash, it has to be alcohol-free. And there are only five smoke breaks throughout the day. You can only smoke two cigarettes during those 15 minutes. Those are the rules.

LEFT Polly's journal entry, the day before her admission to Renfrew.

I break quite a few of the rules. I have cigarettes in my room. I have breath mints. No breath mints or chewing gum are allowed. I actually have a razor in the room that I use just on my armpits because I'm too lazy to check out the sharps at night. And I just finished my Diet Mountain Dew that I had in here, so I got to work on getting another one in. At dinner we're only allowed one salt-and-pepper packet, which is a really big deal for me. I am a pepper fanatic, so whenever I meet a girl who doesn't use her pepper or her salt, I get them to pocket it. I don't drink sugar in my coffee, but I always ask for it because then you can barter for different things. It's almost like being in prison.

I did a lot of exercising in my room when I first got here, things like stomach crunches, push-ups, leg lifts. At one point I had a roommate whom I didn't really trust, so I exercised in the shower. I would lie down in the bathtub and do stomach crunches. One of my suitemates had brought the really big bottles of shampoo and conditioner, so I was using those just to try to pump up. Anything to burn calories, to get the fat off. You have to be very careful who you can and can't trust. A lot of girls around here want to be the perfect patient, and that means telling on anybody for anything.

There are a lot of parts of the day that I dread. I'm on morning weights. It still makes or breaks my day. If I've gone up too many pounds then I'll be in a bad mood the entire day. So it's hard. It's a battle all day long in your mind. When I first got here, I fought the eating disorder very heavily, though I did purge on my second day because it was pizza. It was a horrifying experience because it immediately took me back to the night that I tried to kill myself. I have not purged since then.

It's scary when food starts to taste good. When I first got here, I was just mechanically eating. It's just putting the food in, not tasting it, just get it down so I can get out of here. The first time I had cookies and actually enjoyed them it freaked me out. It threw my whole view off. I was like, Okay, I liked these cookies, does that mean I like cookies now? Or does that mean I just liked those two cookies that I was required to eat? I even asked myself, Does that mean I'm supposed to go to the grocery store and buy cookies now? I mean, I'm 30 years old and I don't know how to grocery shop.

RIGHT Polly smokes illicitly in her bathroom. Residents are only permitted to smoke during designated breaks on the smoke porch.

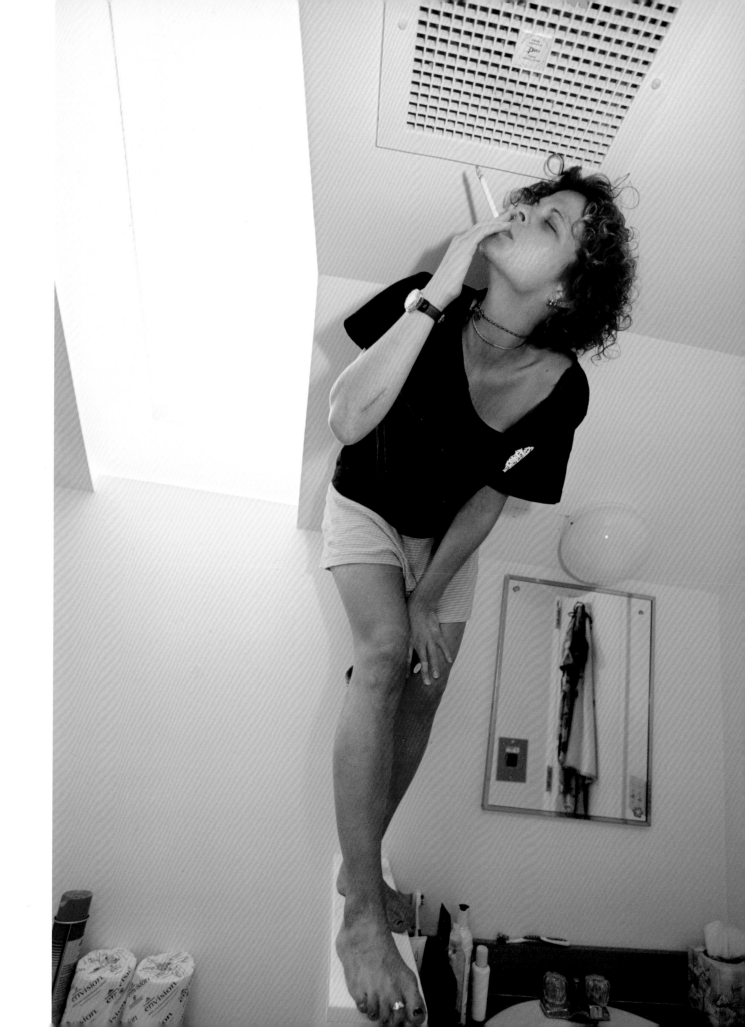

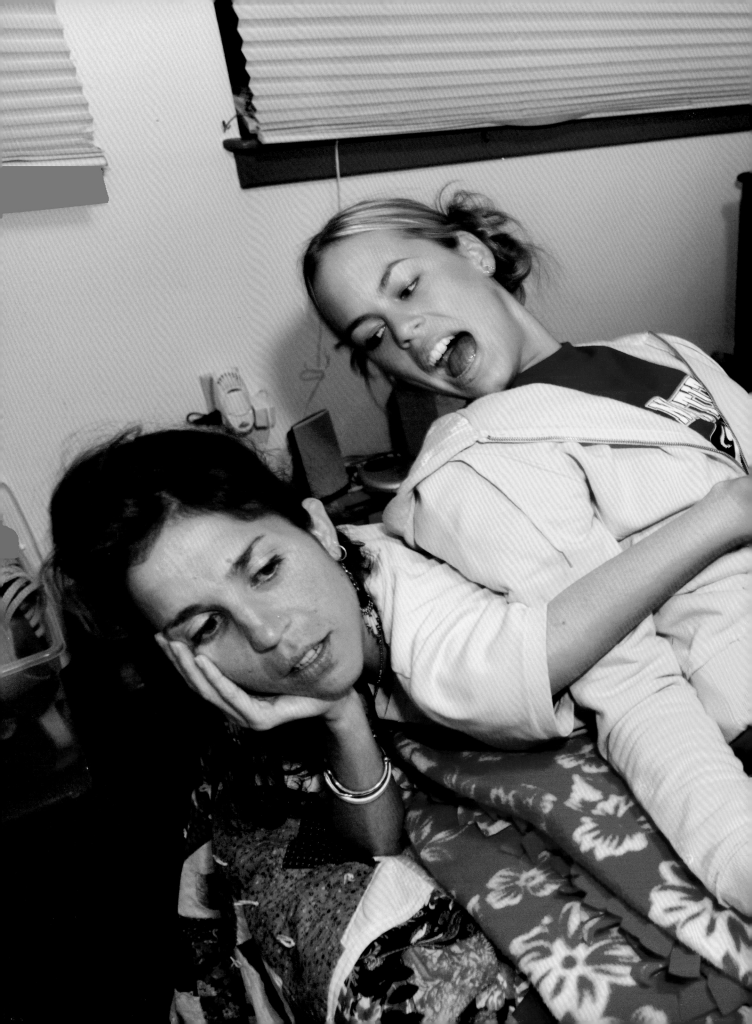

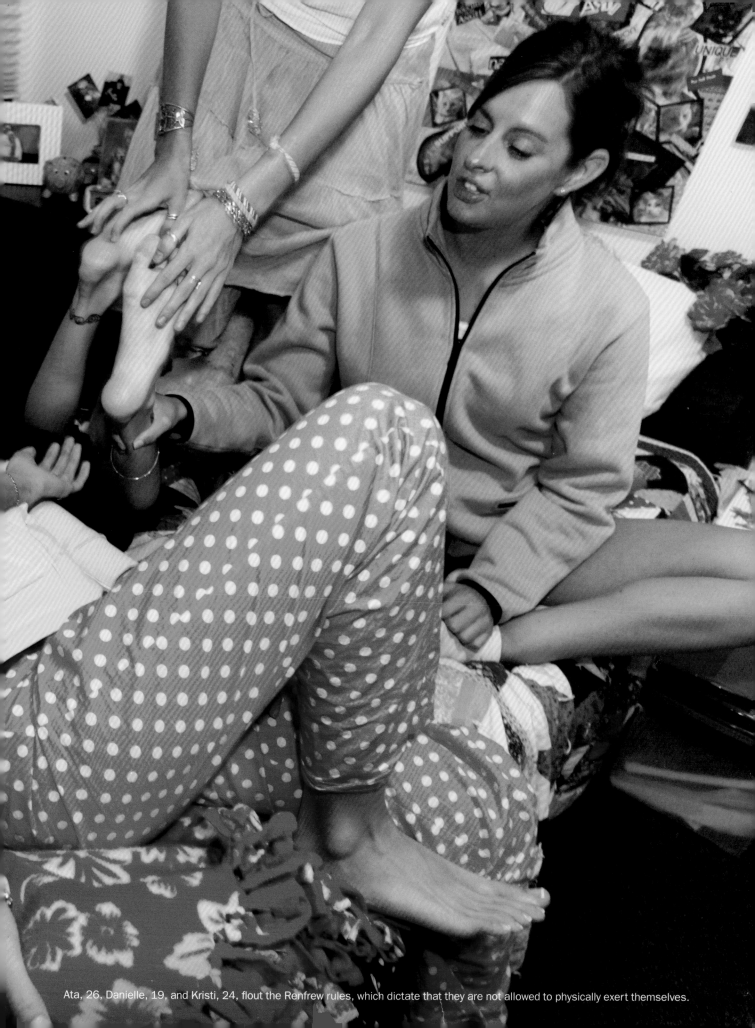

Ata, 26, Danielle, 19, and Kristi, 24, flout the Renfrew rules, which dictate that they are not allowed to physically exert themselves.

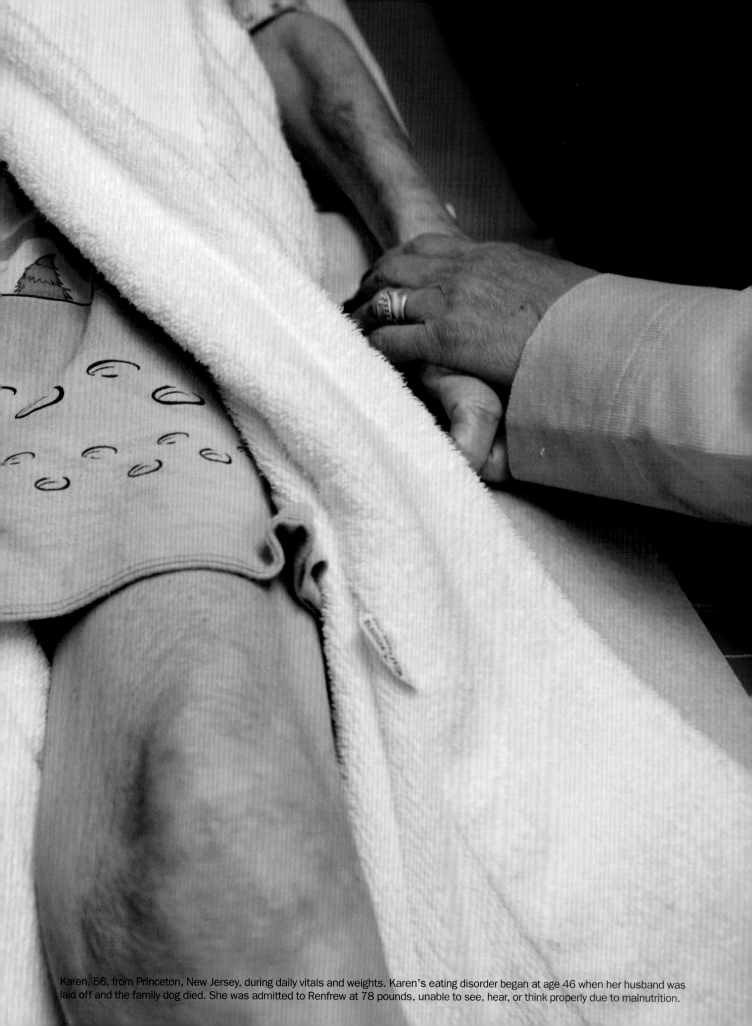

Karen, 56, from Princeton, New Jersey, during daily vitals and weights. Karen's eating disorder began at age 46 when her husband was laid off and the family dog died. She was admitted to Renfrew at 78 pounds, unable to see, hear, or think properly due to malnutrition.

LAURA

Someone called me a whale when I was in sixth grade. I was always heavy when I was growing up. My parents were concerned, because my father has diabetes and they didn't want that to happen to me. So I went to fat camp to lose weight. At first my parents forced me, but I made friends there, so it was like a regular summer camp, you just came back looking great. You got weighed and measured every three days. When you came out losing weight, everyone would clap for you. There was a lot of social activity. The people who were thinner got noticed more, and the thin girls wouldn't want to go out with the bigger guys. In the end, the so-called "beautiful people" got together. I would come back from there having lost 20 pounds, but I would just gain it back.

In high school, I was an athlete, so I never really felt overweight. I was the strongest rower on the team in high school, but my coach told me I was not on the varsity boat because of my weight. He was a bad influence on me. So I started losing all the weight. My father was the first diabetic to swim the English Channel, so he's been a positive influence on me, but I don't think as a man he realized the body pressures of having to get weighed a lot. Then my family's housekeeper and nanny went on a diet. She's lived with us for 10 years and is my best friend. Watching her diet and how successful she was motivated me.

It started off as just getting in shape because I was going to be a freshman in the fall. But I went overboard and kept on losing more and more weight. I didn't

know when to stop. I got a full scholarship to my college for rowing, but by then I was too skinny for the rowing team.

I go to Southern Methodist University, and it's very competitive. You have to wear sundresses to football games, and everyone is a Southern belle. When you're rushing your sorority, the girls judge you. They think, Laura, oh, she's the one who had that designer purse on, you know. It's all about image.

A lot of people gain weight when they go to college. They have the Freshman Fifteen. I was worried; I didn't want to ruin what I'd accomplished. One of my suitemates used to keep a food journal on her whiteboard. It would always say, Breakfast: nothing. Lunch: apple, banana. Dinner: sandwich. And then she would run 10 miles. When she would see that I came from the gym, she would automatically put on her running shoes. It was something that triggered me, like, Well, if she's on a diet, I should still be on my diet. I think I got addicted to feeling accomplished. Between March and December I went from 220 to 120 pounds. After growing up in a household where I was constantly told I need to be a certain weight, when I started to actually see results, I went overboard.

I can't be an athlete right now. I have a heart condition from the anorexia. I don't like how I look. I'm too bony. When I sit down on a hard surface, it hurts because I don't have any body fat there. It was getting cold in Dallas, and I have 6 percent body fat when it should be

around 18. I bundle up when it's only 50 degrees out and no one else is wearing a huge peacoat. Just me.

It is hard that I'm in treatment during vacation because I was supposed to go to Switzerland and Austria today and go skiing in the Alps. I could get pneumonia there because I don't have any insulation, and I can't go skiing because it would burn too many calories. I felt disappointed in myself that I had to ruin the family vacation. But I feel better now because my parents told me it's not my fault. It's Christmastime, so I asked Santa for a Chanel bag, and I hope it is under the tree.

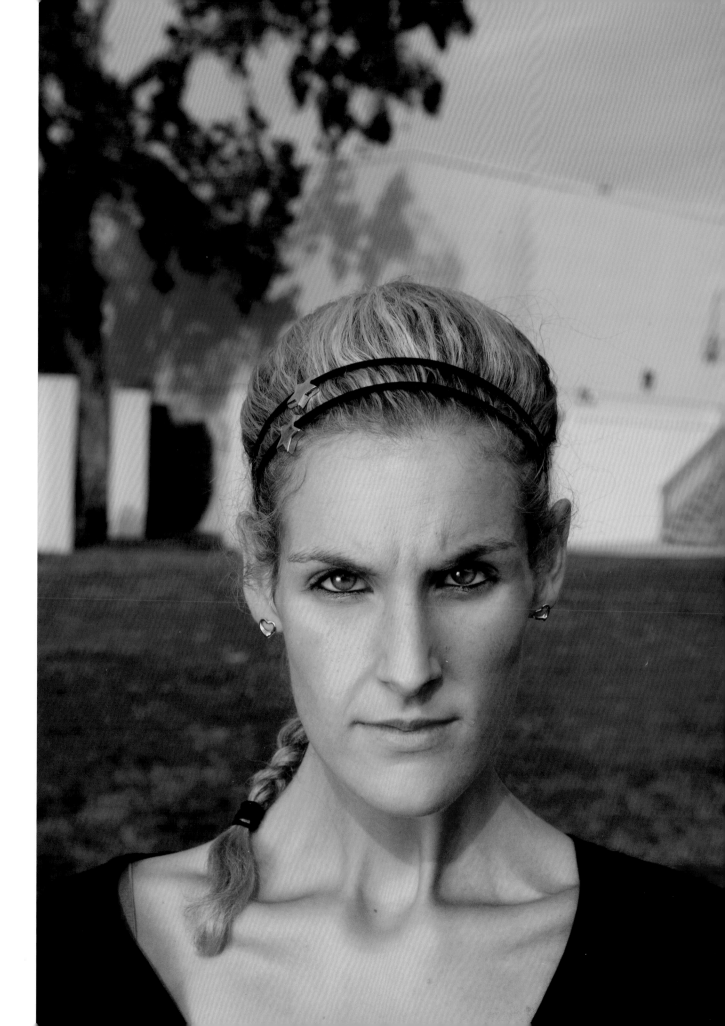

SHANTELL

I was born with a congenital heart disease, so I had open-heart surgery at the age of five. I was constantly naked in front of doctors, mostly men, doing all sorts of stuff to my body that I didn't understand. I was literally on a table, a subject of study. I had no control over who saw what of me. I was exposed.

At the end of eighth grade, I was raped by my neighbor. That whole summer I stayed inside my apartment and ate a lot. But then I started modeling, so I had to be thin. I didn't really want to do it because I was a tomboy. I wanted to be an actor, to do film and theater. The agent said if I got into commercial work that would be a stepping stone.

I found it very exploitative. I was very uncomfortable. I was the athletic type, and they wanted me to quit sports because of the different bruises that would leave. One time I was doing lingerie and I was 14 years old. The modeling industry is very white and very heterosexual, and so I didn't relate much to that at all because I was a lesbian. Then another time, I was 17 years old and wearing clothes from the juniors department. I felt like a doll. They had me on a bicycle with braided pigtails. I felt like I was too big for that part. So I went into the bathroom to throw up, just because I wanted to be smaller.

At first they loved my looks. Then the industry switched to waif. The owner of the agency took me into her office and said everything about me was beautiful, except that I needed to lose 5 pounds in my face. I had never heard that I needed to lose weight in my whole life. I didn't know how you did it in your face. I was probably a size four, but waif was a size zero. Waif was no body. You literally had to look like you were starving or like you were on heroin. I stopped eating and started doing diet pills and drugs. I used coke because it helped me to eat, oddly enough. I could just grab something and then go and do a line or two to not feel.

The cutting started when I was 13 years old. I did it for myself, just little things on my arms. And then I stopped. Shortly after 9/11, I was back in therapy and things were extremely emotional for me. I found myself regressing back to that time period, and I started cutting again. I always cut with a single razor, just slashes, up and down my ribs. For two of them, I had to have stitches.

I have cuts on my stomach. I have cuts all around my feminine area and my legs. My arms. My feet. My forehead and my temples. Once I did a cut that was like a belt of blood all the way around my waist. It felt good. I'd go sit in the shower after cutting and just watch the red water. Seeing the blood, I felt like a warrior.

I cut so I didn't feel pretty anymore, to damage the property. I didn't want to do anything anymore that exploited my body. I just kept wanting to cut and shrink, cut and shrink, cut and shrink, so no one could see me, and if they did, they wouldn't like what they saw. Cutting was a release because I wanted to cry so much, and I had stopped crying when I was 6 years old. The blood was like physical tears. At least there were drops.

I think with cutting and anorexia, it's to be able to see the feeling of pain, or anger, or self-hatred. And it's really to punish yourself. That's why the two come hand in hand. We put the hatred back onto our bodies because we're being objectified and oversexualized.

Sometimes when I see the cuts, I'm afraid that it's going to interfere with personal relationships. Who really wants to see that on their lover? And there's a bit of shame, going out to a swimming pool, not wanting children to see those marks. Other times I just embrace it as part of me. Even though I'm not 100 percent better, it reminds me of where I've come from. Of what I've survived.

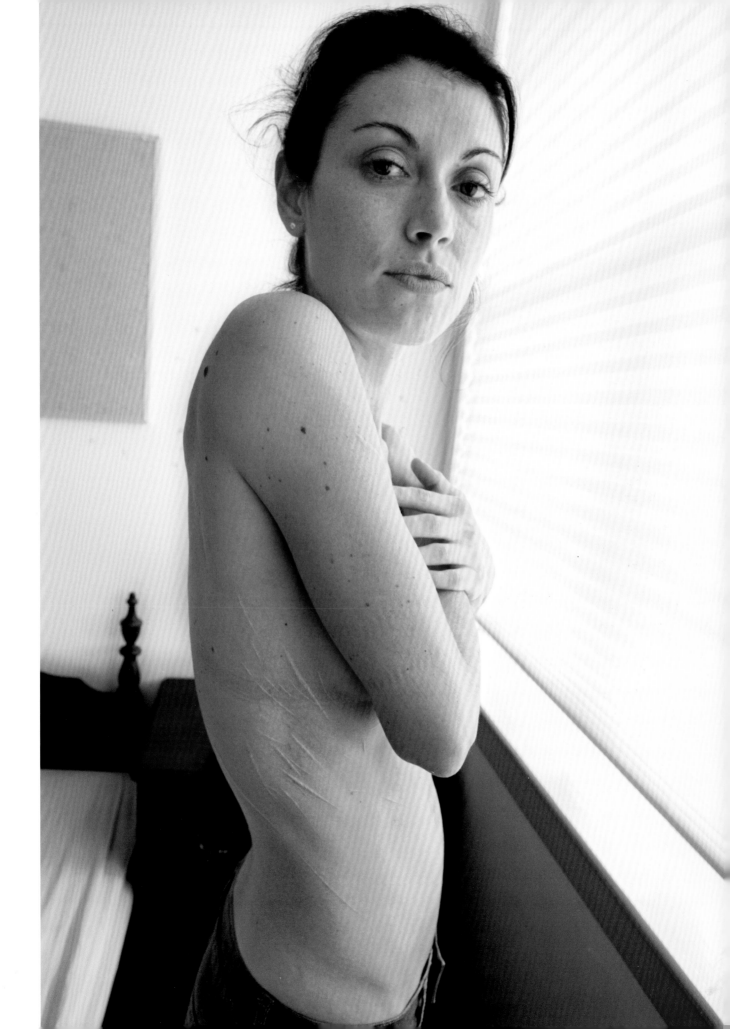

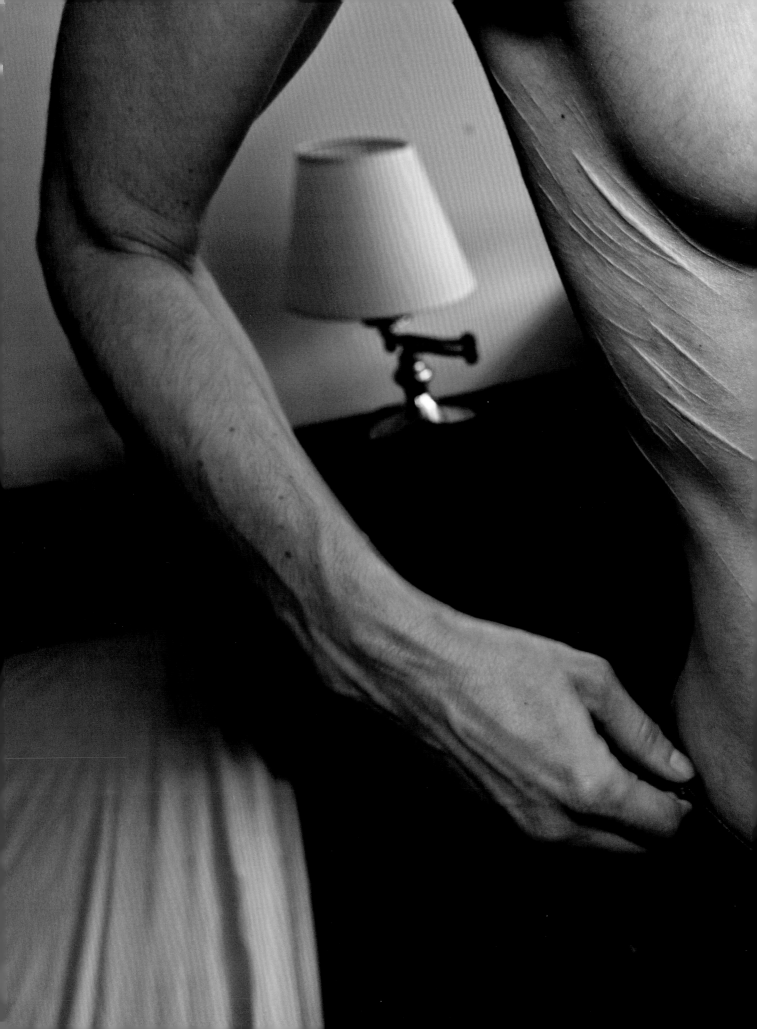

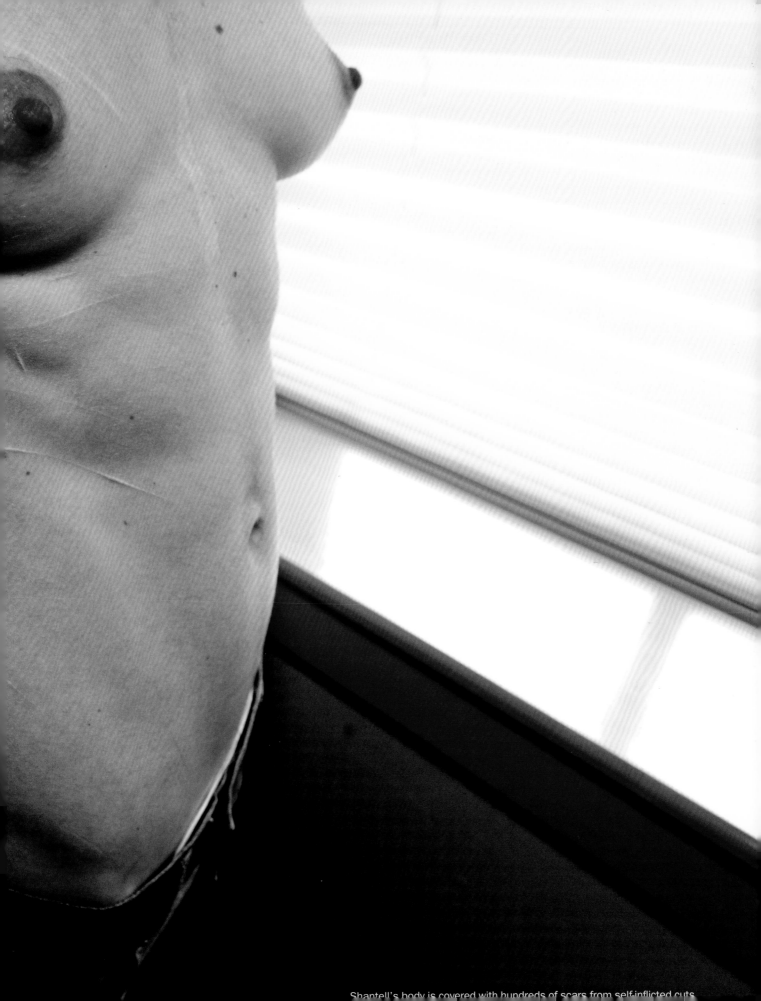

Shantell's body is covered with hundreds of scars from self-inflicted cuts.

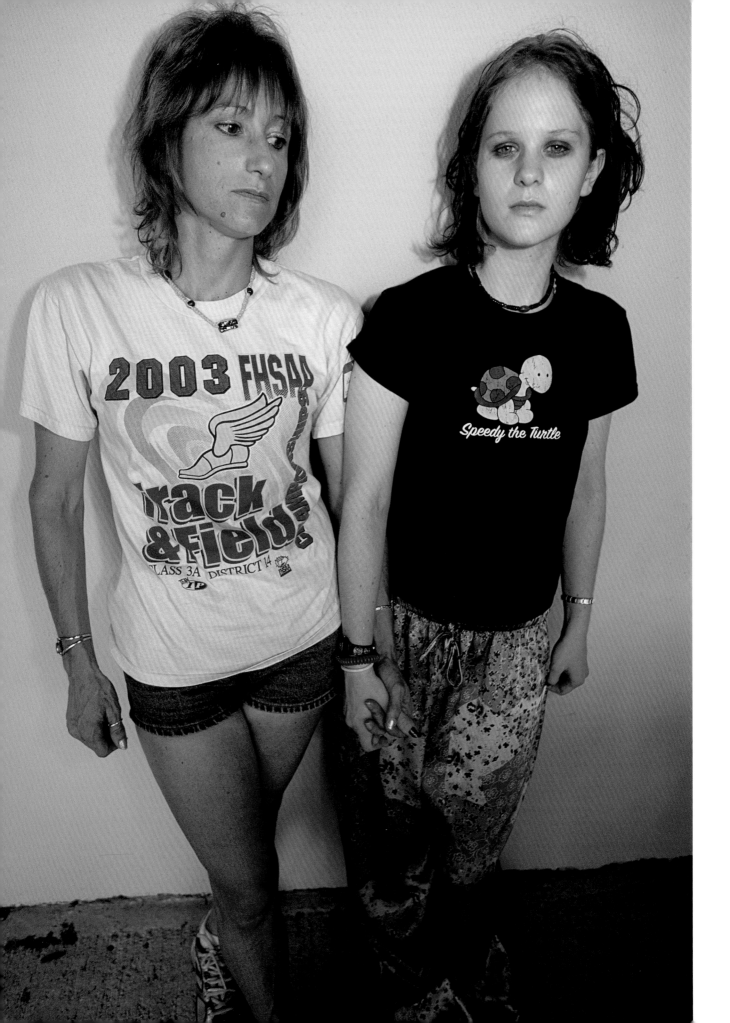

BRITTANY

When I was about 8, I became a compulsive overeater and closet eater. I started dieting when I was 12 because I had a bad body image and a lot of my peers were thinner than I was. I was always that big girl, so I wanted to change that.

I've always had a boyish figure, but once I started going through puberty I thought getting breasts and hips was gaining weight, and I wanted to do anything I could to get rid of it. I wanted to be a stick like some guys.

I don't want to have to deal with being a woman. I don't want to have to deal with the problems that come with it, or with the good things that come with it. With having children and going through the pain of birth. With having menstrual periods. I didn't want breasts because with my hockey equipment it would make me look bigger.

My parents divorced about four years ago, and that pretty much sent me into a rage. I was trying to fill that emptiness of not having my father. I wanted something for myself, so I started a diet. But once I started dieting, I couldn't stop. I was out of control.

When I was eating nothing, my mom would force me to eat something, but then I would purge that. The purging started when I was 15. I kept it secret for about a month and then I told my mom. She knew. She just didn't know what to do because she has an eating disorder also.

All my life my mom has been a weird eater. I'd see all these other moms eating birthday cake with their kids while she would just make it, but not eat it. We would do this thing called chew and spit. We would have the greatest time with it. We would buy bags and bags of candy and just chew it and obviously spit it out. We just thought of it as a good time; we didn't think of it as a problem. And it was.

My mom told me about bingeing and purging, so I tried it. Then I went on the Internet for a checklist of what symptoms occur when you're anorexic or bulimic, and I went through them to make sure I had every single one so I could try to be the perfect anorexic. I cut out the fat in my diet to miss my period. I tried to force myself to not sleep so that I could actually have sleep disturbance. I said I had constipation so I could get laxatives, which I kind of fell in love with. I looked at my checklist every day

LEFT Brittany (right), 15, from Cape Coral, Florida, with her mother, Ann Marie, 42, during visiting hours. Brittany was admitted to Renfrew at 97 pounds, having dropped from 182 in one year. Brittany's mother also struggles with an eating disorder.

to make sure that I had all the symptoms. I told my mom, "I'm not perfect yet," and she told me, "The perfect anorexic is dead."

When I first got here seven weeks ago, I weighed 97 pounds. In one year I had lost 85 pounds. My heart rate was down to 36, and I was practically dead. My mom referred to me as a mummy. My skin was so thin, it was like ancient. I lost most of my hair. Everyone said I looked kind of yellowish-gray. I had fine hair on my face. I was having to shave all of my arms and even my face sometimes, and I had blue hands and feet. I had water retention, so my ankles were thick. My bones were so weak, I couldn't play hockey anymore. My eyes were turning yellow because my liver was not working from throwing up so much. I had canker sores all over my mouth, and for a while I had blood in my vomit. My lips were always chapped. My hands had blisters from inducing the vomiting. My muscles were being eaten away, and my legs were becoming really weak, so I had to wear special hose to support my legs from basically collapsing. I liked showing them off, like, I have anorexia, look at this.

When I first got here I wanted to be the sickest, so I wasn't eating at all. They told me that if I wasn't eating they would have to put me on a feeding tube. I wanted the feeding tube. That would mean I'm so sick that I actually need to be force-fed. I don't want to die; I want to live and be the perfect anorexic, so I'll have my feeding tube to keep me alive while being sick.

My mom recently told me that she was completely jealous of me and that she was going to starve herself until she got down to my weight. That's how sick the disease is. My motivation has shifted many times since I've gotten here, but now I want to be better so that my mom will get better.

I want to leave here and get back into hockey and get a hockey scholarship for college so that I can be a pharmacist. I'm going through 20 different pills a day, and I'm learning about all these new names, and it's very interesting. I've always had an obsession with medicine and helping other people get better, so I might as well make a career out of it.

RIGHT, CLOCKWISE FROM TOP LEFT Brittany, 8, in her hockey picture; Brittany, 9, poses for her cheerleading picture; Brittany, 13, during her punk rock phase; Brittany, age 10.

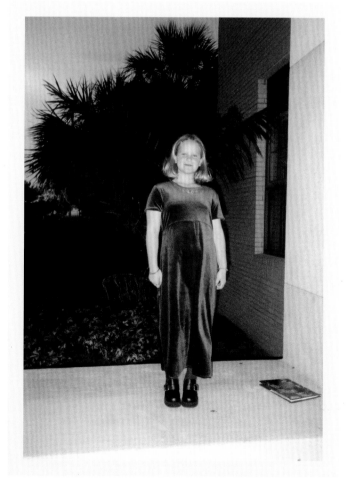

Mommy kins,
No matter what happen with this,
I want you to be strong, do not fall
in the path I have taken, your
better than that. And trust me when
people say "it's not what she would
have wanted", believe me, they are
not lying. I want to see you in heaven
And hear about the long life you lived,
all the way to age 95! lol. Your sons
and family need you, don't fail them.
What do you care about more, ANA
or your children and husband and
loved ones! Grandpa and I are looking
down on you right now, so stop those
tears, I love you, with all my heart and
soul.....I let the bully get me, you don't
let that demon ANA get you!!
Start to smile! And sing your
songs of joy and christianity!
I love you sooo
much, your daughter
Brittany Marie
Robinson

BRITTANY'S MOTHER

From a very early age, I knew Brittany had an addiction to food. Around the age of 10, she started sneaking food and overeating. I found empty wrappers in her room. Over the next four years, she developed a pretty hefty weight problem. She was very upset about the way she looked. Around her freshman year in high school, Brittany decided to lose weight. She started by exercising a little more and cutting back on fats and sugars. Soon I noticed she was obsessing about everything.

She dropped a third of her weight in three months and was not able to eat much of anything at all. I would sit with my arms around her and try and talk her through putting any kind of food in her mouth. I knew that I needed to get her into a treatment center.

Given my own struggles with anorexia and bulimia, I was very afraid. The way we're wired, there's a propensity toward addictive behaviors. All it takes is that euphoria that you get from eating disorders, and I could see that happening in her very quickly.

I always thought I was too heavy, even though I was a tiny little thing. The physical, emotional, and sexual abuse in my childhood set me up to not have an identity. My physical self was all that was left. I wanted to have complete control. I've been to many treatment centers, and the only thing that's worked for me has been my faith. It's a weakness that I'll struggle with for the rest of my life, so I can relate to what Brittany goes through.

I never interfered with what my children were eating, but in the back of my mind was always that panic: They're going to be overweight; they're going to be miserable; people are going to pick on them. Brittany used to come to me with stories of being made fun of because she was overweight. It just broke my heart.

In our society, kids are so bombarded with the message that the physical body is the be-all and end-all. The biggest deception is that they think, If I could just lose this weight, people would be my friends.

Part of it I blame on living with me. My own eating disorder was a trigger, because Brittany thought, If my mom is still at the point where she can't get through this, then I'm never going to be able to. The guilt from watching my daughter in physical and emotional agony is horrible. But I just can't let go of my eating disorder. It's definitely an addiction.

LEFT A page from Brittany's journal in which she imagines herself in heaven, writing a letter to her mother. "Ana" is code for anorexia.

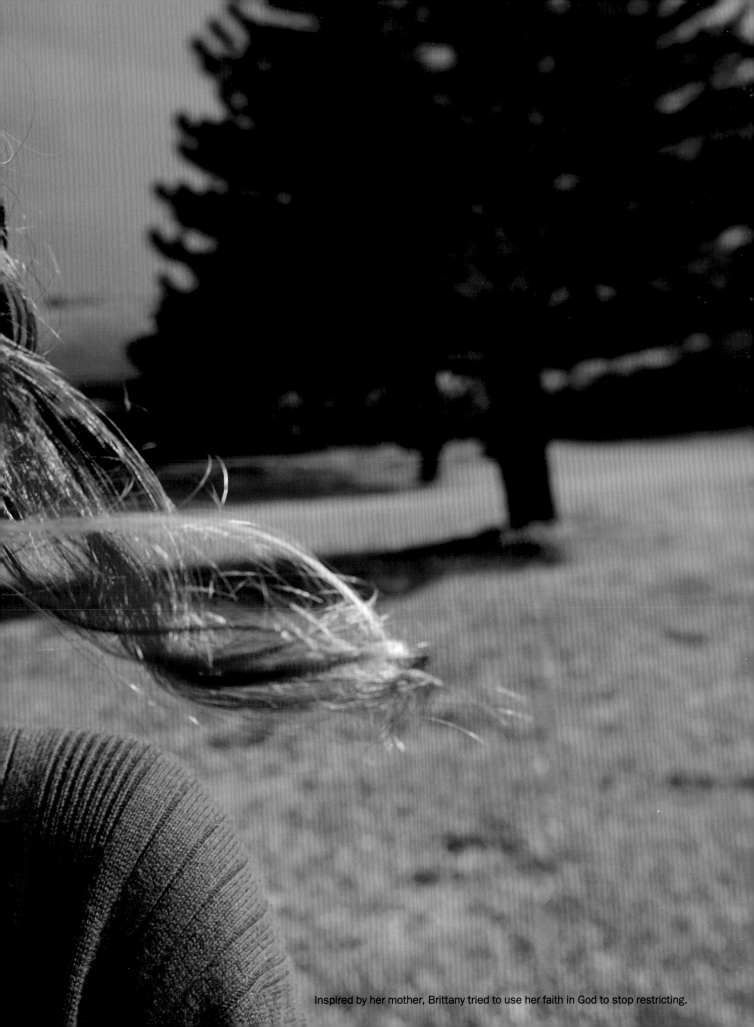

Inspired by her mother, Brittany tried to use her faith in God to stop restricting.

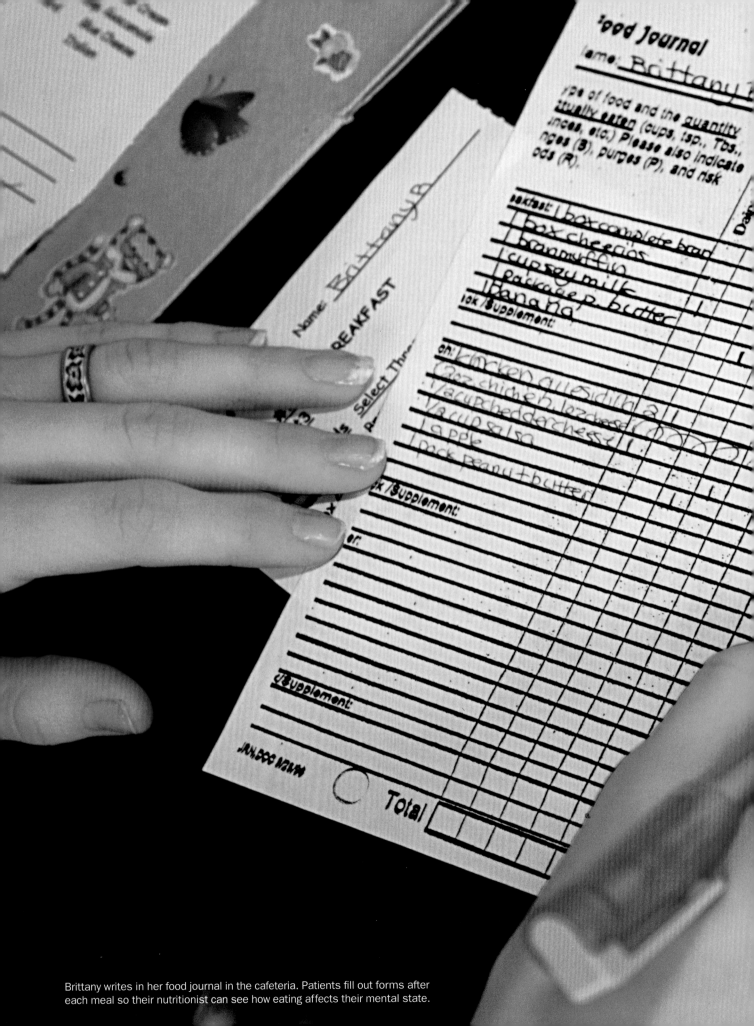

Brittany writes in her food journal in the cafeteria. Patients fill out forms after each meal so their nutritionist can see how eating affects their mental state.

...son

Patient # 2012_7

Date: July 18, 2004

Day: M T W

Vegetable	Starch/Grain	Other	Fats	Cups/Decaf Fluids	Mood, thoughts, and feelings before, during, and after meals or deprivations and why.	Circle one number for hunger and another for fullness for each meal.			Please rec... eaten durin... supplement... it much easie... you ate. Plea... and hand in...
						Hunger	Neutral	Fullness	

"Breakfast was fine, same old, same old. Only 2 more meals left until I'm off trays! But I didn't like the bran muffin today, it was undercooked! oh well, I ate it anyway.

0 (1) 2 3 4 5 6 7 8 (9) 10

I got fairly stuffed, but it feels fine.

0 1 2 3 4 5 6 7 8 9 10

☑ Lunch was good. I had it with my family. I'm st...

0 1 2 3 4 5 6 7 8 9 10

Exercise activity

Length of exercise s...

0 1 2 3 4 5 6 7 8 9 10

0 1 2 3 4 5 6 7 8 9 10

What I learned today:

0 1 2 3 4 5 6 7 8 9 10

What I'm grateful for today:

1 2 3 4 5 6 7 8 9 10

1 2 3 4

What fun, healthy... thing did I do...

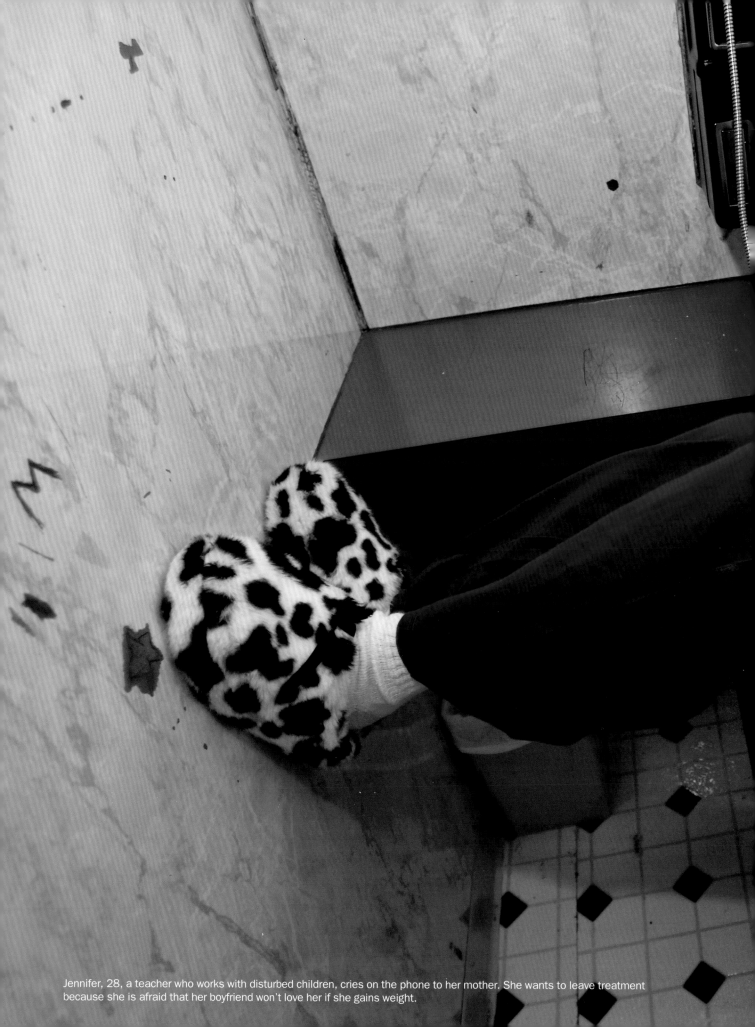

Jennifer, 28, a teacher who works with disturbed children, cries on the phone to her mother. She wants to leave treatment because she is afraid that her boyfriend won't love her if she gains weight.

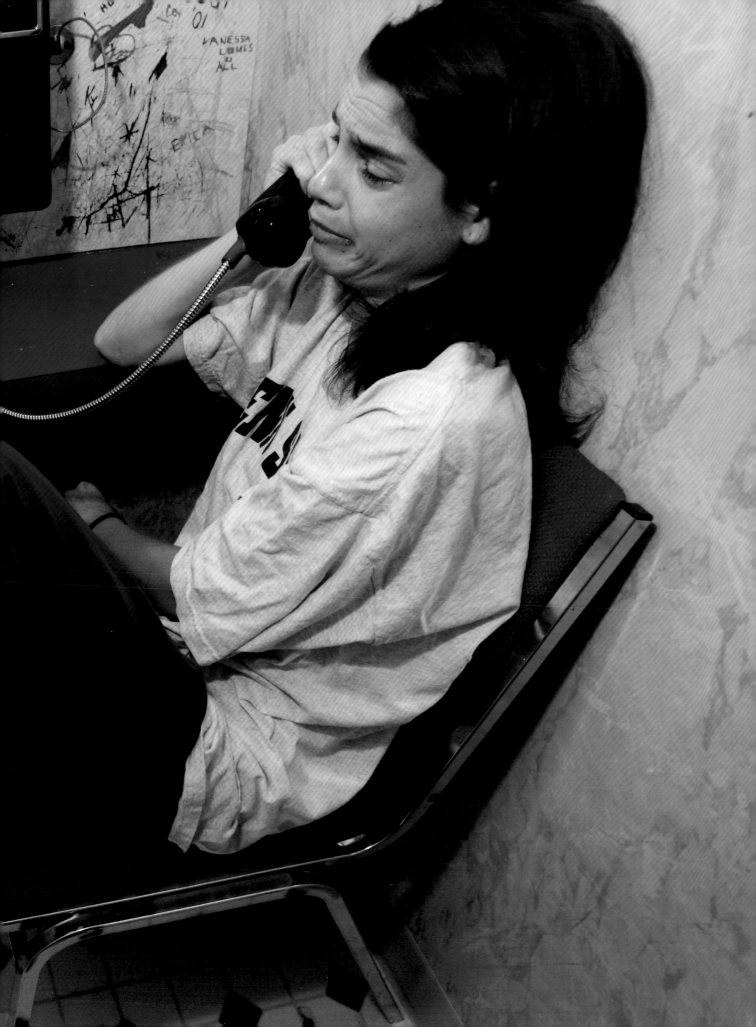

It was hell trying to be a mom and having anorexia. I was cooking and cleaning the house and doing the things that I should do, but as far as having a relationship with my kids or playing with them outside, I was too depressed. Whenever I talk to them on the phone, it saddens my heart because I know that right now they don't have a mom there.

I was the perfect child for my mom. I got good grades in school. I sang well. I didn't sass back. When I was 5 years old, I was molested. Different people would touch me. It was this one person who touched me when I was 12 years old that made me start throwing up. I felt ashamed. I was scared. The only thing that comforted me when I ate dinner was to get rid of it real fast. That would calm me down. When I was 10, my mom's boyfriend's daughter showed me how to purge. One day, we were at the table and we were eating dinner and she said, "Cheryl, come here." We went into the bathroom and she said, "You want to lose weight? This is how you do it." And as she was saying that she stuck her fingers down her throat and threw up the food she had just eaten.

After I'd been touched, I didn't want anyone to look at me. I wanted to be invisible. Anytime men would give me looks, it was like, Oh, I'm not doing a good job. I have to get smaller. I wanted to stay thin like a little girl. I married my husband at 18. He's 11 years older than me. He is a minister and he truly loves me. It had to have been God who brought us together. He came along, and the first thing he did was touch my face. And then he asked me for a date. He was very kind. Many people say that he robbed the cradle and that I was looking for a father figure. My dad died when I was 5 years old.

When I was pregnant, I didn't throw up at all. But after each one of my children was born, I would go right back to throwing up, 12 to 15 times a day. When I was 27, it turned into anorexia. I got sicker. I was always passing out, having seizures. My husband checked me into a hospital. There I had a black therapist,

and the first words that came out of her mouth were, "Why do you want to be thin? Us black women are supposed to be shapely. We're supposed to have hips. Black women are supposed to have a behind on them." You would be surprised how many black women purge their food. Bulimia is very known in the African-American community, but black women are too ashamed to get help. When I landed in the hospital, I had family members come up to me and ask, "What did you do?" and I told them that I purged food. They said, "Well, I do that."

I used to love the books where I would read an anorexic story. I loved seeing the skinny women on TV and comparing their bodies to my body. I loved Karen Carpenter. I would get on the computer and stay all night long and see how small she had gotten. She was my superstar.

I went all the way down to 85 pounds. It came to the point where my brain would hurt and I couldn't remember anything. I couldn't even remember where my son's school was to pick him up from basketball. We were on the way home one time and he looked at me with a puzzled look on his face. He didn't say anything, but you could tell on his face that he was concerned because I was just riding around and couldn't find my way home.

My eating disorder was a safe place for me. Every time I would purge, I would think of the people who I was mad at, and the more I thought of them, the more food came up. Anorexia made me feel good. It made me feel like nothing could ever happen to me, that I could be so thin and still walk around. It made me feel like Superwoman. It made me almost invisible.

CHERYL

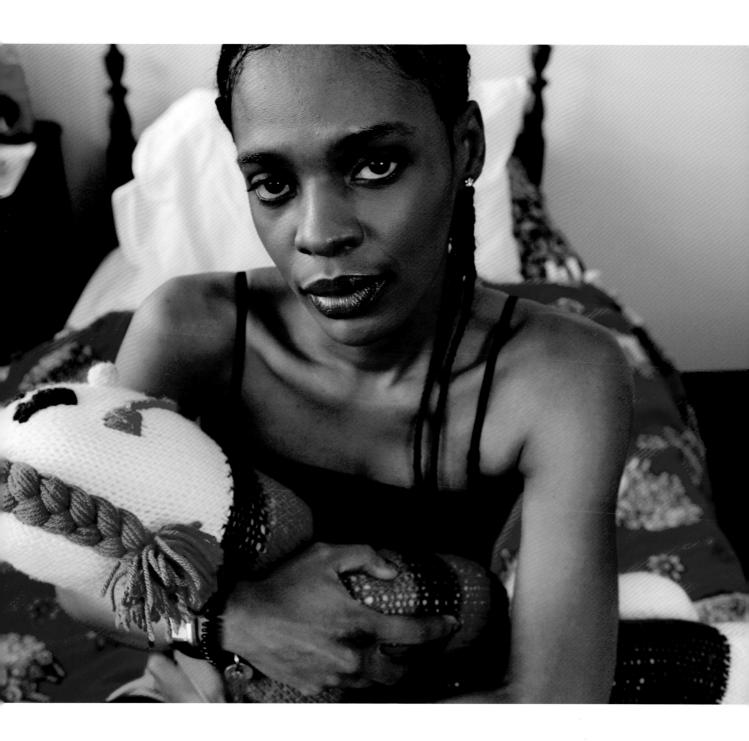

CARA

The thoughts started around fifth grade. I remember praying to God each night that my stomach would go away. I just hated my body so much. Around that time, my brother, who is two years older, started getting involved in steroids and having rages. I remember racing home from school, hoping I could get into my parents' bathroom because there was a lock on the door and a telephone in there. Otherwise, if I was watching TV, he would come up to me and kick me in the ribs and kick my head and punch me. Never on the face, to leave no marks. Every day he would make mooing noises at me, or call me a pig or a cow, or just say how fat and ugly I was. I tried to tell my parents but they were in denial about the whole thing. My parents were very involved with their careers and were gone almost all the time. I felt completely helpless and unprotected.

Then, in my freshman year of high school, a senior asked me out. I knew he had been sexually involved with his girlfriends. So when we began kissing, I just had this feeling of complete embarrassment. I felt so disgusted with my body. I remember feeling so inadequate.

In about two months, I dropped 60 pounds. By that point, my brother was in and out of rehab, so my parents didn't say a whole lot. It was summertime. I spent my entire day out at our pool, or I would walk all day. All I was allowing myself to eat was half a plum or half a piece of toast.

The more weight I lost, the fatter I felt. I talked to a dietitian at one of the local hospitals because I wanted to lose more weight, and I didn't know how to do that when I wasn't even eating. She immediately took me over to the eating disorder unit. The director came out and started yelling at me, pointing at my hip bones saying, "Don't you see those? Don't you see how unattractive that is?" I was literally scared to death. Within days I was admitted to the inpatient eating disorder program, but I was basically in denial.

When I got out, people treated me like a leper. I became friends with this one girl. I would go over to her house and her mother would give us food, but then be like, "Oh, you guys are pigs." She would say horrendous things. And I'd want to go home and my friend would lock the door and not let me out. To think of it now, it was the strangest thing. But I kept going back, because at least it was someone.

At Renfrew, there are a lot of cliques. It brings up some feelings of not fitting in when I was younger. At meals, there are certain people I feel comfortable with, but a lot of other people want to sit around them, too. It's very hard for me because right now I don't have a lot of laughter in my life. I don't have the ability to be carefree and joke around. I want to be involved in the conversation, but a lot of times I get shut down and people talk over me. I don't have a lot to say right now.

There's a lot of immaturity here. The other day, counselors brought up the fact that people who work in the kitchen have been finding peanut butter and butter underneath the chairs. They found a bagel with cream cheese stuck somewhere, and they were finding lots of cereal under chairs. And the girls were making really rude comments about it for a long time. We're all going to have slip-ups, but one of the healthiest things for us is to admit it and get help for it. But when people are making fun of it, how much harder is it going to be to come clean?

Being here with adolescents, I look at their bodies and that's what I want my body to be, too. I started this at 13, and I don't want to look like a little kid, but I'm also afraid of looking like a woman. And if I'm going to be a woman, I feel like I would be so repulsive to men. It's hard to recognize that, at 31, I need to be in an adult woman's body.

I lost out on all those years. I missed out on high school being a fun experience. I missed dating. I didn't go to my prom. I've lost jobs because I was so sick, I couldn't come in to work. I've had to pay for doctors and therapists. I've spent money on diet pills, laxatives, exercising. I'm 31 years old and I have no money. I don't have any connection with anyone. I don't have anything to go back to.

Throughout the years that I've had the eating disorder, I've had four long-term relationships. Looking back, I realize how similar all these men were to my father. They're all very controlling, and I didn't feel I had a voice. One guy drank. He would constantly belittle me and say that I was no fun because I didn't drink. He constantly made

LEFT Cara stayed in treatment over the Christmas holiday.

comments about women's bodies, women with big breasts and so forth. And other times he would just be mean, making fun of me and saying how ugly I was and that my hair was so bad because of my eating disorder.

The past two years, the furthest thing from my mind was to be in a relationship. As I was losing more weight, I knew how unattractive I would be to men. It just made me want to hide my body. The eating disorder kept me safe. I felt the smaller I was, the more protected I would be. And later on, it began to numb my feelings. I didn't want to feel anger. I didn't want to feel loneliness. I didn't want to feel unprotected. By not eating, I didn't feel those things. But I didn't feel anything else either.

Bulimia was also a way to get things out. There was so much buried. Bingeing, I was almost in a trance, it was such a powerful presence that took over my body. And then afterward, it was a release. I would be so exhausted I would be like a drunk, passing out. It just wiped me out, and then I would be able to sleep and I wouldn't have to feel and deal with things.

I need to find a place besides my mother's house to live. My brother has remained extremely involved in drugs and alcohol. Right now he is in prison. He will be returning home a couple of weeks after I go home. My mom is letting him stay there. She thinks that he's not going to drink because he's been in jail. But that's not how it works when you're an alcoholic. So I'm the one who has to find a new place to live. Since I was a child, my brother's problems were much more important than mine. His disease has been destructive to other people, whereas my disease has been more destructive to myself, so there is definitely the feeling that his is more important.

Over the years, I wanted to change, but I felt addicted. I came to the point where I just wanted to die. I didn't have a plan for suicide, but I prayed that I would just not wake up. But if I died, the only people at the funeral would be my mom and my grandparents, and there would be nothing good to say about me. The only thing I've done with my entire life is change my body.

RIGHT Cara on the hurricane-damaged Renfrew grounds.

ALISA

Since the time I came out of the womb, it has been ingrained in me that you are defined by your weight. When I was 7, my mother took me to the pediatrician and the doctor said, "What are you going to do about your daughter's weight?" And my mother said, "What do you mean, what am I going to do about her weight? She's 7." He said, "Well, she's fat." They put me on a 1,000-calorie meal plan, I took off 6 pounds, and they rewarded me with a Snoopy notebook.

When I was a kid, every time one person would feed me, somebody else in the family would say, "She doesn't need the calories." My sister was thinner than I was and we hated milk. To make it more tolerable, she was allowed to have chocolate milk, and I wasn't, because I didn't need the calories. I hung on to every word: my grandmother saying, "You're going to grow up to be fat like your father." My aunt taking a cookie away and telling me I should have more willpower.

My eating disorder became symptomatic around the age of 14. We were vacationing and going out to eat a lot. I felt really guilty about it and bought some laxatives and took too many. After that, I always had to expedite the elimination of any food that I consumed. From laxatives, I went to diuretics and then restricting and purging.

I've been in and out of treatment a few times in the last 15 years. About a year ago, I was somewhat in recovery and I decided to go on the Atkins diet. I eliminated all carbs and just had lean protein and vegetables for about six months and then eventually cut out the protein and decided to restrict my calories to 300 a day, then 280, and then 260.

Every morning I would eat the egg white off of one hard-boiled egg. I would have two cups of coffee and five to seven pieces of sugar-free candy. For lunch I had lettuce with either mustard or vinegar. I would go to a restaurant and order a Caesar salad without dressing, cheese, or croutons, and just vinegar on the side. For dinner I would have lettuce and two cups of sugar-free Jell-O. I would try to incorporate some protein into my day, maybe a bite of chicken or one piece of fat-free cheese. Eventually, I was down to 170 calories a day.

RIGHT, ABOVE Alisa, 30, from Port St. Lucie, Florida. A divorced mother of two, she has been hospitalized five times in the last three months. RIGHT, BELOW Alisa's journal entry.

I thought hard — Anorexia
Anorexia was easy. I didn't have to
do anything. I didn't have
to interact w/ others or fulfill
any roles, there were no
responsibilities, there were
no expectations. Even my
direction was pre-planned &
calculated. That's life inside
the tunnel.

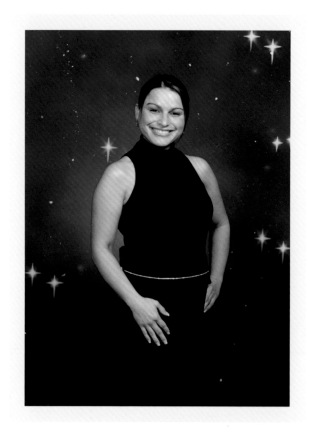

One day, I overdid it. I wanted four peanuts and accidentally had seven and thought, What am I going to do? I completely ruined it. I knew I was going to purge, so at that point I just binged for the hell of it. The next morning I hopped on the scale, and I had lost 2 pounds, so I came up with my own theory that I had jump-started my metabolism. Every few weeks I would binge and purge. I would just do it over and over and over again for three, four days, and it usually wound up resulting in dehydration and hospitalization because I would also use diuretics, hydrochlorothiazide, laxatives, enemas, and ipecac.

I could tell you about one particular binge. There was nothing enjoyable about it. I started out that morning at Dunkin' Donuts and I got a dozen doughnuts, two muffins, and an extra-large iced coffee. Then I went to Burger King and got three biscuits and a bacon-and-cheese croissant with two orders of hash browns and a large Diet Coke. Then I went to McDonald's and ordered a few breakfast items as well. Then I went by the grocery store and picked up a few items for after breakfast: two half-gallons of ice cream, two bottles of whipped cream, these little pastry things, peanut butter, and marshmallows. I went home and had the doughnuts and the breakfasts from McDonald's and Burger King. At that point, I was so stuffed I thought I was going to die. I had chest pains, so I purged and then had the rest of it. And then for lunch, I went out and did it again.

When I was younger, I could purge anywhere. Later, it got more difficult. I would only do it in the shower. I thought it was so disgusting. Each purge would take an hour to an hour and a half. I'd just do it over and over again. I would go to extreme measures to make sure that every little bit was up. I kept drinking more and more water until eventually it ran clear. And if I felt that I didn't get everything up, then I might use ipecac. Ipecac is a first-aid measure typically used if somebody overdoses on medication. It was actually what Karen Carpenter died of. I was so severely dehydrated that I stopped salivating and my parotid glands backed up and hardened. I looked like a chipmunk. I scarred my hands. I cut them on my teeth. It's embarrassing.

I probably should have been here months ago, but my son was in school and I thought the only way that I could do it without disrupting my children's lives was to do it during the summer, so they could stay with family. But then it became a race against time, because I knew I only had until summer to do whatever I possibly could to take the weight off. I became so destructive with the ipecac and the restricting. Part of me wants to leave and come back in six months when I've taken off 20 pounds. I know I have to be here but I'm not ready. I don't want anything to do with recovery if it means being fat. The eating disorder has affected all my relationships. I've distanced myself from friends, family, my parents. It's just a hassle being around people. The eating disorder impacted the relationship with my husband, because I felt like he was always in the way. I had missions to accomplish. I had to lose weight.

LEFT, CLOCKWISE FROM TOP LEFT Alisa, 29, chaperones a senior prom, two months before admitting herself to Renfrew; Alisa, 19, with her 2-month-old son; Alisa, 18, at Lackland Air Force Base in San Antonio, Texas, in her first month of training; Alisa, 17, in her softball picture; Alisa, 9, in a school photograph.

may 2006	may 2007	may 2008	may 2009
S M T W T F S	S M T W T F S	S M T W T F S	S M T W T F S
1 2 3 4 5 6	1 2 3 4 5	1 2 3	1 2
7 8 9 10 11 12 13	6 7 8 9 10 11 12	4 5 6 7 8 9 10	3 4 5 6 7 8 9
14 15 16 17 18 19 20	13 14 15 16 17 18 19	11 12 13 14 15 16 17	10 11 12 13 14 15 16
21 22 23 24 25 26 27	20 21 22 23 24 25 26	18 19 20 21 22 23 24	17 18 19 20 21 22 23
28 29 30 31	27 28 29 30 31	25 26 27 28 29 30 31	24 25 26 27 28 29 30
			31

CALORIES

Tues 18

1 egg white	15
4 pieces sf candy	30
2/3 cucumber	30
romaine stalk w/Tabasco	15
iceberg lettuce	10
2 bottles crystal light	20
1 piece ff cheese	30
1 egg white	15
4 peanuts	16
2 Tbs salsa	10
2 Tsp Pepper sauce	10
3 cups sf jello	30
1 cup coffee	9
Total	290

Wed 19

1 egg white	15
coffee (2 cups)	18
5 pieces sf candy	35
romaine lettuce (1 bite chicken)	25
balsamic vinegar	5
2 pieces sf gum	10
6 peanuts	24
5 pieces of candy	30
sf jello x3	30
1.5 cups spinach	20
ff cheese	40
1 egg white	15
1/2 cucumber	23
	290

Anorexia became my life. I can't tell you the last time I went out and met a friend or went to a movie or watched TV. I wake up at six o'clock in the morning and I don't make it out of the house for two hours. I change my underwear seven times and my clothes three, four, five times. When I come home, I spend so much time counting calories and getting on and off the scale and exercising and trying on the same clothes over and over again.

The first thing I did when I got to Renfrew was look in the drain in my room. I thought, Would it be possible to purge in here if I had to? And it wouldn't have been. I would have had to disassemble the entire drain, and that's just disgusting. It's messy. There's no way that somebody could go in there spur-of-the-moment and purge in their shower and get rid of it and clean it up. They would just know.

When I look around Renfrew, I see severely emaciated people. Part of me wants to leave because I feel like I stopped too soon. It's like looking in one of those mirrors at the carnival. It's so distorting, and everyone around you is distorted. I just feel so overweight. The fact that some of these people are so underweight just makes it worse. My arms are too big. My legs are too big. My face is too big. My stomach is too big. My behind is too big. I should have a better body. I brought so many clothes to Renfrew, and I keep repeating the same outfits. I dress to hide. Whether my shoes are flat or have a heel impacts whether my legs look longer or shorter, whether they look thinner. Everything I wear is determined by weight—not color, style, or season.

It's difficult being in Renfrew because I'm not used to the drama. It's like going back to high school. I don't want to say that I am different from the other patients because I'm a mom. However, my experiences are different. If it wasn't for my children I'd probably be dead. The three things that I have made time for in my life are my children, work, and anorexia. The anorexia is my best friend. Before I came, I would go to bed every night with the phone next to me, in case that was the night that I had a heart attack and had to call 911. I don't even want to think about what would happen to my children if I died. They didn't ask to be brought into this world. I have a responsibility to see that they have a good life. That's why I'm here.

I can honestly say I was never abused. I think it's cultural. I think it's environmental. I just want to be thinner. The beauty of this disorder is that it's the one goal that you never reach. I'm addicted to the process. There have been many times in my life where I tried to find satisfaction through other accomplishments, but nothing measured up to this one. I remember years ago thinking, This is what I really want. This is the one thing I want so bad. I just want to be thin. If it takes dying to get there, so be it. At least I'll get there.

LEFT Alisa's calorie journal from when she was attempting to limit her calories to 200 to 300 a day.

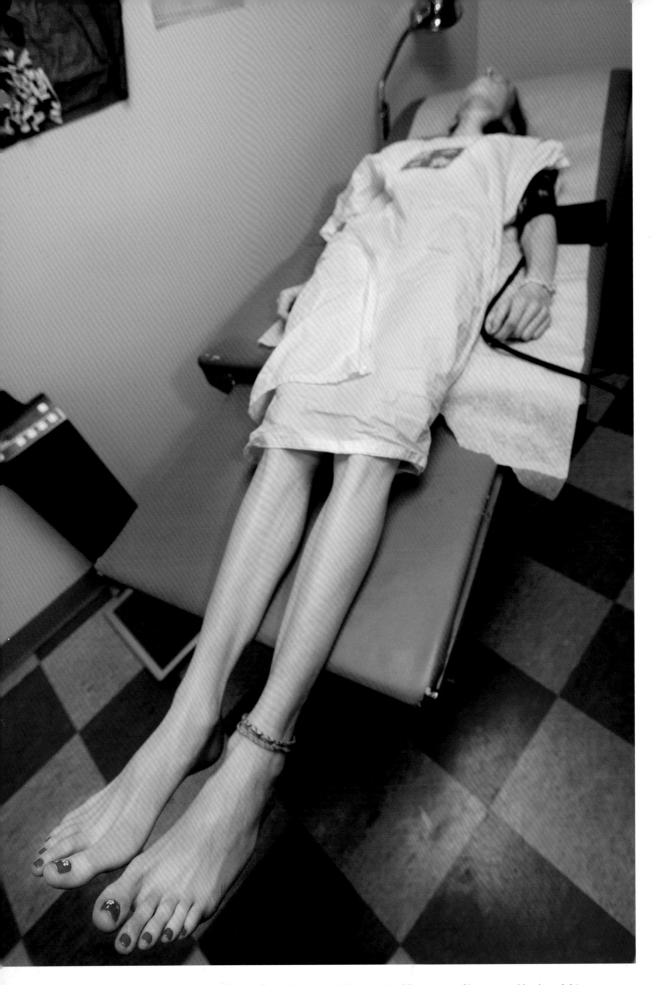

Aiva, 16, gets her vitals checked. She entered Renfrew at 77 pounds, 69 percent of her normal body weight.

DR. DAVID HERZOG

Eating Disorders:
Truths and Consequences

As the media continues its fascination with thinning Holly-wood starlets and models, myths about eating disorders persist. Let us set the record straight. Eating disorders are not a fad, not a phase, not something one chooses to develop. They are not fashionable. They can begin as simply as a diet and they most often create emotional distress and physical endangerment. While adolescent and young women are at highest risk for developing an eating disorder, these illnesses occur in individuals as young as 7 and as old as 70, in women and men, and across all races, ethnicities, and socioeconomic groups. With 5 percent of the population suffering from eating disorders today, they are difficult to overcome, and they do destroy lives.

Those who struggle with eating disorders—anorexia nervosa, bulimia nervosa, or a combination of the two—live day in and day out with relentless thoughts about the size and shape of their bodies. Setting their eyes on thinness, they will pursue it at any cost. Where those with anorexia nervosa are extremely strict about their food intake and exercise exces-sively, those with bulimia nervosa engage in binge eating followed by purging (self-induced vomiting, laxative, or diuretic use) aimed at preventing weight gain. There is more to eating disorders, however, than food and weight. Those are the outward signs of the illness. Inside, the person is experiencing tumultuous emotions that she manifests or numbs by mis-treating and manipulating her body.

Once an eating disorder gains momentum, an individual cannot stop it alone. Professional assistance is required. The nature of the illness makes it very difficult for sufferers to ask for help. Some perceive themselves as not having a problem, while others may be ashamed of their food behavior and go to great lengths to conceal it from their families and friends. Months or even years may pass from the onset of an eating disorder to the beginning of treatment, while the person's

DAVID HERZOG, M.D., is an internationally renowned expert on eating disorders. He is the principal investigator of a National Institute of Mental Health–funded longitudinal study, now in its 18th year, that maps the course and outcome of 250 women with anorexia and bulimia nervosa. He is director of the Eating Disorders Unit, Child Psychiatry Service at Massachusetts General Hospital and professor of psychiatry (pediatrics) at Harvard Medical School.

health grows steadily worse. Greater awareness of these disorders is needed so that those afflicted might seek help more quickly.

These illnesses can cause major medical problems, and even death. More than 90 percent of women with anorexia nervosa suffer bone loss, which places them at risk for fractures and resulting disability. Up to 10 percent of people with anorexia nervosa die of this disorder, which is the highest among the psychiatric disorders and more than 12 times the death rate of young women in the general population. Some of the deaths associated with anorexia nervosa and bulimia nervosa result from medical complications, such as abnormal heart rhythms; others are from suicide. The suicide rate of individuals with eating disorders is 57 times higher than expected for women of similar age. The binge-purge habits of people with bulimia nervosa can cause electrolyte abnormalities, which can lead to dangerous heart rhythms. The starvation state of anorexia nervosa weakens the heart muscles and predisposes to rhythm abnormalities.

Many patients with eating disorders have associated psychiatric problems such as major depression and anxiety disorders, which may predate the eating disorder. Individuals with eating disorders often struggle with obsessions and com-pulsions apart from those that involve food. Some become fearful in social situations and lead isolated lives. Others have substance abuse issues with alcohol or drugs. Past physically, emotionally, or sexually traumatic experiences are not uncom-mon. For those who have suffered trauma, disordered eating may serve as an escape from intense emotions and memories associated with the past abuse and, in the case of physical or sexual abuse, also may serve to help these individuals regain control of their bodies. Coexisting psychiatric conditions make recovery from eating disorders all the more difficult and, at times, life-threatening.

No single influence causes an eating disorder. The illness stems from a variety of factors and researchers are currently investigating how these factors interact to cause an eating disorder. Although not all Americans abide by the "thin is in" standard of beauty, weight bias is a problem. The majority of young girls aspire to thinness as a way to "feel beautiful" and see overweight girls as unattractive because of their weight.

Girls can be subjected to mean-spirited teasing, and many girls report memories of being "judged" on their body size.

The family environment can also play a part in leading to or maintaining these disorders. Complex parent-child interactions are commonly experienced during the course of an eating disorder. Diet talk, frequent weighings, and emphasis on working out in the household may send children the message that they must be not only fit, but also thin in order to please their parents.

Twin studies confirm that genetic vulnerabilities appear to play a role in eating disorders. Research is now underway to determine which genes may be involved in contributing to these disorders. In addition, growing evidence points to the role of neurotransmitters (chemical compounds that transport messages between brain cells), such as serotonin, norepinephrine, and dopamine, in the mood and anxiety disorders commonly associated with eating disorders.

Personality factors appear to predispose certain girls to eating disorders. The pattern of perfectionism, self-doubt, risk aversion, and obsessionality can contribute to eating disorder formation. Modes of thinking can also set up risk: operating in extremes—thinking and doing in extremes, seeing the world in black and white, good and bad, thin or fat.

Dieting and body dissatisfaction may increase the risk of developing eating disorders. Some people diet even though they are in a normal weight range. Reducing nutrient intake can lead to extreme hunger, followed by eating a lot of food in a brief period of time and feeling out of control (bingeing), and this can become a vicious cycle. Furthermore, a body deprived of food slows its metabolism. When the individual ends her diet, her body's new rate of burning fuel may lead to a return of the pounds she has lost and to a renewed resolution to embark on yet another weight-loss campaign.

Treatment of an eating disorder, unless it is caught early, is often complicated and lengthy. A comprehensive team evaluation followed by a treatment plan involving professionals from many disciplines is critical. Treatment typically includes a combination of medical monitoring, psychotherapy, nutritional counseling, and medication. In adolescents with eating disorders, family therapy must be included. Hospitalization may be necessary to curb potentially dire medical complications, to restore nutrition, and to help a patient begin to address the thoughts, feelings, and behaviors that are part of her illness. Although many eating disorder patients admitted to inpatient units can present as dangerously thin, others who are admitted can have a normal weight but dangerous eating and purging patterns.

Residential treatment facilities, such as the Renfrew Center, can be helpful to patients who are severely ill and need the structure and safety of a "24-7" environment. Voluntary

admission to a residential center is often recommended for individuals who have been stabilized medically in an acute care hospital and need extended inpatient services and for those whose symptoms have worsened during outpatient treatment. Upon completion of residential care, in order to sustain the gain made, the patient may enter a partial hospitalization or intensive outpatient treatment program.

Treatment proceeds along a continuum of care depending upon severity of illness. Partial hospitalization, which lasts up to eight hours a day, includes supervised meals and structure similar to that of an inpatient unit. Once an individual is ready to return to work or school, there are intensive outpatient programs, such as evening programs consisting of supervised dinner followed by cognitive behavioral group therapy. Many patients with anorexia nervosa may require years of outpatient psychotherapy.

With comprehensive treatment, particularly if it is rendered early in the course of the illness, most patients with eating disorders improve, and many recover. Unfortunately, some individuals do not get the quality or amount of care they need. This problem can stem from one or more factors. First, it is not unusual for a person with an eating disorder to be ambivalent about getting better; her readiness to change may vacillate, or she may feel unsure about which kind of treatment program to enter or how long to stay. Second, depending upon where she lives, a treatment setting that would meet her needs might not be available. Third, health insurance does not always cover recommended services for eating disorders. An insurance company's decision about whether to pay may affect the type of inpatient program a patient is admitted to, her length of stay, or the number of outpatient visits she is allowed to have after hospitalization. Denial of payment by an insurance company sometimes means that a patient must leave the hospital before she has reached a healthy weight or point in her recovery, placing her at an even greater risk for relapse and re-hospitalization. Dilemmas related to insurance become even more complicated when a patient finishes a reasonable length of stay in residential treatment but is denied payment for the aftercare that would help her maintain the progress she has made.

While 5 percent of our population may be clinically diagnosed with an eating disorder, even more struggle from the same issues to a milder degree and often never get help. In light of this era of "diet crazes" and the competitive nature of American society, dieting and weight loss have become points of connection and commonality among individuals. In order to change the context and values around eating and weight, we must strive to emphasize values of health and personal fulfillment over those of "thinness as beauty" and "beauty as fulfillment" in our culture.

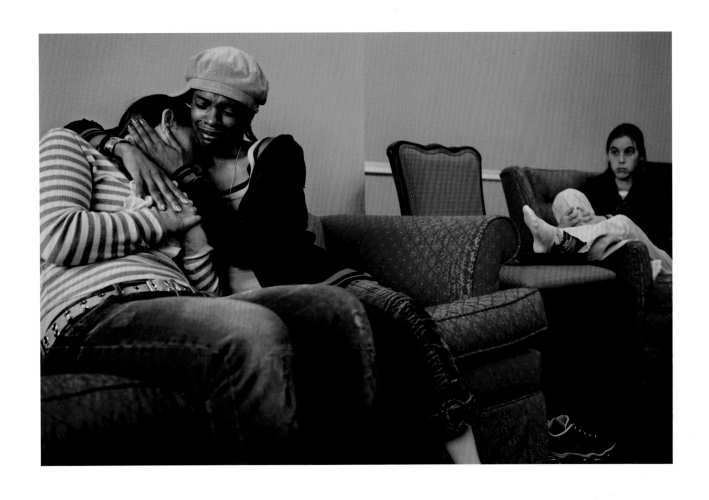

Cheryl, 35 (center), consoles Catherine, 24, in an Experiential Therapy group during which Catherine relives the physical and emotional abuse from her childhood.

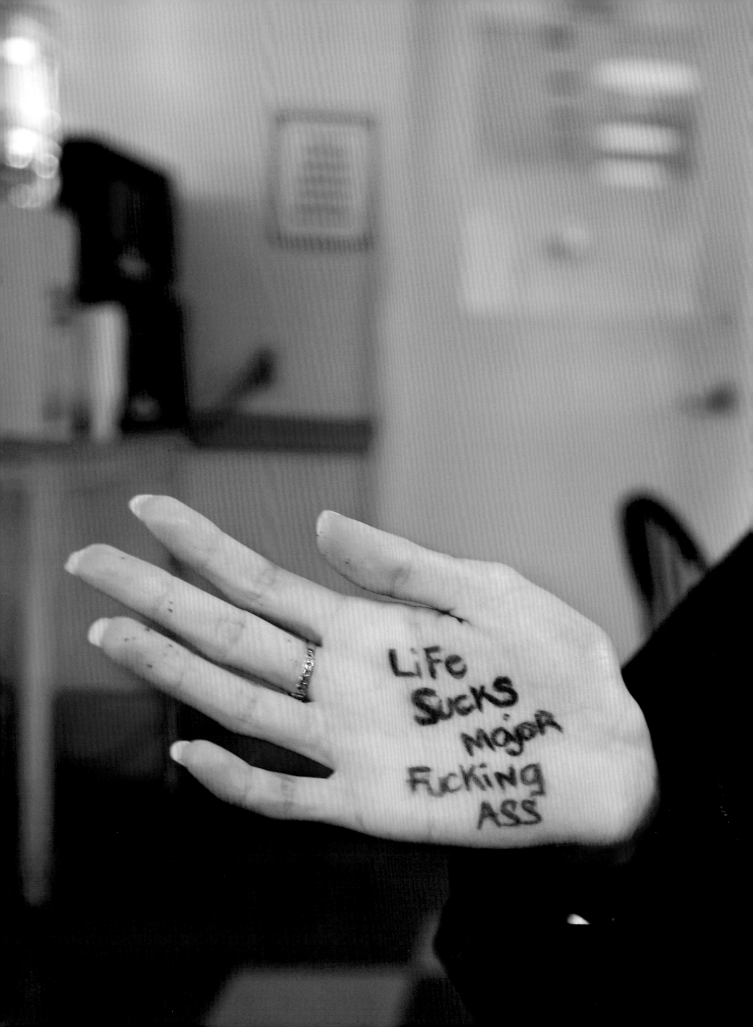

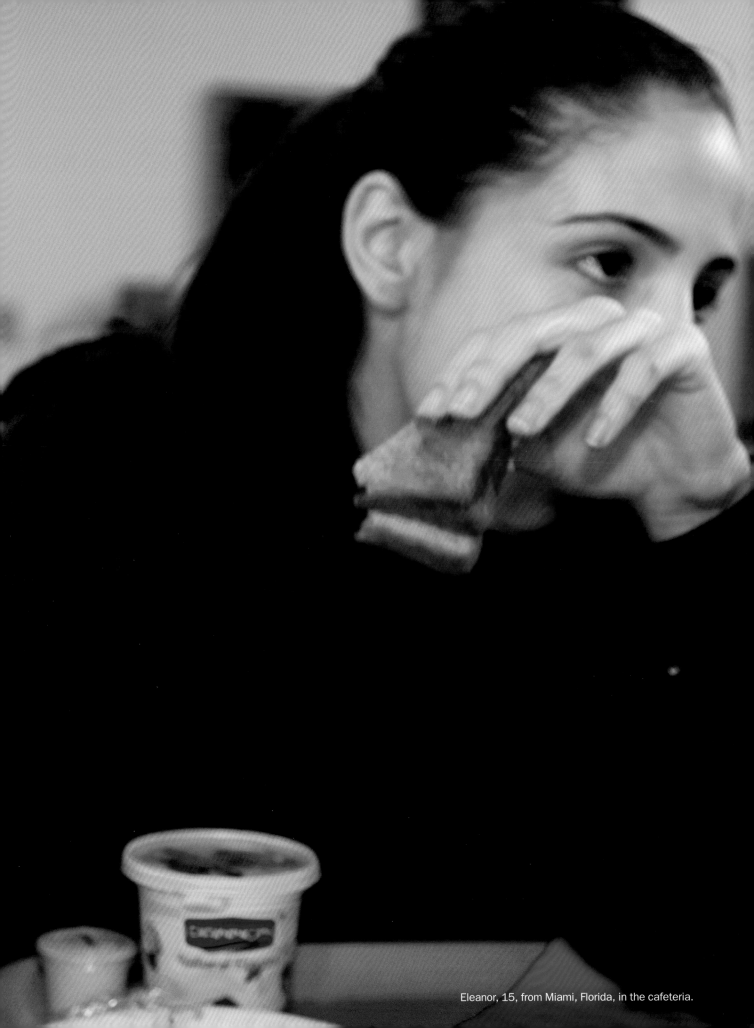

Eleanor, 15, from Miami, Florida, in the cafeteria.

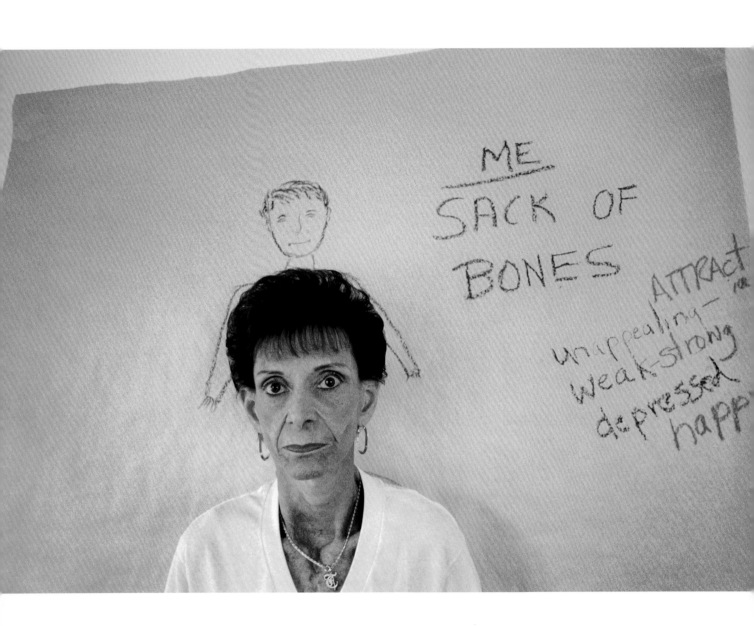

Toby, 63, from Hollywood, Florida, stands next to her body tracing in art therapy.

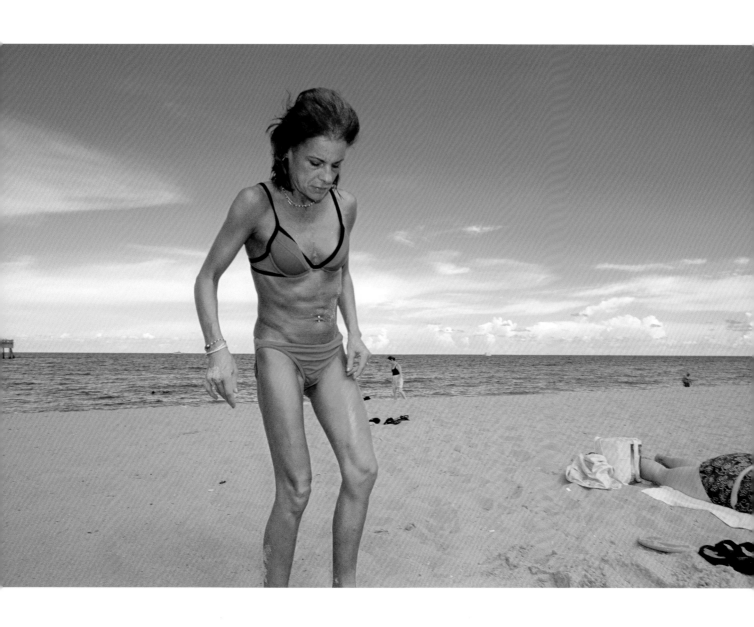

Cathy, 46, from Providence, Rhode Island, on a therapeutic beach excursion, Deerfield Beach, Florida.

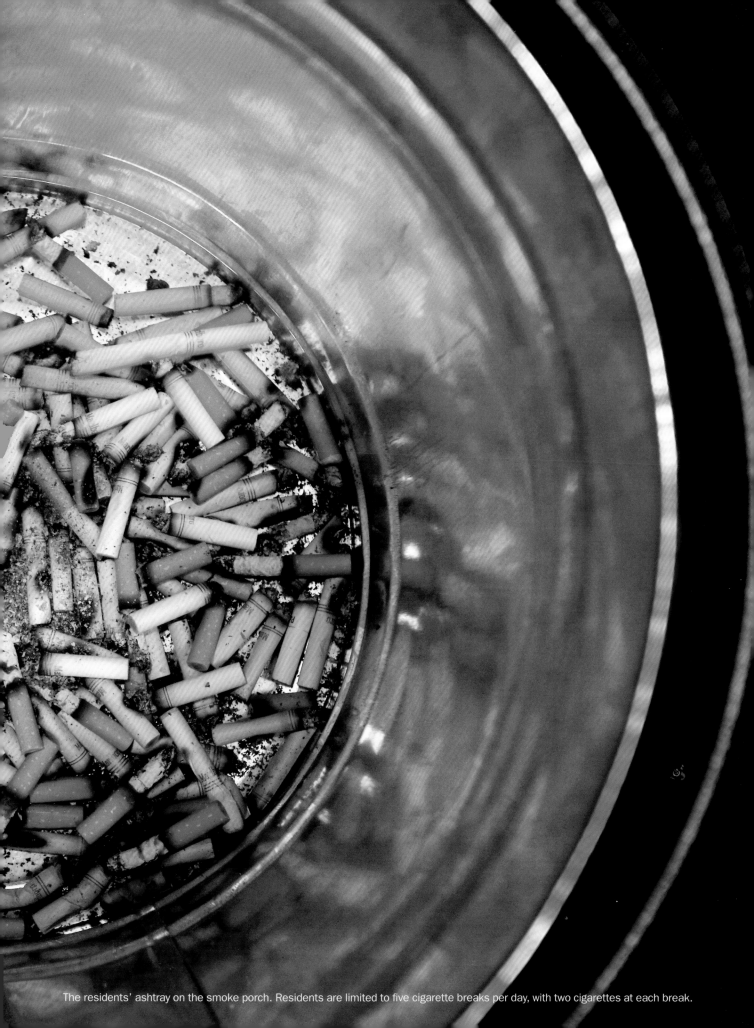

The residents' ashtray on the smoke porch. Residents are limited to five cigarette breaks per day, with two cigarettes at each break.

SHELLY

There's way too much time to think about things that overwhelm me. What I'm supposed to be doing. What I want to do. What I feel like I can't do. I'm constantly beating myself up. That's all I hear when I'm by myself and there's not a lot of noise to distract me. I don't like to be by myself.

When me and Kelly were growing up, we never slept by ourselves no matter what. Kelly is my identical twin. I'm older by six minutes. She's really thin, and people think she has an eating disorder, but she doesn't. She eats what she wants but she works out and stuff. I used to be a lot thinner than she was. When we were growing up, people would say I had the thinner face and Kelly had the round, fatter face. So I just wanted to keep having that thin face.

We looked a lot alike when we were growing up. We were dressed the same for a long time. We did our hair the same with the same ribbon, same color, same everything. We had the same outfits, just different colors. It was really annoying. I remember walking through the middle of church every Sunday dressed in these outfits I absolutely hated.

We were so close, we thought we were like one person. We would always play outside with each other. When we got our own rooms, we didn't even sleep in them. Kelly would come over to my room and we'd sleep on the floor in sleeping bags with our heads together. I felt like I always had to take care of her. Growing up, my mom said I was the one who worried the most and Kelly was the less serious one. Kelly took more after my dad, whereas I took more after my mom.

We moved to Salt Lake City when we were 15 because our parents had just gotten divorced, and it was not pretty with my mom and dad fighting all the time. My brother was up in Utah in school, so we just packed up our house and moved there one summer with my mom. We were in 10th grade, and we were both really shy. We kind of stuck together for that whole year, just me and her.

When we were 9, Kelly and I both started swimming, and we were natural athletes. I was swimming at senior events when I was 13. One day in my senior year, this lady came to the pool and asked to do an article on me and Kelly. I thought it would be a small piece, but three days later this huge picture of me and Kelly in our swimsuits was on the sports page. The article was about us leading our swim team

RIGHT, ABOVE Shelly (right) and her twin, Kelly, at Deerfield Beach during a family visit. RIGHT, BELOW An entry from Shelly's journal.

When asked how they could tell us apart, my mom would say Shelly has a skinnier face, Kelly has a chubbier face and Kelly is the silly, wild one and Shelly is the more serious one. My mom dressed us alike until we were in 5th grade. I didnt mind it at the time, but we got a lot of attention. Now I feel as though we look totally different. It is really frustrating to me because we are two seperate people, yet no one can seem to grasp that in my family.

to the state championships. I was really embarrassed that I was in a swimsuit where everybody could see. I remember being so nervous. I tried to steal all the newspapers from the library and from all around the school but they were in those little locked boxes.

In 11th grade, Kelly and I started restricting and cutting back on fat and calories and stuff. It got really bad the first year of college when me and Kelly lived in the dorm together. Then Kelly went away to Mexico and it got even worse. I had a bunch of friends, but I felt like I had lost my best friend. She came back and was totally different, and I was still the same person. I freaked out the first time I saw her drink a regular Coke. I was like, "What are you doing?" She's like, "What? I'm just having a Coke." And I'm like, "We drink Diet Coke." She's like, "No, I want to have a regular one." She still drinks regular Coke. It shocks me.

When we started to split up, I got really overwhelmed. We started doing our own things, dressing differently, wearing our hair differently. I was worried we might not get as much attention as we had gotten in the past for looking alike. It's really scary when you've had somebody your whole life to go through life with and you go in separate directions. She was doing everything that she wanted to do and I wasn't. I just felt like I couldn't keep up with her. I felt like I wasn't good enough, and that eventually led to my eating disorder.

We've grown apart a lot. I would get angry with Kelly if she ever tried to intervene. I would just push her further and further away, and she would try to call and I would be really mean or would just ignore her. I refused to do anything with her. We drifted apart, even though she tried really hard. I just let it go.

I don't think she knows how to handle my eating disorder. At first she would scream and get mad, and then I would start eating again because she would break down. We'd have these huge arguments and then my mom would be there, crying and freaking out. I finally stopped caring about what everybody thought and just did what I wanted to do. I know it made her angry and mad. She hated when we'd go to dinner because we'd have to pick some place where I might eat something. And she hated when I wouldn't eat or would just eat a little bit. One time she caught me throwing up in the bathroom. It was horrible. She was like, "I won't tell Mom if you don't ever do it again." So I was like, "I won't do it again." But I kept throwing up in the bathroom. The door didn't lock, so she just came bursting in to tell me something like she always does, and I was in there and I was like, Oh my God. She caught me.

I want to be 96 pounds. I know Kelly doesn't hardly ever get under 100, and if she does it's usually just 98 pounds, so I'd still be smaller. I don't want to look exactly like her and I don't want to get fat. What is the other thing to do? Get really, really thin. So that's what I did. I thought I would feel different if I looked different.

RIGHT, CLOCKWISE FROM TOP LEFT Shelly and Kelly, both 8, at a dance recital; Shelly and Kelly, both 7, dressed as devils for Halloween; Shelly and Kelly, both 5, dressed as genies for Halloween; Shelly and Kelly, both 7, with their Easter bunnies; Shelly and Kelly, both 4, at a tap recital. All childhood pictures from Lake Charles, Louisiana.

When we were little we had a close relationship, but we've never really told each other feelings. We never talked about things like that. # I also feel really guilty b/c when were growing up we would fight and I would hit her and tell her she was fat. I dont think we have ever told each other we love each other and we have only hugged each other maybe 5 times in our whole life. We just have not had + Although we have an emotional tie to each other, it goes unsaid. We can feel what each other is feeling and thinking, more than we would have to say it. # I do not want to get Kelly depressed and sad and dragged into what I have been living, so I keep my distance and pretend that I am ok and happy when we are together, but I really dont feel like doing see that anymore, so I just dont hang out w her anymore.

FOODS I AM OK WITH:

- Low-cal bagels - Low-fat tortillas - FF cream cheese
- FF cheese - Powerbars - FF Sour cream - Turkey Sandwichs
- Yogurt - Soy lattes - Frozen yogurt. - Baked Chips
(lite)
- Fruits - Veggies - (Fat Free) - grilled chicken.
- Salad Sushi - Shrimp - egg whites

FOODS I want to be OK with:

- Rice - Fish
- Potatoes -

FOODS I'll never eat:

- Any thing Fried - Red meat - Full Fat condiments
- Pizza - Real Ice Cream (batter, etc.)
- Donuts - Oil
- Fast food (except subway) - Real Cheese
- Chinese food - Pasta

I know that Kelly didn't want to come here to visit. I didn't want her to either. I've gained 20 pounds. I was embarrassed for Kelly to see me like that, because I've always been the strong-willed one who was able to lose weight really fast. But then at the same time I was like, Well, I'm healthier now, so it's probably a good thing that she sees me like this.

It was really stressful to have her come with my dad. I wanted to make Kelly feel proud and I don't think I did. I wasn't doing very good that week, and I felt like I disappointed her and stressed her out more. She said a lot of things that were hurtful. Things I needed to hear but that I'm not used to hearing: That I was the same person that they dropped off two-and-a-half months ago. That I wasn't trying hard enough. That I was just going to go back and do the same thing over again.

I don't think I'm the same person that I was three months ago. But I think that when they come here, I revert back to that old role that I played in the family, where I want to be the dependent one. The one who's always in a bad mood and depressed. Every time I go back home I just fall into that same role, so I know I can't go back. No one else has changed except me, and I think people are still expecting me to be that same person, so it's really hard to be somebody different.

Kelly thinks I can just snap out of it. She's very strong, and I don't think she understands why I have so much anxiety and why I'm so depressed. She's always been able to just say that she wants to do something and go and do it, whereas I've been extremely scared. I don't think Kelly could ever be what I am. I don't think she'd ever let herself get this weak.

People came up to me here and said, "Oh, you guys look exactly alike, she's not thinner than you," which I was scared she was going to be. I don't know if people are lying and I really am bigger, though. Truthfully, I did look at her body. I did compare myself to her. But I compare more the way she acts and the way she talks. I see someone who's confident and strong and whom everybody really likes. Who's smart. And I don't see that in myself.

1/17 ⟶ 96 lbs (not moving)

7/21/04 — 99.1 lbs and climbing & freaking out . . .

LEFT AND ABOVE Entries from Shelly's journal. She lists her "safe" foods and her "fear" foods and tracks her weight gain while in treatment at Renfrew. Residents are not allowed to talk to each other about weights, calories, or numbers.

Aiva, 16, with friend Kylee, 15. Kylee wears medical support hose prescribed to aid circulation.

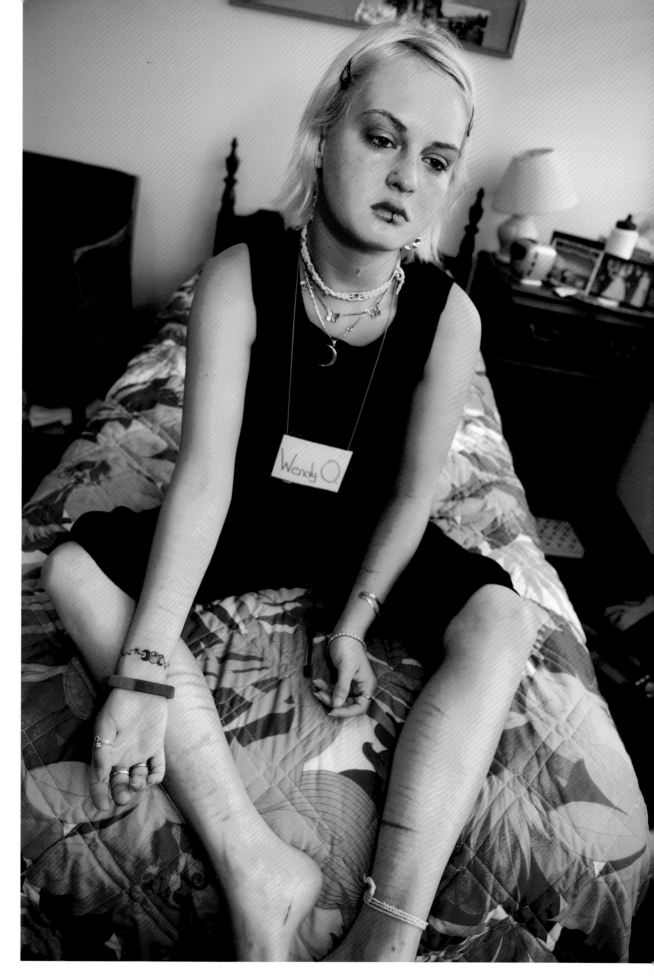

Wendy, 20, from Boynton Beach, Florida, in her room. She has self-inflicted cuts all over her arms and legs.

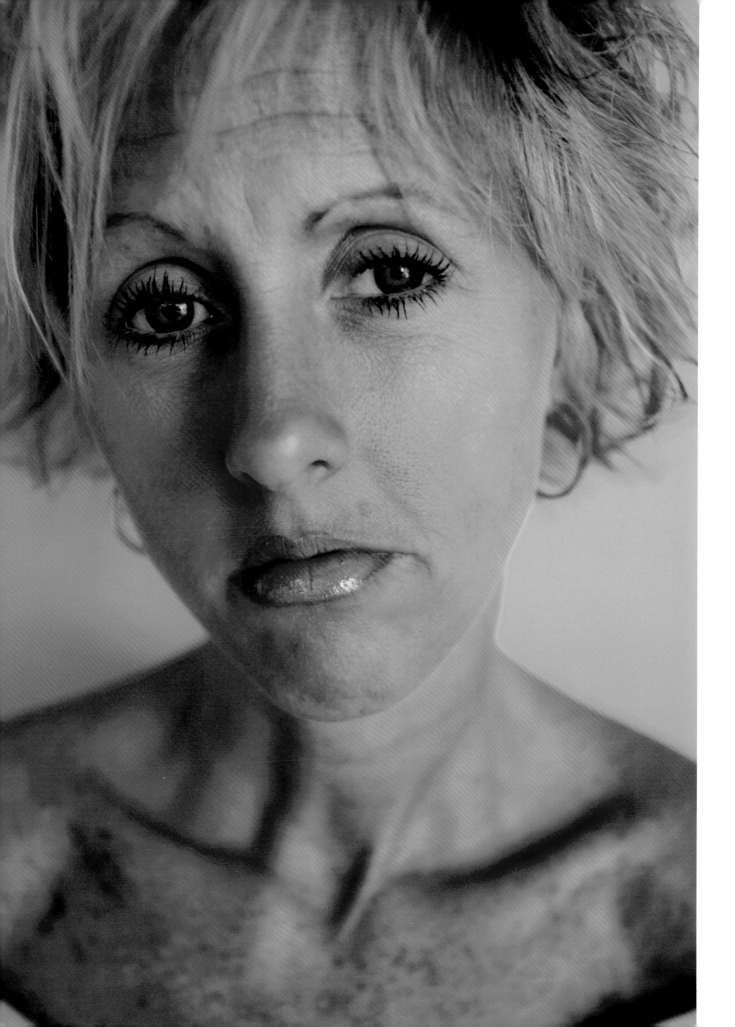

ROBIN

For the longest time, I didn't realize I had an eating disorder. I didn't eat breakfast, I didn't eat lunch. I would have something for dinner, then take 50 laxative pills. I just did it. It was the same as brushing my teeth. All I thought was, Oh well, I take too many laxatives. No big deal. Never in my life did I feel this was something that could damage so many organs and cause so many problems. And I consider myself pretty educated.

The big wake-up call was when my doctor actually got on his knees and grabbed my chin and said, "I can't let you leave this office. You can either stay and get better, or your children will be going to your funeral." My potassium was so low, he was in amazement that I had not had a heart attack. Lack of potassium can weaken your heart muscle, and if you get below a certain body weight, your body can start to feed off that muscle in particular. It was very, very frightening. It's ironic that you strive to be young and thin and fit and it can turn out the total opposite way.

I liked being thin. I felt really in shape. I know I'll have to grow old someday, but I want to stay young as long as possible. I think being thin and looking nice and being able to wear clothes nicely, people automatically assume that you're younger. That's a great feeling. I work hard at my figure. The reason I came to Renfrew is because I wanted to learn how to do it more healthily.

The only time I wasn't thin was when I was pregnant with each of my three children. I was miserable. The second the baby was born, all I could think about was getting the weight off. I was determined to be a thin, well-dressed, attractive mom. I worked in an office and wanted to be respected, and I felt like it was the way you presented yourself. We have so many advertisements that compare being thin to whether you're intelligent or not. To get your foot in the door, you have to be an attractive, thin woman so that you can prove your intelligence and get on your way.

I know my husband loves me unconditionally. I don't think it would matter to him what I weigh, as long as I'm healthy. He's often said, "I'd much rather have you here with the boys, helping to raise them, than for you to die because you're striving to be thin all the time."

I've always been into the latest hip clothes and what was in style and makeup and hair. I had a breast augmentation. I just wanted to look like I did in high school. I also wanted a thigh lift, but the doctor said I was too thin, that it would be more scarring than anything. When it comes to clothes, I make sure that I have jewelry that matches and shoes that match and things like that. My girlfriends have nicknamed my getting-ready routine "the process." My husband teasingly said to me, "If anybody's gonna think you're doing anything, it's going to be in your showers." And sure enough, it came up in our community groups that I was probably exercising in my shower. It upset me.

It seems as if whenever I'm around a bunch of women, there's always talk about me. Either because I try to wear the finest clothes or the nicest shoes or the nicest jewelry. That's just my thing and it always has been. This is me, and if you can't see past that and know who I am intellectually, then I feel sorry for you, because I have a lot to offer intellectually and it's not all what you see on the outside.

I project a lot of charisma when I come into a room. I just have that sense of confidence. I really thank my parents for that because they instilled in my sister and me that we were beautiful people and that we were intelligent and we had what it takes to be a success in life.

MARY

24, FROM ATLANTA, GEORGIA

Talking has always been hard for me. Showing my emotions through my body was an easy way to get them out. It was about looking on the outside the way I felt on the inside. To show people I hurt this much. I was so unhappy I just wanted to kill myself. The anorexia and the bulimia were a slow suicide. It was a way to get rid of myself.

My parents were divorced by the time I was 5. My dad got custody, and my sister and I were taken away from my mom. We were both really sad, and we didn't have anyone to turn to. My dad wasn't there, and my stepmom didn't care. We weren't really allowed to express our feelings with crying and stuff like that. My sister started cutting and burning herself around the age of 5. She never really showed her emotions, and I guess that was her way of getting things out.

When I was 14, I started restricting; I was having a lot of problems with my dad, and I really missed my mom. Then we went to live with my mom, and everything got better. Around the age of 17, I started getting overwhelmed again and feeling like there was no way to release the pressure, so I started cutting myself. The pain felt so good. The easiest thing to do was roll up my sleeve and cut my arm. Then I got obsessed with having all of the scars in one place and having them all the same length and depth and looking the same. I have hundreds of cuts. It got to where the only way I could feel good was if I broke through the skin enough to where I exposed muscle or bone and I would have to get stitches. I never lied about what happened. The

looks you get from hospital personnel are awful. They think that you're wasting their time. I have a little box of stuff that I use to cut with, and I have a pocketknife on my key chain. I've been out in public and bought knives on a whim, just because I felt like I had to do it. In college, I used to go to the student bookstore and get the dissection scalpels. I have deep scars on my body. The deep ones are the ones that did the most for me. As much as I hate the scars, when I look at them and remember how it felt, I don't feel bad. I don't know that I am going to give it up. I get such a high off it.

People think I do it for attention, and I don't, because I've hidden it for so long. I only started showing my scars, like wearing short sleeves, in the last year. And it's just because I got so tired of trying to hide things and pushing people away. My parents didn't know about the cutting until about a year ago, when I attempted suicide and was in the psych hospital. My mom came to visit, and they had bandaged my arm from cutting. She doesn't really talk to me about it, and I'm okay with that.

When I was 21, I was eating regular meals and purging, and then I gradually started cutting down to where I was eating nothing for a couple of days and just drinking a lot of water. And I would purge the water, too, because I couldn't stand having anything in my body. I wanted to hide and be empty inside.

The first time I came to Renfrew, I only stayed a week. I didn't really want to get rid of my eating disorder. I came back

and stayed for about four months. It was hard to go from being here where your every need is taken care of to going out in the world in this new body that I didn't like. It was easy to relapse. It's not like other addictions, where you can abstain from them for a while. With food, it's something you have to confront three or four times a day, every day.

This is my third time at Renfrew. I still think about restricting all the time. I've tried to get out of things and cheat my way through. I have cut myself. I have scratched myself. I've gone outside and taken a stick to my arm and rubbed it until there was no skin left. I've purged in treatment. Having an eating disorder is just one big lie. You have to keep so many secrets, you can't help but give up your integrity. You become this person that you never thought you'd be.

POLLY

PART 2

I feel like I don't even know my body anymore since I got here; I have changed so much. When I look at myself, I don't like what I see. I see somebody foreign. I have put on weight. That's been a battle. I told them when I got here that I had no intention of gaining weight, that I was coming to quit throwing up. They told me straight up that I needed to gain weight and that if I was gonna be here I was gonna gain weight. My metabolism shot through the roof, so I started burning calories really fast and I was going through three pairs of pajamas a night because I had the night sweats so badly.

I've got what a lot of people call the refeeding belly. When girls have been here three or four weeks, usually they start getting a belly. The rest of the body may still be really thin but they've got a belly. That's been very difficult for me because my stomach is the one area that I've always been okay with.

Getting my period is a new thing. I used to have one every once in a while but now it's like my body is trying to get back at me because I have had my period almost every day since being here. So that's hard. It's very hard when new girls come in and they're really skinny. I look at myself and I'm like, Oh my gosh, I'm so fat and look at that new girl and how skinny she is.

Outgrowing clothes has been very difficult. It's hard knowing that I'm going home, and most of what I have isn't gonna work anymore. I'm gonna have to clear my wardrobe. I've asked my mom to clear part of it, from when I was wearing children's clothes. My stomach has started growling again. I can't even tell you in how many years it hasn't done that. I don't feel like myself. I don't feel like I'm in my own body and it's really, really weird.

I was a laxative junkie, so coming off the laxatives is not fun. There is a lot of constipation initially. There was one girl who went 17 days before she went to the bathroom because she had so abused laxatives. I've been on laxatives for years. When I was at my worst, I would take 25, 30 a day.

I got to go out the other night for my very first time and I went to take a roll of film to get developed. I walked into the store, and I was like, Oh my gosh, I could totally buy a box of laxatives right now. But how can I sneak it in? So then I was like, Okay, I'm not gonna be able to get it in so I'll just open up a box and punch out a bunch of them 'cause I can put them in my pocket. And then I was like, Oh my gosh, I'm

RIGHT Two months into her treatment, Polly got the National Eating Disorder Association symbol tattooed on her hip. In the eating disorder community, red represents anorexia and purple recovery. Residents are not allowed to get tattoos while at Renfrew.

106

trying to steal. I've never shoplifted in my life. Here I was, thinking, It's okay, I'm over the laxatives, I haven't had one in almost three months. But I got outside of Renfrew and I wanted them immediately.

Tomorrow I go out on my first excursion, which is driving me crazy. I'm so anxious. I don't want to stay at Renfrew for the rest of my life but I don't want to go out. Tomorrow we're going to the beach and it will be very difficult being in a bathing suit in public. I've already talked to the counselor about if we are required to wear a bathing suit, which they said we are, and if we are required to take our tops and bottoms off, you know, our cover wear—and it's strongly encouraged. I put my bikini on the other day and was just mortified by what I saw. I don't know yet how or if I'll actually take my shorts off.

We're required to have a snack every time we go on an excursion and that's very difficult for me. Two days ago was the first time I had eaten in public in three months, and it had been years since I had eaten something in public that I didn't actually throw up afterward.

The crazy thing about eating disorders is that it's so hard to understand unless you have one yourself. Eating ice cream in public, or eating ice cream, period—I've had my family, my mother, so many people say, "Just eat it." And I can't. Honestly, I can't even think of how to explain why and how it's so difficult. There's that healthy part of me that sits there and says, "It's only ice cream, big deal. Eat it." And then that other part of me, the eating disorder, is just terrified that I'm gonna have it.

The sick part of me still says that food's the enemy. Food is gonna make me fat. Food is gonna ruin my life. When I eat the wrong foods—sweets or anything like that—my eating disorder is really pissed off. It makes me feel so guilty. The unhealthy part of me is still sitting there putting me down for being weak, for giving in. It says that I'm gross and disgusting. That if I were strong and had the will power then I wouldn't eat it. That by letting myself have something like candy I'm just gonna get fat. I hear the word "fat" over and over and over and over.

RIGHT Polly writes in her journal about getting caught smoking in the bathroom. She was told by staff that if she breaks any other rules, she will be given 24 hours' notice to leave.

Thursday 9:15pm 07-08-04

I got busted by Diane, the cleaning lady, smoking in the bathroom. Tumbling on down to Level I, mmmm..., exactly where I was when I got here. Could I please be a bigger fuck up?! Why do I do such stupid things? I feel like such a failure, and I know I'm a disappointment to the family. I know it just killed Mom hearing what a mess I had made down here. Then, just now, I learned that both Kailee and Shelly were told to watch who they hung around with. I didn't get told that so obviously its me.

I was told yesterday by Donna that Gail Brooks is reluctantly "allowing" me to stay but that if I screw up even once they will hand me a 24hour notice to leave. Nice.

I have seen so many girls do so many things that were so much worse, and I get treated like a fucking criminal. They want to know what else I'm hiding. If I tell them about my tattoo then I'll be totally kicked out.
← cab Michelle + I took to get the tattoos. maybe it's time for me to just leave.

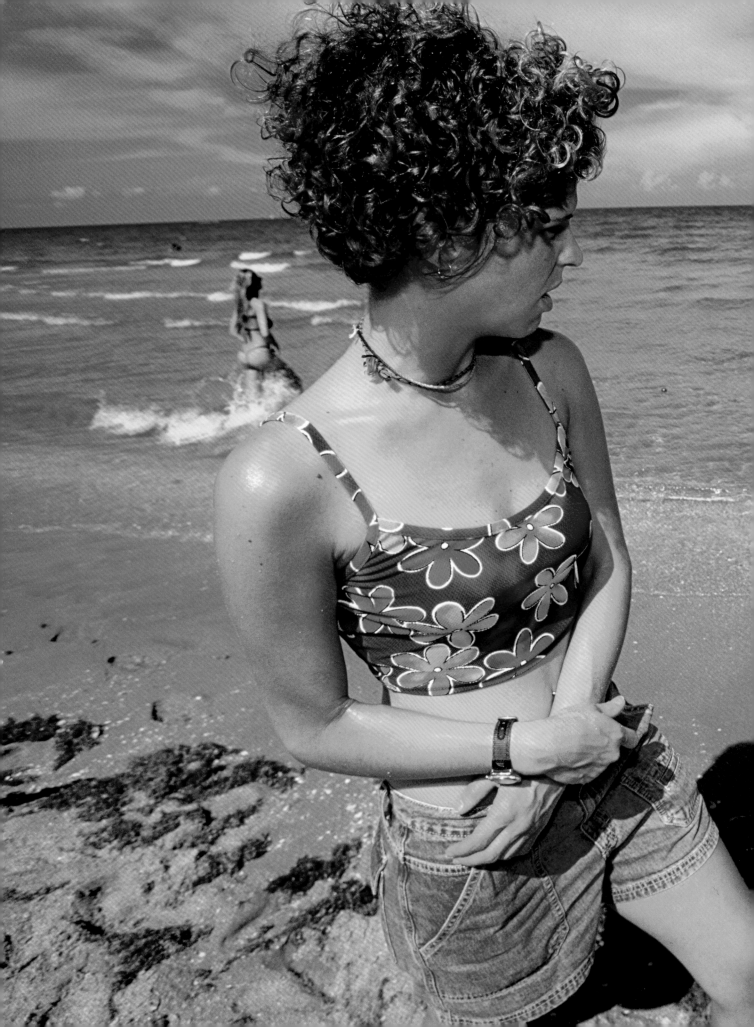

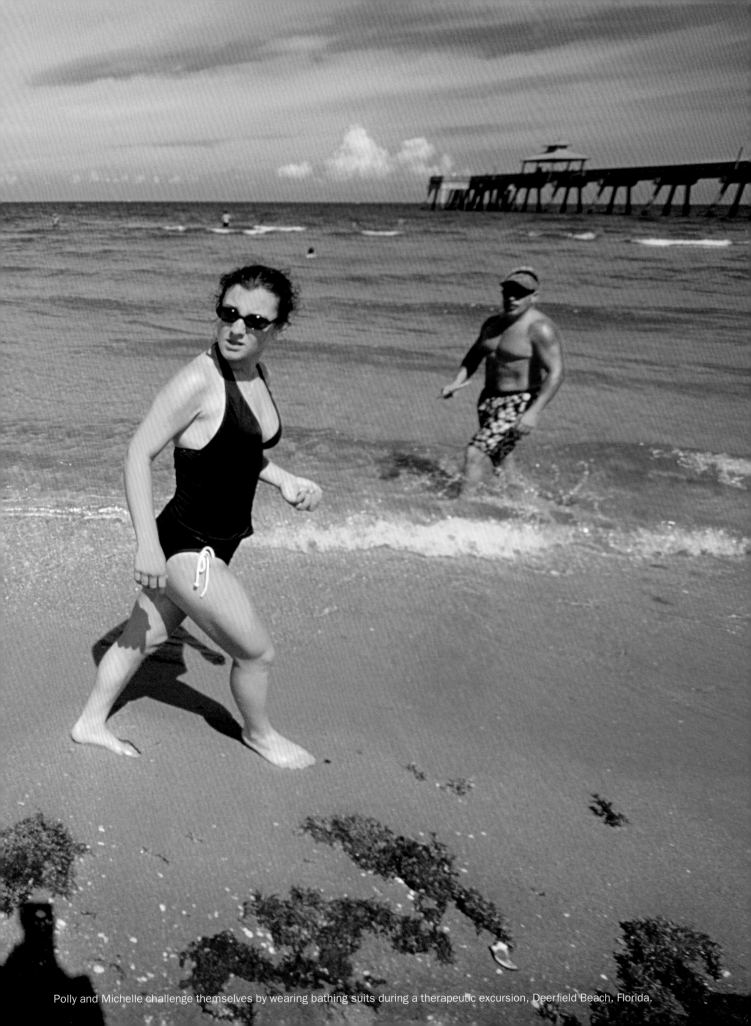

Polly and Michelle challenge themselves by wearing bathing suits during a therapeutic excursion, Deerfield Beach, Florida.

Tuesday 07-13-04
really late.

Well, the decision has been made for me.
Renfrew is kicking me out. Shelly and kailee
fucking ratted me out for giving shelly
some pills over four weeks ago, and they
told about the tattoo. Fucking bitches!
Renfrew gave me my 24. There was a big
meeting in Jail's office, and then a smaller
one with just me and "my so called team."
We had my mom on speaker phone. She
was hysterical. She and I were both
begging them to let me stay. Kailee and shelly
avoided me all day.

I don't know why I even bothered to eat.
I threw everything up all day long.
I have never cried as much in one day as I
have today.

Tomorrow is really going to suck. It's going
to be so hard to say goodbye to some of the girls.
I'm scared to death. I haven't been in the
"real" world since April.

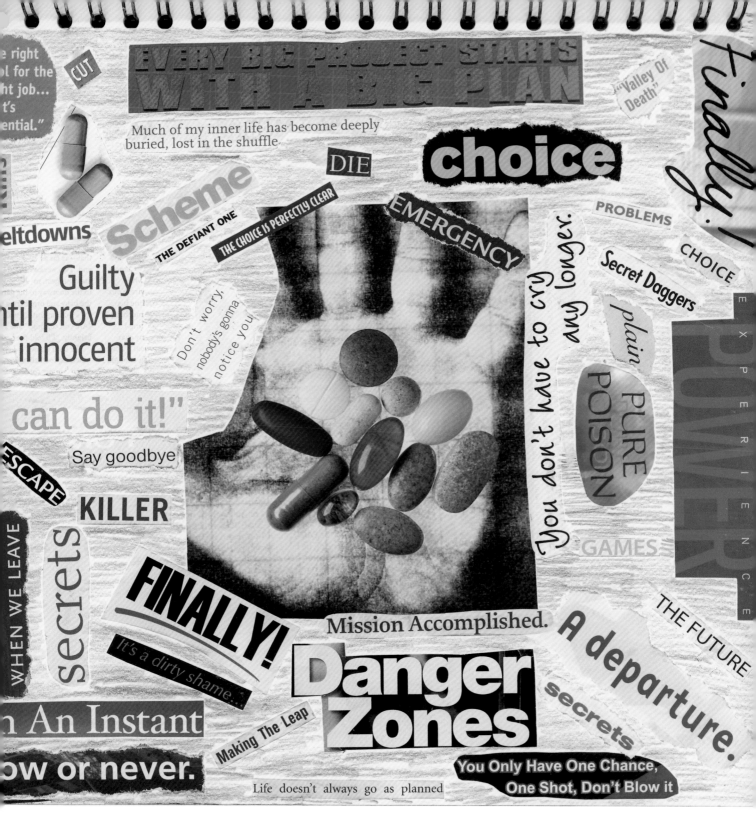

EVERY BIG PROJECT STARTS WITH A BIG PLAN

Much of my inner life has become deeply buried, lost in the shuffle.

DIE

choice

"Valley Of Death"

finally!

CUT

the right ...ol for the ...ht job... ...t's ...ential."

Scheme

THE DEFIANT ONE

THE CHOICE IS PERFECTLY CLEAR

EMERGENCY

PROBLEMS

CHOICE

Secret Daggers

...eltdowns

Guilty ...ntil proven innocent

Don't worry, nobody's gonna notice you

You don't have to cry any longer.

plain PURE POISON

POWER

EXPERIENCE

...can do it!"

Say goodbye

ESCAPE

KILLER

secrets

WHEN WE LEAVE

GAMES

THE FUTURE

FINALLY!

It's a dirty shame...

Mission Accomplished.

A departure.

secrets

...n An Instant

Making The Leap

Danger Zones

...ow or never.

Life doesn't always go as planned

You Only Have One Chance, One Shot, Don't Blow it

LEFT Polly's journal entry after she was given 24 hours' notice to leave Renfrew. Polly purged repeatedly that day for the first time since she began treatment. ABOVE Polly made this collage after she left Renfrew. She uses her art to express her suicidal thoughts rather than act on them.

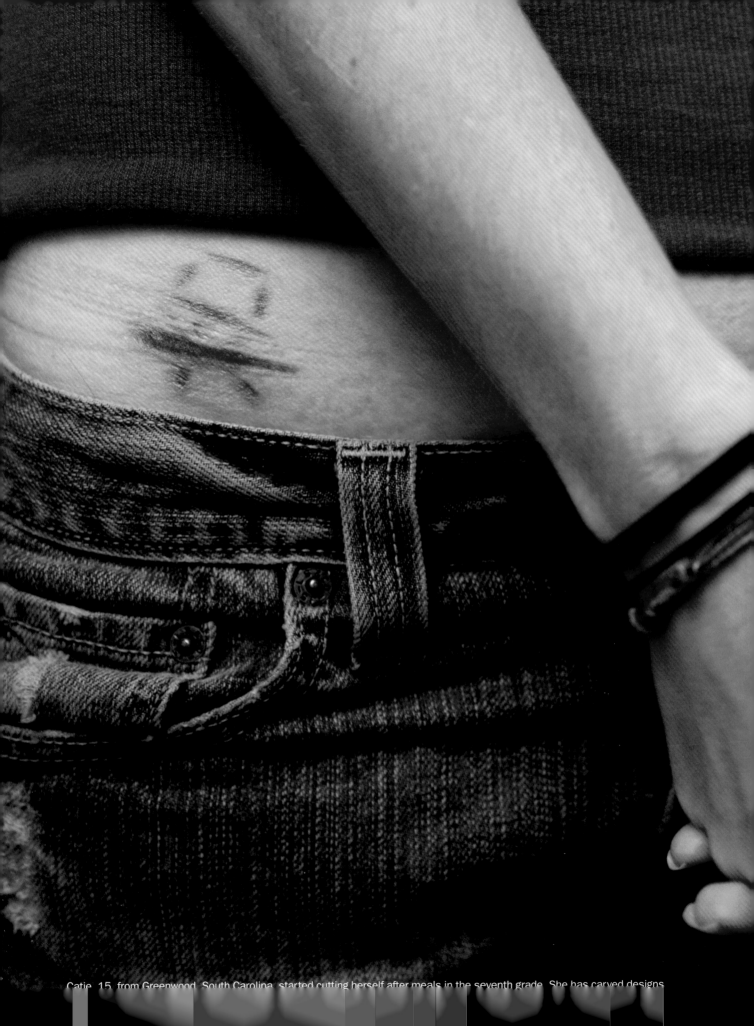

Catie, 15, from Greenwood, South Carolina, started cutting herself after meals in the seventh grade. She has carved designs

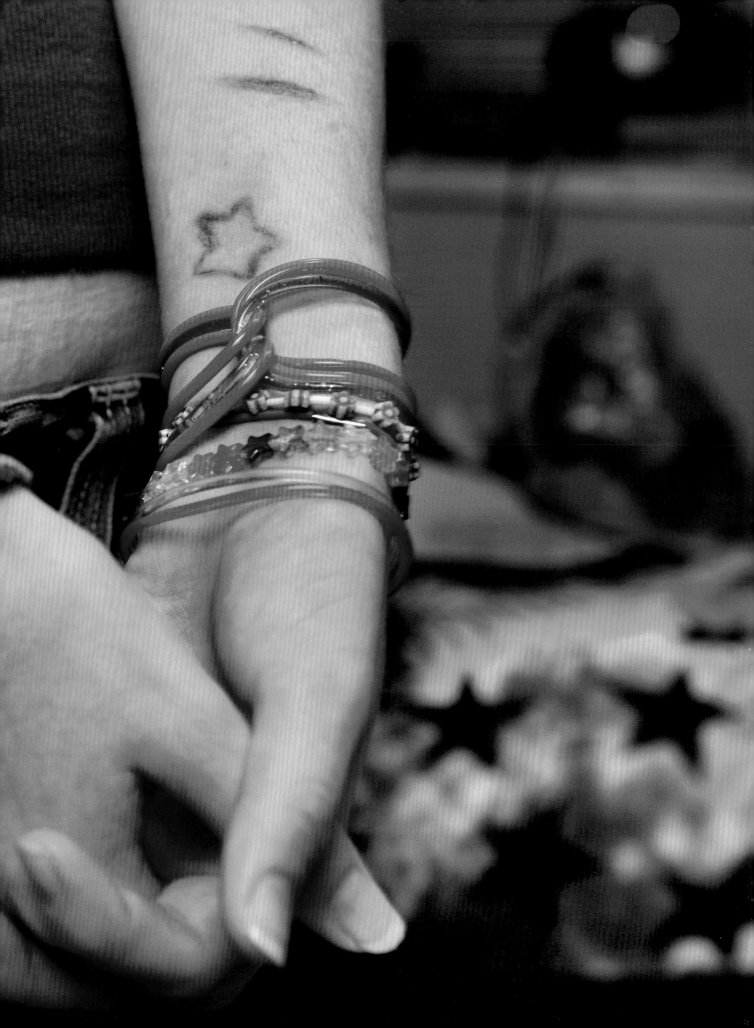

When I was little, I always ate a small amount of food. My mother passed away from cancer when I was 6 months old. My dad didn't know how to cook. The little Chef Boyardee bowls that have meals in them would be my whole dinner until I was 8 or 9 and my dad remarried. That's all I would eat. I never wanted anything else.

I've been dealing with depression for a long time. My grandma told me that she's seen tendencies in me since I was about 3. I was sexually abused from when I was 6 until I was 10. And eating disorders run in my family: On my maternal side, two people have had them. When I was in pre-K or first grade, I was always looking at the other girls in my class thinking, I wish I looked like them. I wish I were thinner.

When I was 13, I was in a school where I didn't have a lot of friends. People didn't like me and made fun of me and I was in a really bad place. I was always regarded as the dork, the really smart girl, the one who's not cool. Don't invite her over for a party because there's no point. I'd always be picked last for a team in gym. I was always the one who would end up sitting alone. I started restricting, counting calories. I started taking food, health, and diet information from magazines, Web sites, TV shows.

I've always compared myself to other people. It doesn't matter if they are a celebrity or a person you see walking down the street. I've always felt inferior to them. Even when I was in my eating disorder, I could look at somebody who I logically knew weighed more than I did and be completely distraught. I knew how thin I was. I could see bones sticking out. It was just never good enough for me. I think it all comes down to self-hatred issues.

I've attempted suicide four times. One time was at Renfrew. I sat in the bathroom and banged my head against the counter as hard as I could. I had just finished a rough conversation with my dad and it was too much for me. The counselor came in and it was a really big deal. I had to be with a one-on-one for about a week.

I really feel at home at Renfrew. It's a whole bunch of girls and it's fun. It's like being in school, but living together. People were nice to me on the first day. It has been one of the best experiences of my life. I've been here five months. I weighed 77 pounds when I came in and now I'm at 112.

I'm wearing my T.E.D. [prescription] hose because of edema. Any water I absorbed, I would retain in my feet. When you're at a treatment center and everybody's wearing T.E.D.'s, after a while, you say, "I'm going to wear mine to the mall and it's going to be the next thing." And you're like, "Oh, your T.E.D. hose look so cute with your outfit." It was a definite fashion statement.

Guys think it's hard to ask a girl out but that's nothing compared to trying to be popular, trying to fit in, trying to be attractive enough, trying to be smart enough. All the things that girls have to go through, having a baby, trying to be true, having to live up to this media standard of blonde hair, blue eyes, perfect clothes, perfect hair. Even if you take away eating disorders, being a girl is always going to be one of the hardest things.

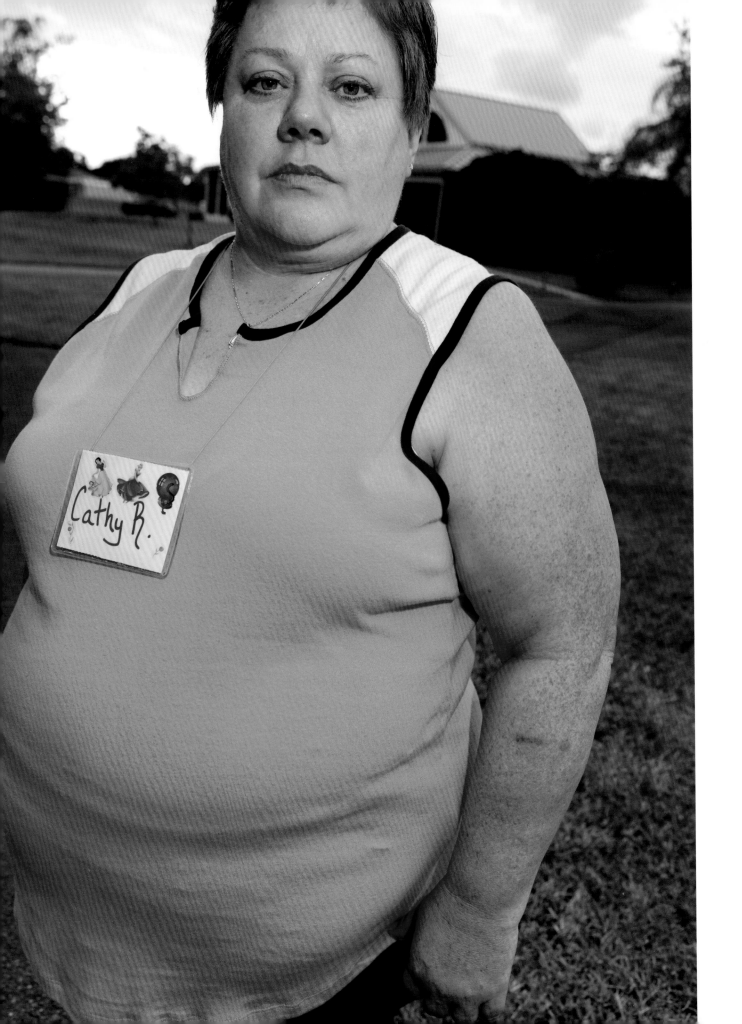

CATHY

I spent 38 years being told that I was a worthless piece of skin. And somewhere along the line, I began to believe that. It started with discipline from my father when I was a young child. Discipline meant being hit with a belt. That beat the hell out of my self-esteem. Then I married the bad boy from the other side of the tracks. And he proceeded to beat the hell out of me for quite some time, and I kept that a secret.

There are six siblings in my family. We're all overeaters. All stage-two diabetics. When we're stressed, we use food to feel good. But I never really had a weight problem until three years into my marriage. My husband didn't want a wife who was overweight. One comment I can remember is, "I guess we won't be going to the union picnic this year." I had just given birth to my second daughter. We weren't going to the picnic because he was not going to be bringing a fat wife.

I became a closet eater. I wouldn't eat a lot in front of him, ever. Night eating was easy, because he was an alcoholic and would pass out at night, dead to the world. I would make spaghetti, have two packages of cupcakes, chocolate milk, chips, and ice cream until I was full. Until I was happy. Until I was able to sleep. It wasn't until recently that I heard the expression "emotional eating." It really felt like hunger.

I was married for 10 years, and I divorced him. The eating disorder subsided. I lost weight without dieting. The binge eating stopped. When my ex-husband would come pick up the kids,

he'd say, "Oh, you're thin now that we're divorced. But you couldn't get thin for me." And I thought to myself, I couldn't get thin because of you.

After four years, I remarried him. A year later, I was 80 pounds heavier. He never touched me in the second marriage, but he found a new way to verbally tear me down. I can honestly say that left more scars than any beating ever did. After 13 years, I divorced him again. For 8 years he was off in his drunken stupor. And he reappeared, sick. I felt sorry for him. I married him again. My eating disorder went over the edge. He went back to being abusive. When he died, I went into a deep depression. I said, "I have to do something." That's what brought me here.

Ten years ago, a psychiatrist at another center told me I would not lose the weight because I wore it like a suit of armor, and that until I faced my fear of intimacy, no matter what I did, I wouldn't lose the weight. I thought that was the stupidest thing I had ever heard, and I left and gained back the 30 pounds I had lost.

I have been more honest in the last three weeks than I've been in the last 30 years. I've talked about my abuse, anger, shame, guilt, everything. When my husband died, I thought I could just somehow start letting go, but I can't. I have to erase all those tapes in my head and I have to re-record. I have to get my self-esteem back.

When I came here, I was the only overeater, so I felt very alienated. But I was welcomed. The girls said I didn't

intimidate them, being overweight. It was only their own bodies they were concerned with. I found out that we all struggle with the same bad body image and the fact that we use food to self-medicate. It's a codependent nightmare for me here, because all my maternal instincts kick in. It's like being in a room full of my daughters. When they say, "I hate my mother," I take it personally.

My oldest daughter is 32 and she's on her third husband. She's with an abusive man. My middle daughter is a flaming codependent. She's a nurse but has a terrible body image. She has a beautiful body but she constantly says, "Does this make me look fat?" My youngest daughter is a recovering addict. She has no self-esteem. I should never have married my husband again because I set a bad example for my daughters. I regret that.

I want my self-esteem back. I deserve a good life. I'm not a piece of shit. I want to be happy in my own skin. I'm going to be somebody that my daughters are proud of. Better late than never.

BRITTANY

When I look at some of the girls here, I want their body. The one whose body I want the most probably weighs 60 pounds. If I were to go out and play hockey with 18-year-old boys and I looked like that, I would be crushed. Hockey's the greatest thing in my life, and I'd be getting rid of that just to have that small body. What would I gain? But what will I gain without it? It's like ping-pong, back and forth. Good thoughts, bad thoughts.

I'm really nervous about going home because I don't think I'm ready. My insurance runs out, so I really have no choice. If my parents had more money I would probably go into the extended care program that lasts a month and costs around $12,000, and I would have enough time to work on my issues.

In my heart, I know I need to stay. I have my first day that I'm going to be back planned out, and there's no food involved. So I don't think that I'm going to make it out in the real world. Here, I've been eating less than half of what I'm supposed to eat. I get my food at the last minute and then I eat all the healthy stuff like lettuce, maybe the entrée because that's hard to hide, and then the other stuff I put in the garbage. I can't stop restricting food.

I still want to lose 40 pounds to get to my ideal weight. I'll do anything to get to that point. I can't stand looking at myself anymore. My eating-disorder voice is the strongest it's been in so long. It's waiting for the chance to not eat. I want to purge, not because I don't want the food in me, but because I want to purge my feelings. When I purge, it feels like I'm getting something out of me so sick and so horrible that I would do anything for it to be gone. The first time I purged, I jumped up and started screaming, "This is awesome!"

I started self-harm when I was 13 because I got into the Goth scene. I was into wearing all black and doing crazy things. I would cut my arms with safety pins and punch myself in my face or my legs so there would be bruises, just to see a sign of strength. It continued here at Renfrew. I had really long nails and would use them to scratch my arm. Once I was in the art room and I used a carving knife for clay and cut myself. When I see the blood leaving me, I see all that's bottled up inside just released. All the hurt inside just coming out. When I restrict and have that feeling of hunger, it's the happiest time for me. I'm so free-spirited.

RIGHT Brittany stands next to her body tracing in art therapy. She has written words on the drawing to express her feelings about her image.

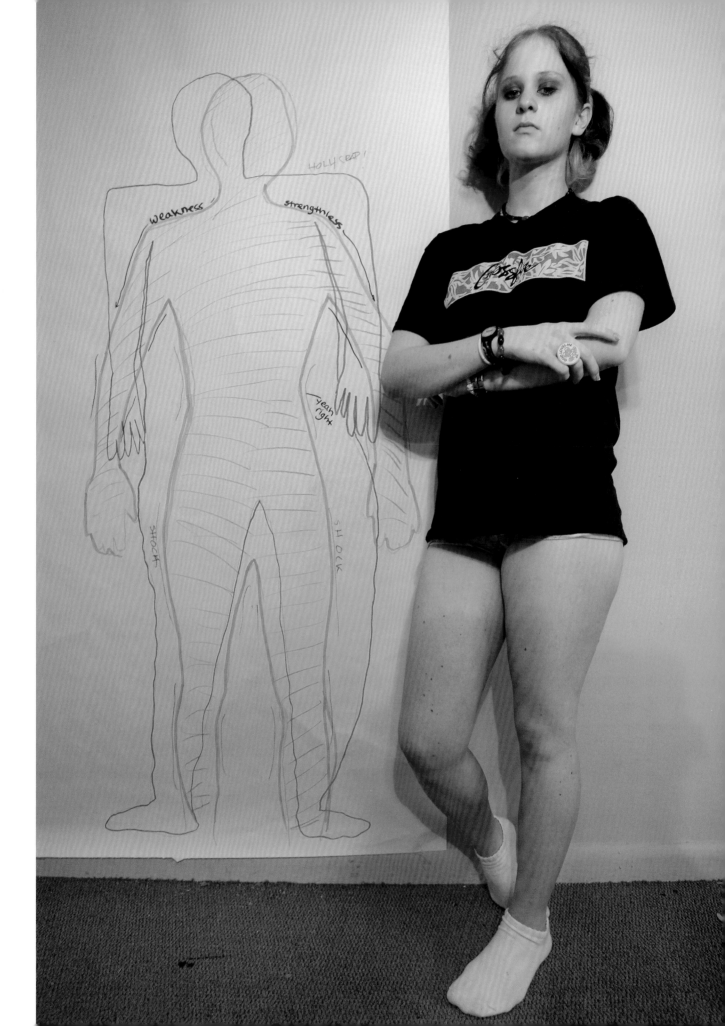

THE Life I Want

NO PRoBlems

Happy

Fun

worry free

Friends

care free

Empowerment

loving

life!

excitment

When I first got to Renfrew, I wasn't eating, I was still purging, I was hiding food. I would exercise at night in my shower, run in place, do sit-ups. My roommate just bit her lip, because I threatened to tell that she was purging. I'm good at hiding things, but the girls here are just like me. They knew about it. When they finally got the courage to tell, I was very thankful. I'm kind of a catch-22. I want to come clean and have integrity, but my evil side wants to say, I faked them out this whole time.

I was doing anything that I could to lose more weight. My mom was doing the same. She wasn't eating. One day she had an epiphany and she got really into her faith and now she's symptom-free. She's eating three square meals a day. That's what got me wanting to get better because I'm so proud of my mom for doing it.

I'm really scared about eating meals with my mom because I don't want to trigger her eating disorder. Part of me cares so much, but the eating-disorder side says, Who cares? Just lose weight—it doesn't matter if anybody else dies with you.

I want this image so bad, this thin, perfect body, and I just can't get it. I can't tell my therapist that I want to lose weight because my eating disorder says, Don't trust her, she just wants to get you in trouble, she wants you to get fat. I told her that I was purging and everyone else found out because she has to tell. I'm going to lie to all the people in my team. I'm going to tell them what they want to hear, and I'm going to act like I'm enjoying my food and am just so chipper, but inside I am just crying and waiting until I can leave. The worst eating disorder I've gone through was the overeating. The me I want is going to look thin and happy. Totally opposite from the me in my old life.

I've got so many thoughts going through my head. How I'm going to restrict at dinner, how I'm going to hide the food, how I'm going to last the rest of the week acting on my symptoms. I'm scared and lonely. Part of me wants to give up my eating disorder. And then a big part, the stronger part, is just waiting for that magic day when I can get out and be sick again. It's got the best of me. I'm losing a battle. I'm like a slave. When I look down the road, I see myself in another hospital. I see myself battling insurance companies again, just to stop myself from dying. I see myself either in treatment or dead.

PREVIOUS SPREAD Three days before leaving Renfrew, Brittany makes a drawing in which she expresses her desire to be thin. RIGHT From Brittany's notebook after she left Renfrew AMA (Against Medical Advice).

Will I become anorexic
Again?

\|\|\|\|\)

~~will~~
~~wont~~
~~wont~~
~~will~~
~~will~~
~~will~~
~~wont~~
~~will~~
~~wont~~
~~wont~~
~~wont~~
~~will~~
~~wont~~
(will) I Will !

Hi, my name is Brittany and I hate my
life! I weigh a lot! And I cant stand getting
picked on any more!!! Please GOD
HELP ME OR STRIKE
ME DOWN NOW!!!

Christina, 17, from Parkland, Florida, eats lunch with her parents during visiting hours.

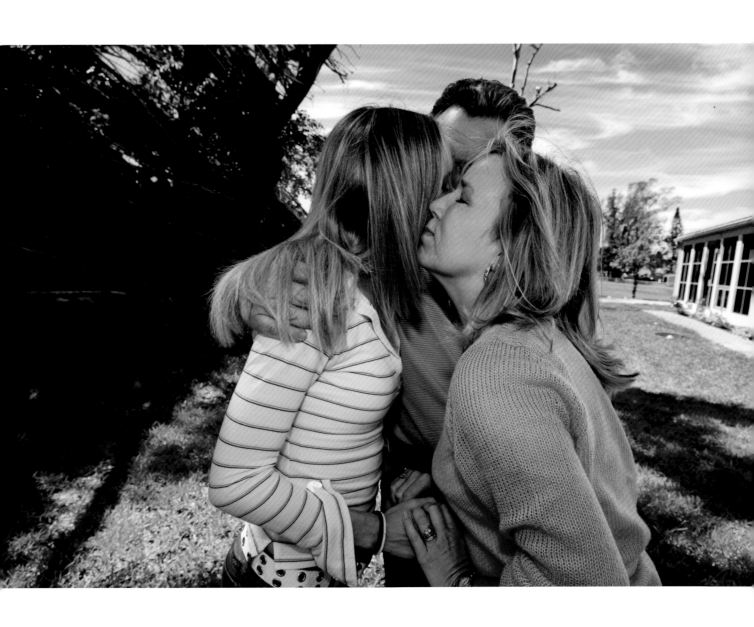

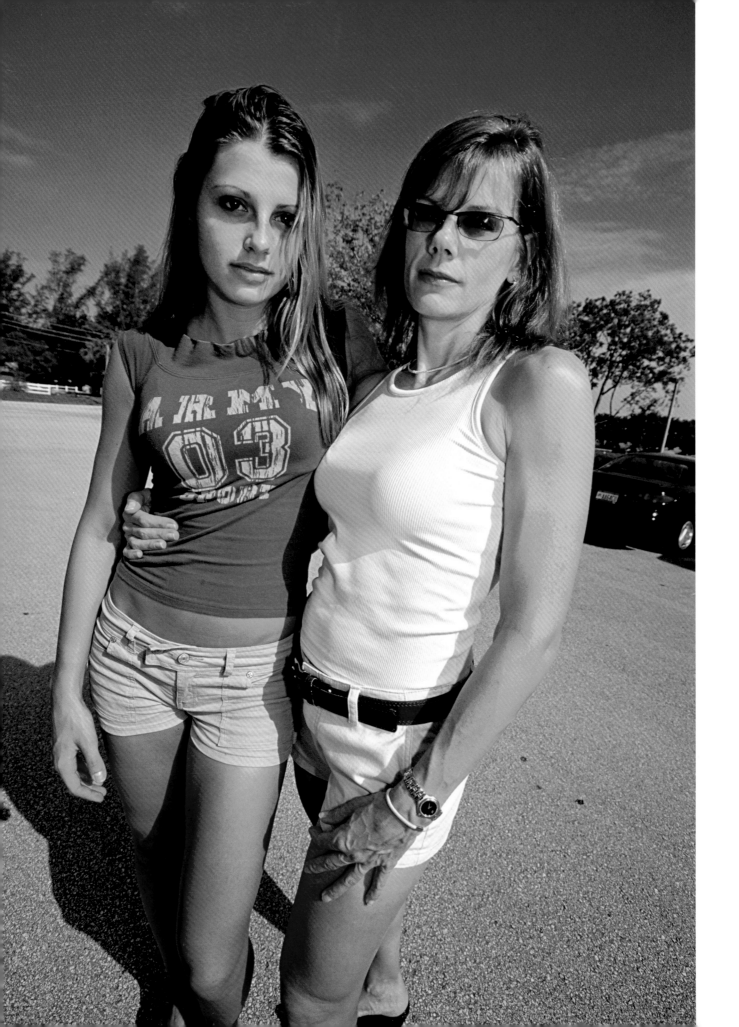

NINA

18, FROM LARGO, FLORIDA

This year I got voted best body for senior class. I was always known for having this kick-ass body, like, "Oh my God, have you seen her? She's so hot!" It made me feel good that I had the ideal body that everyone wanted and hardly anyone has. I felt the only way to have that was to have an eating disorder. Now I realize that I can eat what I want.

In the beginning, there was a community meeting where I was basically bashed. Some of the girls started gossiping about the way I dressed and said it was triggering. I'm sorry I am gifted to have a body where I don't have to work extra hard. When I weighed 118, I always wanted to lose 5 pounds and I always thought I was fat. If six months ago I had woken up in bed this size I would have freaked out. Now I'm 131 pounds and I'm absolutely comfortable.

The biggest thing I've learned here is that I can eat. Before coming here, I was only eating high-fiber breakfast cereal and half a chicken breast with salad. Anything varied would either trigger a binge or I would think I had blown it and go to the gym. Here I didn't do any exercise and I was eating the biggest breakfast I've ever eaten, the biggest lunch I've ever eaten, the biggest dinner I've ever eaten, and I didn't gain a pound. I used to think, "What am I going to do one day when I have a husband and kids and I can't even sit down at the dinner table with them?" Now I can just eat and enjoy it and be a person again.

I haven't purged at all because the only way I'll purge is if I binge, and that wouldn't be an option here. If you come here knowing that you want to get better and you're here because you can't take it anymore, then you're not going to do that. But if you're here because you're being forced, you're going to try to get away with as much as you can. I know girls here like that.

When you have an eating disorder, you think everyone around you who looks good has an eating disorder. I always felt inferior to my stepmother because I felt bigger than her and I'm a kid. I thought that she had an eating disorder and that I would have to live the rest of my life with one to be able to look like that. I wondered how she could have had kids, because I lost my period. They tested my estrogen level and I was at a 9, and I should be in the low 100s. Menopausal is around 40. Once I found that out, I sat there and cried and my mom held me. I was like, "Mom, I want to be normal."

When I came here, I was a little freaked out by how skinny the anorexic girls are. They look like skeletons. They look like they're in a concentration camp and they're saying they're fat. It's harder for them to recover because they're going to gain so much weight. It's so much easier to go through recovery as a bulimic.

I was going to get a boob job the summer before college because I was completely flat-chested. I thought if I could just have boobs, then I would have the most perfect body in the entire world: big boobs, skinny stomach, everything. But what does that get you? I don't need that anymore.

I look in the mirror now and I think I'm pretty. Sometimes I think my face is weird-looking, or I think my stomach looks fat, but it's gotten so much better. I'm not gaunt, I don't have circles under my eyes from malnutrition, and I feel so much healthier now. I see a happier person. I just started getting into modeling, and the one thing that I am afraid of when I go back home is that they're going to say, "You're not thin enough." I don't like that skinny, bony, you're-about-to-die look, when you're not a human being and you can't even reproduce. If they want me to lose weight, I'll just say, "No, I'm not going back. I've been through an eating disorder for the past three years and I'm not going to ruin my life for you, F. U."

LEFT Nina with her mother, Joan, 43, during a family visit.

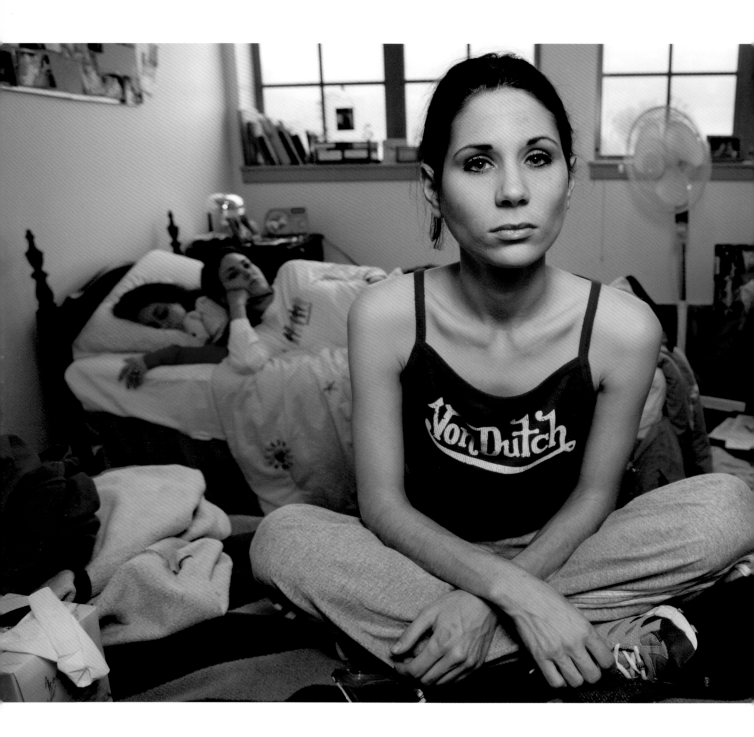

For the past seven years I've spent over $1,300 a month on food, just to throw it all up. Most of my binges lasted for 10 to 11 hours. It was always at night. I would buy ice cream, frozen foods, pizzas, bags of cookies, cake, cheese sticks, breakfast foods, pasta. I always bought two cases of Diet Dr Pepper. I would eat for 45 minutes and then throw up for 45 minutes, eat for 45 minutes and go throw up. But it was never enough. I had to keep eating. I've done it for 24 hours nonstop.

I feel like I shouldn't even have this disorder. There are people here who have been sexually abused and come from parents who are just horrible. I had a wonderful childhood. I never went without anything. I grew up as an overweight child and was teased, that's about it. I stopped eating when I was in ninth grade. Once I lost weight, I became popular.

My mom gave me a gym membership to Spa Lady. A personal trainer asked me if I wanted to do a fitness competition and I said yes. He had me on a strict diet of boiled chicken, vegetables, no carbs. One day I just binged and said, "I don't know what to do," so he told me to throw up. I've been bulimic ever since.

I got a scholarship in college and majored in industrial engineering. I did promotional modeling as a side job. I felt really good. I was at my lowest weight and people thought I was pretty. I learned that being thin, people want to be your friend. Being overweight doesn't get you any friends, doesn't get you a job, doesn't get you a boyfriend.

I had one six-year relationship. My boyfriend knew about my eating disorder. He was with me through two other treatment centers. I saw him cry over me continuously. One time I had binged so much and I couldn't purge, so I made him drive around with me to all these different drugstores to find ipecac, a drug that induces vomiting. And once I took it, I was very sick. I drank the whole bottle and was dry-heaving and didn't throw up. I can remember feeling like I was going

to die. He called Poison Control and stayed up with me the whole night. He kept saying, "Just breathe, just breathe."

I went from having an amazing sex life to not being affectionate at all. I was so uncomfortable with my body that if he would come on to me, I would want the lights off or I'd want to wear a shirt. And then I didn't want to be touched at all. I felt disgusting. We've been broken up for a year and a half. I haven't had sex with anybody since him. I've had no sexual desires at all, not even to please myself. It was like my eating disorder was my boyfriend.

After my first week at Renfrew I walked out, left all my stuff and took my credit card. I walked to Publix, bought about $80 worth of food, sat in a construction site, and binged and purged for 7 hours. At two in the morning, I called my parents and asked them to come pick me up because I had walked out of Renfrew. I came back, and I've been here for three months.

I'm going to work my ass off to stay in recovery. But there's this little voice that's getting louder and louder as the hours go by, screaming at me, "As soon as you get out of here you can binge! Just keep doing what they tell you to do so you can get out of here!" And then there's another part of me that's like, "I'm never going back there." It was hell. I was almost prosecuted for writing bad checks. I was in credit card debt. I've stolen food. I've eaten out of garbage cans. I've taken food and sprayed Windex on it so I wouldn't eat it and then ate it anyway. I know this will kill me.

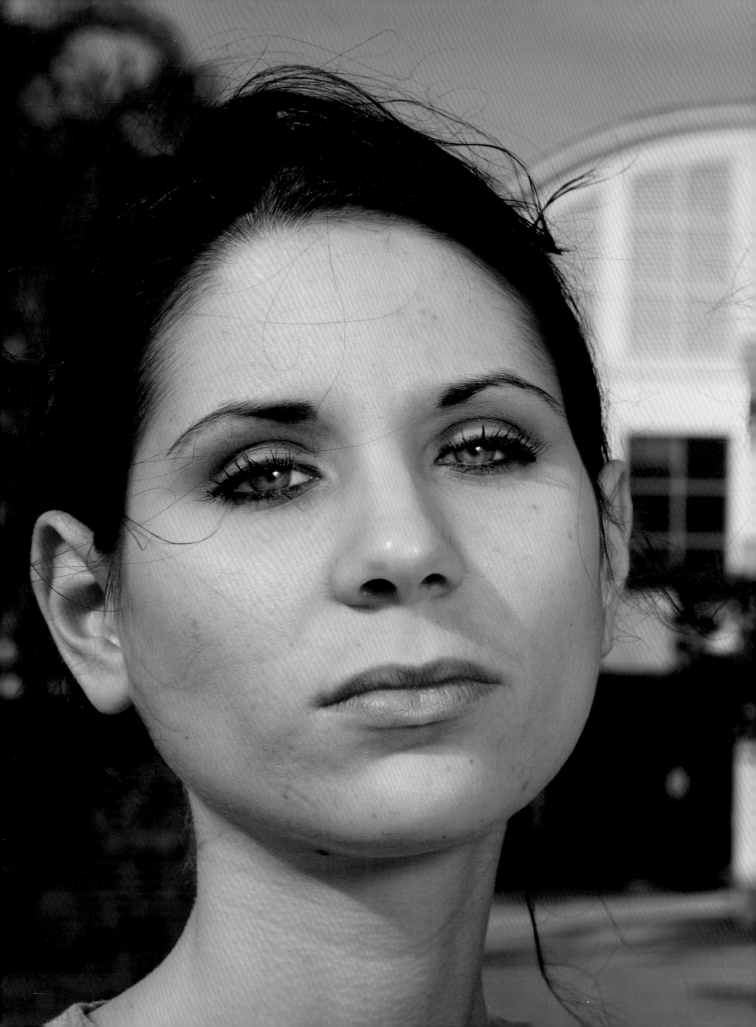

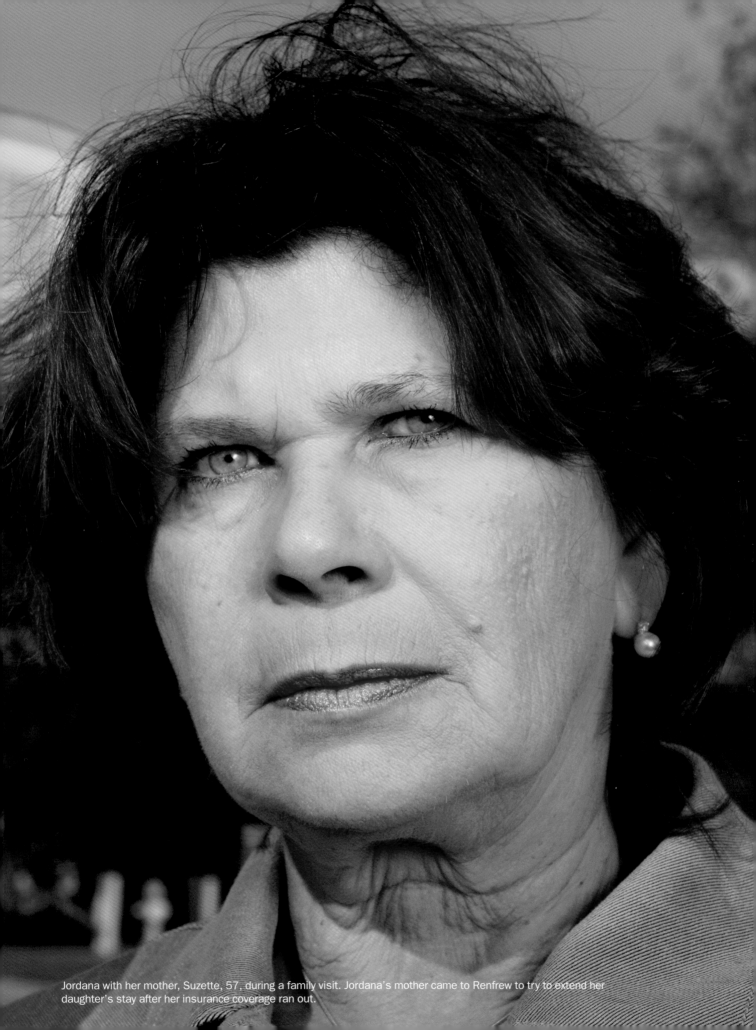

Jordana with her mother, Suzette, 57, during a family visit. Jordana's mother came to Renfrew to try to extend her daughter's stay after her insurance coverage ran out.

ALISA

I was at Renfrew a little over two months. Am I better? Am I recovered? No. But I've come a long way. When I first got to Renfrew, I said that I wouldn't resort to purging, but it became so overwhelming that I did. I had been putting on a little weight, which I felt really insecure about. Then one day I had to eat a snack, and I could not handle that. I purged in the shower. I disassembled the whole drain and hated every second of it. I thought about checking out, but instead I told Adam, my therapist, the next day. I said, "Help me. Come hell or high water, let's do whatever it takes."

There was a lot of guilt associated with spending this time away from my children. I always thought I was doing the right thing. I invested so much time into making sure that I raised them right and that they were proper and polite and that everything looked good. Upon my return, I really noticed that I hadn't been as nurturing as I should have been. I love my children with everything I have. But I guess I have to make a decision as to whether I want my children to be able to look back and say, "My mom worked really hard and she was able to buy me everything that I wanted," or whether I want them to say, "My mother spent quality time with me and was nurturing." I realized I hadn't enjoyed motherhood.

That's when the breakdown occurred. All of a sudden, I couldn't get out of bed. I couldn't imagine life without the eating disorder, but I was overwhelmed by the thought of living with it forever. I just cried and said, "Take the eating disorder, take everything, please." In that moment, I truly didn't want to live any-more. And the worst part about it was, I didn't have that option because I have two children. I was stuck. I cried, and the more I let it out, the more I felt, and the worse I felt. But I feel that because I was broken, I am one step closer to being recovered.

At first, I didn't tell my children that I went to treatment. I thought I could protect them. But then I had to tell my son. There was a reason why he was moving in with other family members and switching schools. He's 10 years old. I said, "Remember how Mommy was in the hospital quite a bit before? How we talked about how Mommy was under a lot of stress from work and wasn't eating right so kept getting sick? Remember how I was always on diets?" And he said, "You mean like the low-sodium diet? You said we couldn't go out for Chinese food because it was too high in sodium. And the low-carb diet. We couldn't go out for Italian food because there were too many carbs."

RIGHT, ABOVE Alisa had to take disability leave from her job as a successful pharmaceutical representative to enter treatment.
RIGHT, BELOW An excerpt from Alisa's journal.

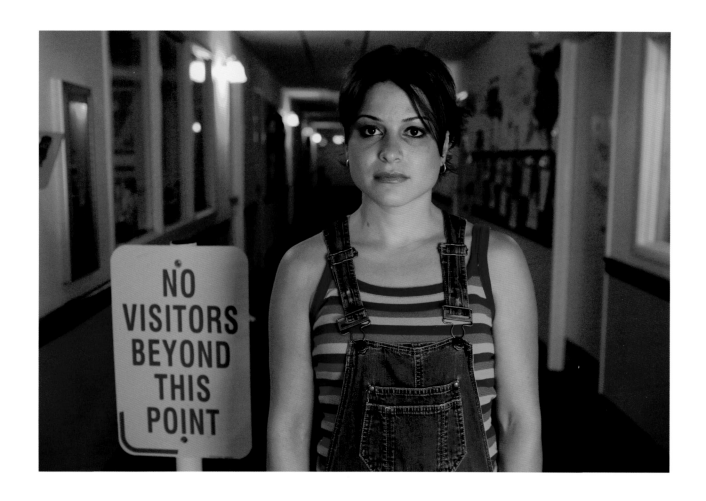

Today is my daughters birthday
and I am not with her
because I chose the eating
disorder over a life of truth.
The greatest gift I could give
my daughter is a mother a
"real" mother.

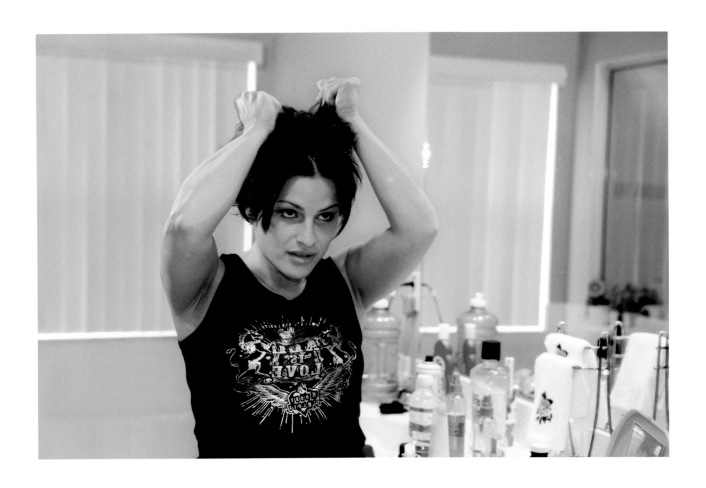

My daughter is screaming! I'm
waiting for a locksmith.
It's probably time for dinner,
but I can't eat yet. It just
wouldn't work logistically. If I
had willpower, I just wouldn't
eat. No. that's unacceptable.
I "HAVE TO" eat. Right? I can't
live without food. Right? WRONG!

That hit me so hard. I told him, "Well, sometimes when people undergo stress, they don't take care of themselves and they start dieting, and it gets out of control. I'm here now and they are going to help me get better, not only eat better, but be a better mom and a better employee and a better person."

I'm really embarrassed to say that I used my children to enable my eating disorder. When my son was a baby, I would say after dinner, "I have to give him a bath." That was so I could go upstairs and purge. And nobody would know. I remember the first time my son walked in on me and asked what was wrong. That night he had made a cake and begged me to have a piece. He said, "Please, Mommy, have some cake." I didn't want to eat the cake but I did for him. And right after that my son complained that he had a stomachache; he said, "Maybe the cake wasn't very good." A little later, he walked in on me purging. And I said, "It must have been the cake." I wound up in the hospital. My family told me afterward that my son felt so bad and guilty that I was in the hospital because he was afraid it was the cake he had made. Those are the things that made me want to die, that made me think maybe my children were better off without me.

I've made some pretty impulsive and drastic commitments in my life to support the disorder. Joining the air force played a part in that. It's not the typical route that most nice Jewish girls from South Florida took, but I thought the rigorous lifestyle would keep me thin. I was so determined to be thin that I thought, It doesn't matter that there's a war going on.

Therapy's been very effective for me. My therapist, Adam, has been wonderful. He almost single-handedly changed my life. In the beginning, I wanted him to see me as strong and intelligent and articulate. I allowed him in a little more and I let my guard down, and then one day I cried. Ending that relationship with Adam, I have to start over. It's going to be difficult, because with him I finally felt comfortable enough to express feelings. I hope that when I start with another therapist, I don't waste another three months playing chess.

It's interesting how my relationship with my roommate, Shelly, evolved. Neither of us thought that we would ever seek comfort or support in each other. I wouldn't necessarily say it was jealousy, but it was almost as if I had met my match as far as the eating disorder goes. We've really grown and bonded in so many ways. I don't think I've ever been this honest with another girlfriend. I would like to remain friends with her. If she's triggering, I'm going to have to be honest and step away. And if I feel that I'm relapsing, I have to be able to tell her because it's only fair. Our relationship is both therapeutic and triggering. It's funny how competition is such a huge part of the eating disorder. It hurts every time another person comes into Renfrew and is thinner or more disciplined than you. My biggest challenge is to accept who I am and live in the moment. I spent 24 hours of every day trying to control or manipulate what was going to happen tomorrow. I never reacted to today. I want so badly to savor every moment.

LEFT, ABOVE Alisa gets ready to go out, Lake Worth, Florida. LEFT, BELOW Alisa's journal entry, written after discharge, when she is back home with her children.

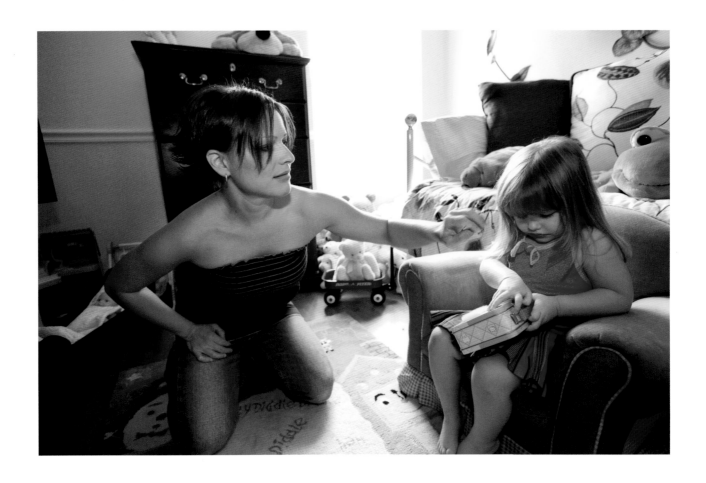

A mommy is not
"you look pretty" or you are
"so cute" but rather "what you
say matters" and "you are
beautiful, not just on the
outside, but also on the inside,
where it really counts."

I am scared to death. Those who leave treatment unafraid and fearless are kidding themselves. But I'm hopeful, and two and a half months ago I was hopeless. I'm most scared that I will get so wrapped up in daily life that the body image will be an overwhelming force that I won't be able to counter. I'm going to have an outpatient team that I'll see on a consistent basis, and I hope I'll be able to acknowledge that even if I changed the way I look, I wouldn't be any happier.

They kept telling me it's not about the food. It's not about the weight. It's really about the feelings. And I remember going into therapy and telling them over and over again, "No, it's about the weight." When I look in the mirror, I still dislike what I see. But there's hope. My hope used to be that I'd get thinner, that I could take off 10 pounds. But now when I look in the mirror, my hope is that tomorrow I'll see the real me.

I think the only way to recover is to be broken. It's either death or be reborn. You can't live with it partially or do this halfway. It's like having to learn to think all over again. But you have to truly want it. When I got here, I didn't want it. I had gone through college. I had been in the air force. I was a mother. I had achieved all of these things but I never wanted anything more than being thin. If I wound up uneducated and on the streets, it was fine as long as I was thin. The day you find something that you want even more than to be thin is the day you're capable of recovery. I really want recovery now because for the first time, there's something I truly want. I want to be happy even more than I want to be thin.

LEFT, ABOVE Alisa with her 3-year-old daughter in their home. Alisa is often late taking her daughter to school because she tries on so many different outfits in the morning. LEFT, BELOW Alisa writes about being a mother. She is concerned about passing on her eating disorder to her daughter.

The vanity in Alisa's bathroom.

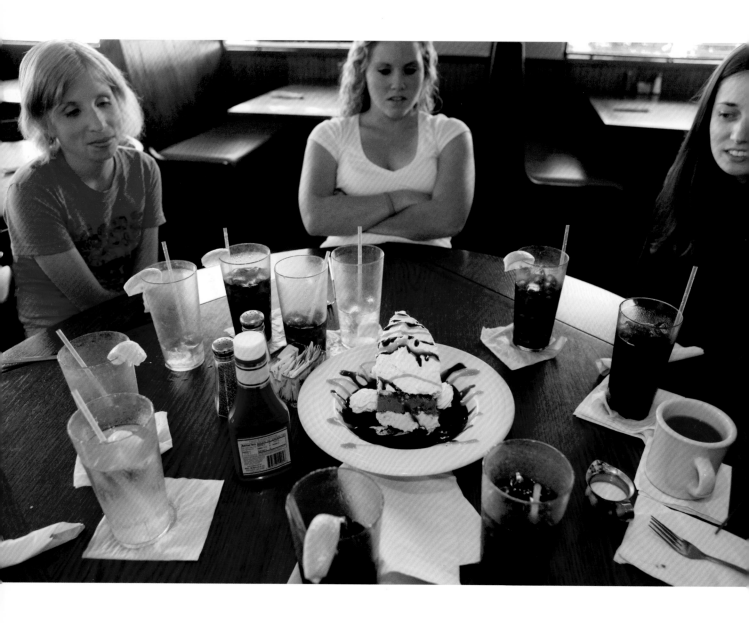

Melissa, 23, Logan, 16, and Mary, 24, eat lunch at a nearby restaurant as part of a therapeutic excursion designed to help them overcome their fear of eating in public, Coconut Creek, Florida.

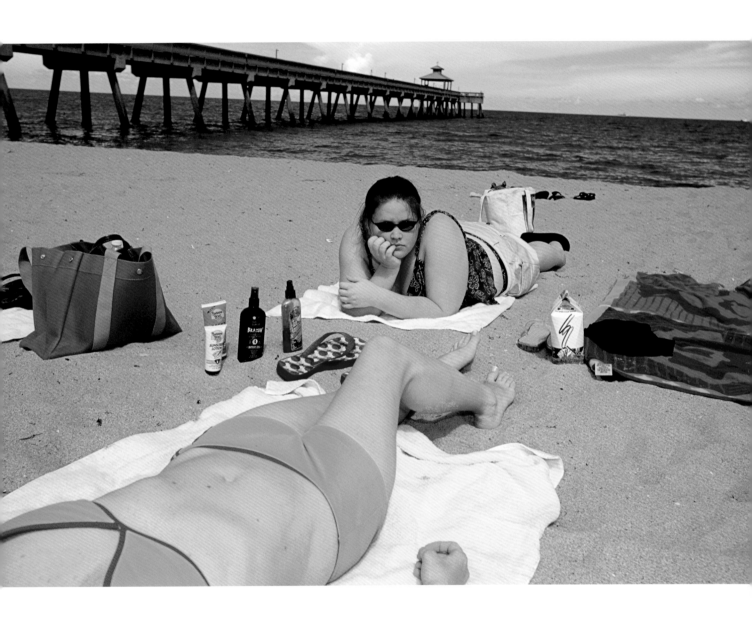

Amy, 20, stares at a Renfrew therapist during a beach excursion on which the women are encouraged to wear a bathing suit and eat a snack in public, Deerfield Beach, Florida.

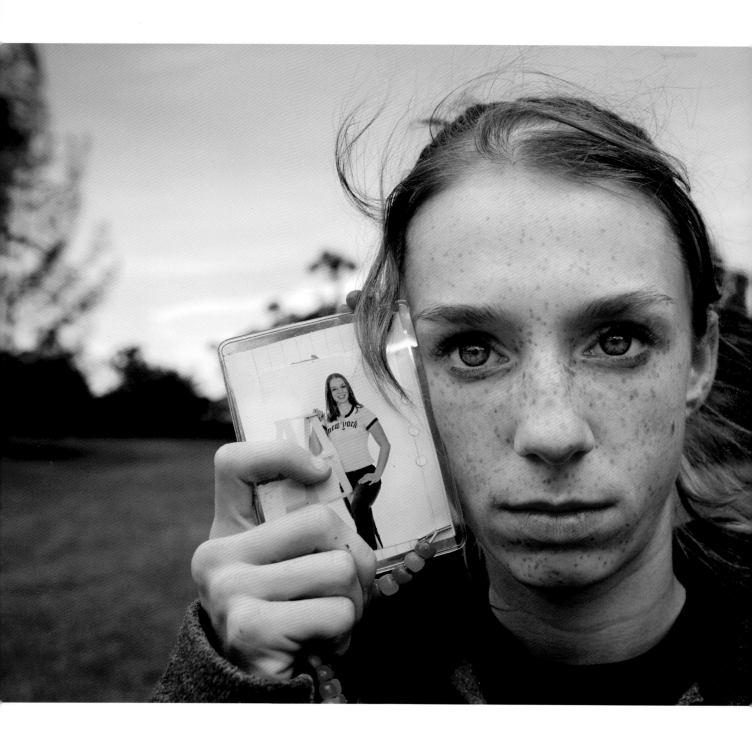

When I was at Renfrew, I carried around a picture of what I looked like before. It's my senior picture. In high school, I was the happiest person. I loved life; I lived it to the fullest. I remember sitting with my gymnastics coaches and my friends and my family, just laughing for hours about absolutely nothing. I haven't done that in a while, and I miss that. My bulimia started when I was 19 years old. I'd just quit gymnastics and it was the end of high school, so everything that I loved came to an end and I didn't have any direction in my life.

It's hard to see what I was then and what I am now. In that picture, I was still involved in track and gymnastics and I was a lot heavier than I am now. I was solid muscle, and right now I have no muscle left on my body. My eating disorder has taken away not only my physical appearance, it's taken away the things I enjoyed like my athletics, running in the woods, going on hikes. Stuff I can't do now. It's taken away my happiness.

In the picture, I see a healthy, happy person who could do anything she wanted. When I look in the mirror now, I'm not happy with the way I look. I'm way too thin. I know I might not be the exact same person I was in the picture, but I want back a glimpse of it. I want to be that person so bad.

People try to understand, but they really can't. Sometimes people say, "Well, why don't you just eat?" They don't understand that it's a struggle. Why would we want to do this every day of our lives? We're ruining our bodies, our insides, our heart, our teeth, our hair. If I could stop today, I would.

I have lost a lot of girlfriends. I can't go out and enjoy myself because I'm always worrying whether people are looking at me weirdly, and I'm always looking at girls thinking, Oh, I wish I looked like that. There's a guy I'm talking to now and he says things that he's not supposed to. It's hard to put anybody in that situation where they have to watch every word they say. My mom

has her days where she is understanding. She goes to therapy with me and is a great support. The more she understands the disorder, the more she can help. At the same time, she sees her daughter dying in front of her eyes, so it's hard for her to control her feelings about the disorder. It's hard to watch me on bad days. My brothers are more scared than anything, and I miss the relationship I had with them. My dad doesn't understand. It's like we don't have a relationship. All we do is argue. He says things like, "Why don't you just eat?" He thinks it's a help, but it isn't. He thinks I can just be normal one day.

I left Renfrew because my insurance was cut off and I could not afford to pay out of pocket. What's so sad about eating disorders is that it's so hard to find help, and when you do it's so outrageously expensive. A lot of insurances don't cover it because they don't think it's that big a deal. There needs to be more therapy options. And we need to find a way for people to get money to go inpatient so they won't end up losing their lives over it.

I believe my eating disorder is going to be with me for the rest of my life. But I've seen people get over the disorder and that's what I hope for myself. I use it as an inspiration every day.

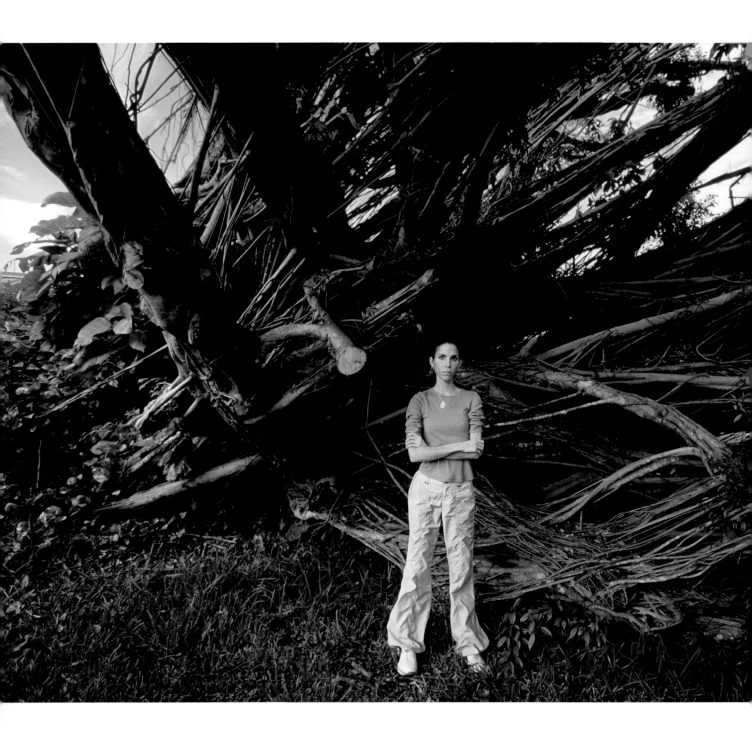

The best anorexic is the one who's six feet under. I don't think I'm good at anything, but I know that I'm a good anorexic. This time I came in at 70 pounds. They said I didn't have more than a week. I was dead. My red T-cells and my white T-cells were all elevated. My liver was elevated. My potassium was extremely elevated. I had eczema. I had protection hair all over my body. I had no hair left on my head. I could barely walk. I couldn't sleep, but I couldn't stay awake.

When I was a teenager, I was a gymnast training for nationals. I started to see other girls cut down on what they ate and I tried it out and found that the less I ate, the more energy I had. The summer I turned 16, I lost 30 pounds in two months. Six months later, my stepfather, who had raised me, was killed in a car accident.

At NYU, I was in a very competitive acting world. I'm an actress, dancer, and painter. I graduated with a 3.9 and was sick as a dog the whole time. I didn't eat, I was depressed, but I was in complete denial. The day I first checked into Renfrew, I surrendered to the disease. From 2001 to now, I've been in seven times. I feel really stupid that it took me so long, but it's the path I had in life. I went into treatment and my life changed. I was talking to people, I was getting dressed in the morning. When I got out, it was like I had forgotten about the treatment. I started restricting. When you leave treatment and things go wrong again, you want to get back into that numb state. Once you lose half a pound, you're done. The more you lose, the more numb you feel, and the more in control you feel.

I had rules for everything. At 10:40, I would have a Diet Peach Snapple. Then, at 2:13, I would have a teaspoon and a half of Light and Fit vanilla yogurt. At 5:13, I'd have a glass of wine. And then at 6:17, I would have some lettuce. That was my diet. If I missed those times, everything was screwed, and I didn't eat till the next day. So if there was traffic or my subway was late and I got home at 6:19, my dinner was shot. I was starving out of my mind, going to bed at night, listening to the clock click and click and

click until the morning, so I could get up and at least have water.

I would watch the Food Network and eat through my eyes. When I would have a really bad day, I would eat three gummy bears. And those nights, I'd be so hungry that I would almost cry. It was hunger for love, for someone to talk to me, but my actual hunger for food was excruciating. I would sit in a ball and hold my stomach at nighttime, staring up at the ceiling, hoping this wasn't the last time my heart was going to pump. I wouldn't even go to sleep sometimes because I was so scared I would never wake up.

When I was in the refeeding process and I was so full, I would take a safety pin and cut myself. I felt guilty for eating so I had to feel physical pain to take that pain away. That's why therapy sessions right now are very hard. The more I eat, the more I feel.

Anorexia is your best friend and your worst nightmare. It's a person who lives inside of you. It was a distraction. I didn't have to deal with anything in the world. I wasn't responsible, I didn't have to do any errands. No one came to me for anything because I was sick. It was never about losing weight. I've always had a pretty great body. My anorexia was numbing out what I couldn't deal with.

Eating disorder is total addiction. It's absolutely uncontrollable. I'd say it's even more addicting than drugs, because it's so impossible to get out of. There's no pill you can take, no Librium, no insulin. Your heart, your mind, and your strength and will and courage are the medicines.

The first step, walking through these doors, is doing 100 percent your first day. I honestly think where there's a will, there's a way. You have to be ready and you have to have integrity. Some people are like slippery snails around here. Put butter on your knife and slide it under the table, under your seat, into your socks. I know a girl here who belted a rock to her waist and put a candle in her underwear so she could weigh more. One girl drank

five gallons of water before she got on the scale. I don't know how she didn't pop.

It's sad because every time I've been in treatment, I've been the only minority. I'm half Puerto Rican, and in my culture this is an alien disease. My grandmother doesn't even remotely understand how I don't eat. A fuller woman is more appreciated in my culture. I think anorexia mainly targets white women because of the media. I don't know if it is a class thing but minorities tend to be poor. My insurance is not taken here. My family has spent over $100,000 on treatment and is in debt. They put a second mortgage on our house. I used the inheritance from my dad who died. That money was supposed to be for my wedding.

The reason I've come back here is the sense of camaraderie and family. I think for healing, that's really crucial, especially when all of us have been alone for so long. To know that someone else out there is struggling with what you're struggling with is just mind-blowing. It makes me feel less like an alien. But it can get pretty catty. We all retreat to being in middle school when we don't like someone. But when the support here is good, it's better than family support, because you're getting it from someone who's going through exactly what you go through.

About three weeks ago, this was the best community that I've ever witnessed. Wherever you looked and turned, there was someone with open arms. Then two people got Baker Acted and one person acted on her symptoms by stealing food and then bingeing and purging in all of our bathrooms, and the community went to hell. The Baker Act is a Florida state law where, when you're a danger to yourself and you're no longer capable of

making decisions for yourself, the state takes you away. They have to handcuff you out of here. Two girls had pretty brutally slashed their arms and there were police and firemen and ambulances. Watching it was terrifying. Last time I was here, a girl tried to commit suicide by drinking bleach and banging her head on the counter.

Women struggle with this disease because our body is our tool. It's our instrument. That's what we're good for. For sex, for homemaking, for cleaning. All you have is your body. The eating disorder allowed me to speak my voice without speaking my voice. It did justice for me when I couldn't speak. It was a mask. It's a shield, a cape that you wrap around you. In a weird way, I think that it protected me all these years. I don't know if I would have survived without it. I was able to not deal with what I couldn't deal with for so long—feelings I had toward what I experienced growing up. My dad would rage and go crazy. My mom silenced herself. We were left alone a lot. I remember being scared. The eating disorder was a way to calm that down and sing that to sleep and soothe it.

Being in treatment allowed me to get my voice back. It gets louder and louder and more distinct. I lose hope a lot and part of me thinks I will never get over my sadness and my deep fear of living, but my goal right now is giving babies to the world. I'm terrified that I've already become infertile from the anorexia. I know that if I get better, I have a chance at it. Whenever I'm at a meal, I do this mental imagery about me being pregnant: what the weather's like outside, what I'm wearing, the scent in the air, what my apartment looks like, and me with a belly. I have had such a prison

cell and demon living in there that I just want to wake up every morning and have my mind not be tormented.

I went to the beach and swam in a bathing suit for the first time in seven years. It was weird. It took me awhile to take off my clothes. My heart was beating. My palms were sweating. It was almost like jumping off a cliff, being really scared, and once I did it, it was so freeing. At some point in your life, no matter what your struggle is, you have to just not think.

RIGHT Ata has been in treatment at Renfrew seven times. During her prior stays, she fled when her weight reached 95 pounds.

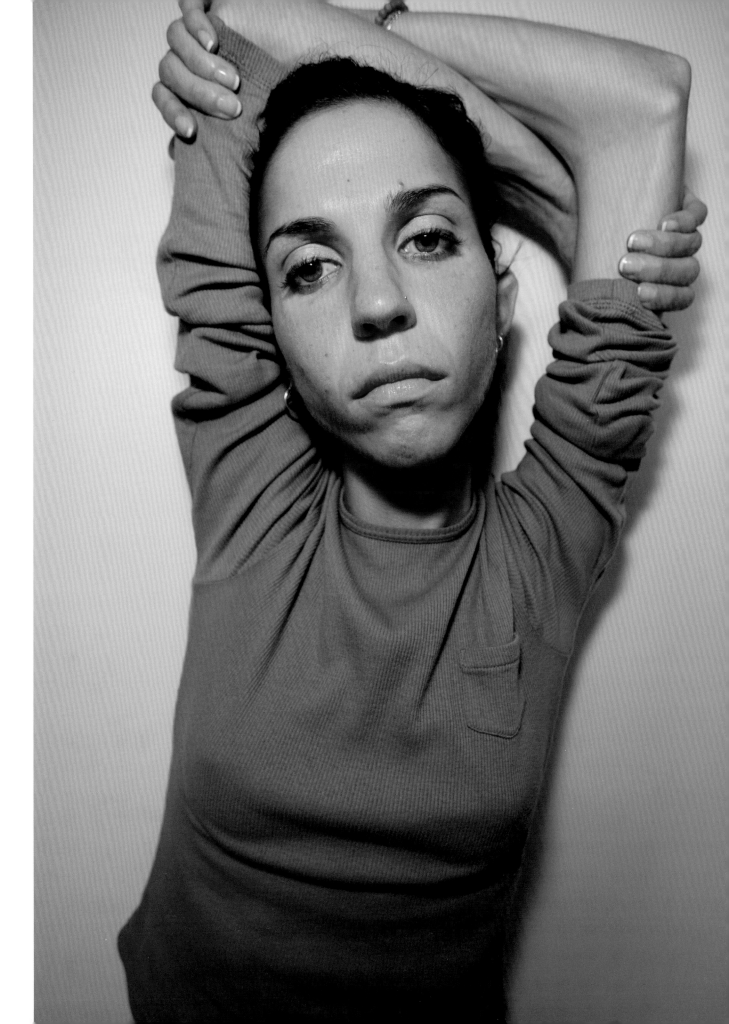

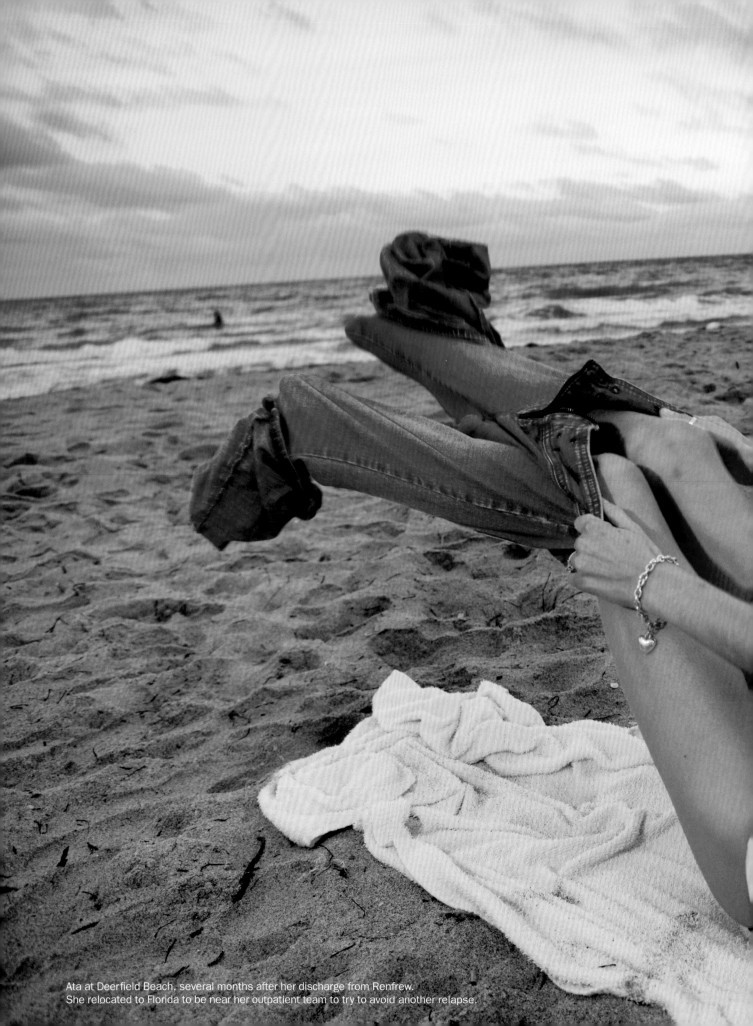

Ata at Deerfield Beach, several months after her discharge from Renfrew.
She relocated to Florida to be near her outpatient team to try to avoid another relapse.

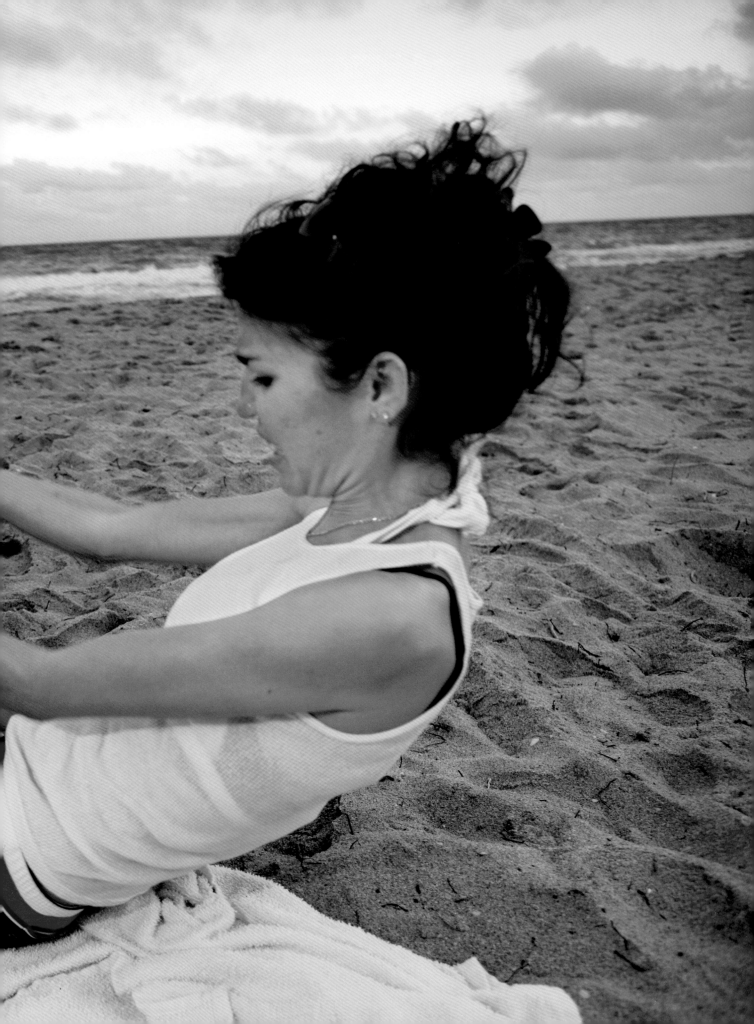

SHELLY

Tonight is going to be the first night that I've spent by myself. I'm really anxious, but excited at the same time. I made a little coffin with flowers on it for my PEG tube. I made it out of clay and painted it black and glued some flowers on there and then stuck my tube in it and shut it closed. I'm taking my tube with me as a little reminder that I don't want to go back to where I was.

I never want to go back to that life again. I don't want to be in another treatment center somewhere in a year. I see myself maintaining recovery for as long as I live. I want to go to grad school, I want to work, I want to have a family. I want everything. I have so many things I want in life, and I can't do them with an eating disorder.

I still want to restrict a lot but I know that I can't to be healthy. The thoughts are definitely there, but it's much more quiet. I've learned to connect what I do with my food to my feelings. If I'm eating and I start feeling like I want to restrict, I try to ask myself what it is that I'm feeling. Am I anxious about something? Am I nervous? Am I angry? Am I happy? I did want to be thin. But it gets to a point where it's beyond that, it's just feelings.

I want to be happier, to live a more balanced life. I want to hang out with friends, I want to have meaningful relationships with my family. I want to fix relationships with people whom I've hurt. Me and Kelly have been keeping in touch better with each other since I've been here. Maybe she's starting to believe that I can do it and that I'm not going to fall back to my old ways like I have before. Plus, I'm so much healthier physically and mentally that I can actually carry on a conversation. I want us to have the relationship that we had, where we could hang out with each other without being scared that we were going to offend each other.

It was hard gaining over 20 pounds, but I've gotten used to it. Whenever I look in the mirror, I see Kelly. I feel like I'm chubby and I look a lot more like her. We're kind of the same weight now, so everybody says we look exactly alike. At first I thought I was giving up control and letting people win, but now I know that I have to be at this weight to feel better, to be physically active, to hang out with friends, to snowboard, to do anything.

RIGHT, ABOVE Shelly holds up a coffin she made in art therapy as a memorial to her now-removed PEG feeding tube. She says she misses "Peg." RIGHT, BELOW Shelly writes about her progress in treatment.

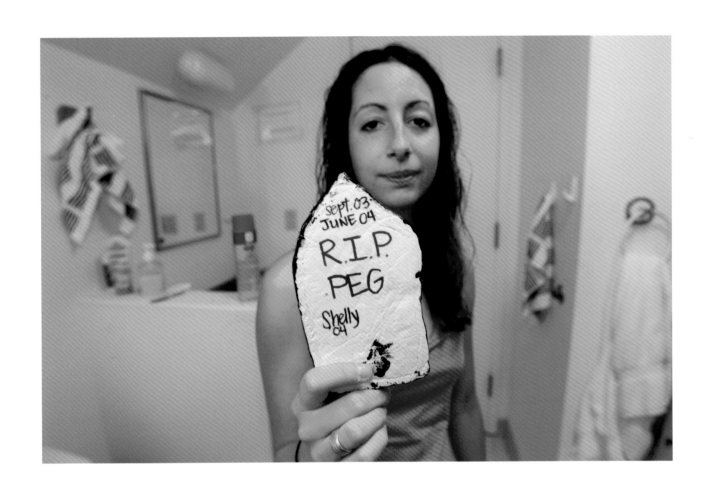

Well Hell, Still having some really crappy body image, but I am at the weight I am supposed to be at. So today we had rounds and Adam told me how proud he was of me and how the team thinks I've made some miraculous 360° turnaround. I really dont like the praise, but it is pretty cool.

I'm going to learn how to surf. I kind of taught myself because I like to snowboard so much, and I needed another hobby to do down here. When I was surfing, I was concentrating and just enjoying myself so much that I was actually living in the moment like everybody tells me to do. There's that whole swimsuit issue, but I don't really care. I'm just out there and I feel healthy and my body's capable of doing things now. If I'm going to be paddling out into the water and trying to stand up, I'm going to have to eat and I'm going to have to be healthy and my body's going to have to weigh more.

I've finally accepted the fact that I have bipolar disease. I am willing to stay on the Depakote because it has mellowed me out. I am having a lot of anxiety, but I know I can't just automatically take a med for that. I need to deal with it. I would really like to have Klonopin. I'm not going to lie. God, I want Klonopin. It was hard to come off of it, and I'm so glad that I did, but at times I would really like to have just one pill. But I know if I start taking one, then I'm going to take two. And then I'm going to need that more often. So I fight it.

Yesterday was my last therapy session with Adam. It was really hard to say bye to him. He's the first therapist whom I've actually told everything to and really trusted. I used to refuse to even think that what happened to me sexually had anything to do with my eating disorder. And then over the past few weeks I decided to talk more about it with him and I've come to realize that it has a lot to do with why I have an eating disorder, why I feel so scared of life, and why I feel so stuck. I don't like when guys look at me, so I always try to be little and fragile like a kid. Textbook answer. I always used to pretend, Oh, I have this eating disorder because I want to be thin and I don't know how to deal with all my feelings. But the reason I have such intense feelings is because of what happened. I'm glad that I made the connection. It's something concrete to work on to help me get rid of it.

I'm going to miss Adam. Me and Alisa joked about being in love with Adam and one of us taking him while the other one had to stand by and watch. Sometimes it was hard, though, because we would compare. I think deep down we were both wondering which one he liked more. She said his eyes welled up when she left. And I was like, I'm going to tell her I saw a tear. I was looking for his eyes to well up and I don't think they did. Dang it!

Alisa started to struggle with purging and restricting about three days after she left. It made me feel really helpless, but at the same time I was like, I don't want to be like that. I can see why she took a few steps back. I would be stressed if I were her with kids and moving and finding a job. But I got really scared because she had been here for almost the length of time I had. It made me really nervous to see her fall back so fast and so severely.

We went out to dinner and she wouldn't stop talking about it. She told me she was purging six times a day and that she was cutting out fats. She told me what she would eat and how she would do it. She got pretty specific. It scared me. I was assertive enough to say, "I don't want to talk about this," so I think I'm at the point where I can say no.

I don't really like it when everyone I know has an eating disorder. A lot of times the talk goes to food and weight and calories and did I eat too much, did I eat too little. I do miss my friends who don't have eating disorders. But it's what I know right now and who I have right now. Hopefully, I'll make more friends. When Polly was here, I didn't focus so much on myself and what I was doing here. I was more wrapped up in making friends and being wild and crazy. Polly and I have a lot in common; we had fun together. But being in a treatment setting, I don't think it was the best thing for us because we both like to break rules and we don't like authority. After she left, I started hanging out by myself more, being alone, writing, journaling. I became more concerned with who I was.

People have told me that I've changed a lot. I've become a lot more confident and I've learned to trust myself a little more. I have done so much work, I don't want to mess up. I didn't waste four months of my life to just go back to restricting or purging. On this treatment, I'd say my family spent $100,000 or more. With prior treatments and hospitalizations, they probably spent close to $600,000 or $700,000.

I have learned that I use my eating disorder to make people take care of me because I get scared of responsibility. I get scared of living life. I feel like I don't know how to do it because I've been taken care of my whole life. And I don't trust myself. I have a lot of self-hatred. Now I've learned ways to be independent, to have responsibility, to trust people more. To not put myself down so much—well, at least to be aware of it when I do. I have learned a lot.

8/2/04 → 104.8 lbs "The most I've ever weighed in my life"
8/4/04 → 103.6 lbs — Thank god :) The Bitch is going down

ABOVE Shelly's nutritionist wanted her to weigh at least 103 pounds, but Shelly was afraid to go above 100. The ideal body weight for her height is 115.

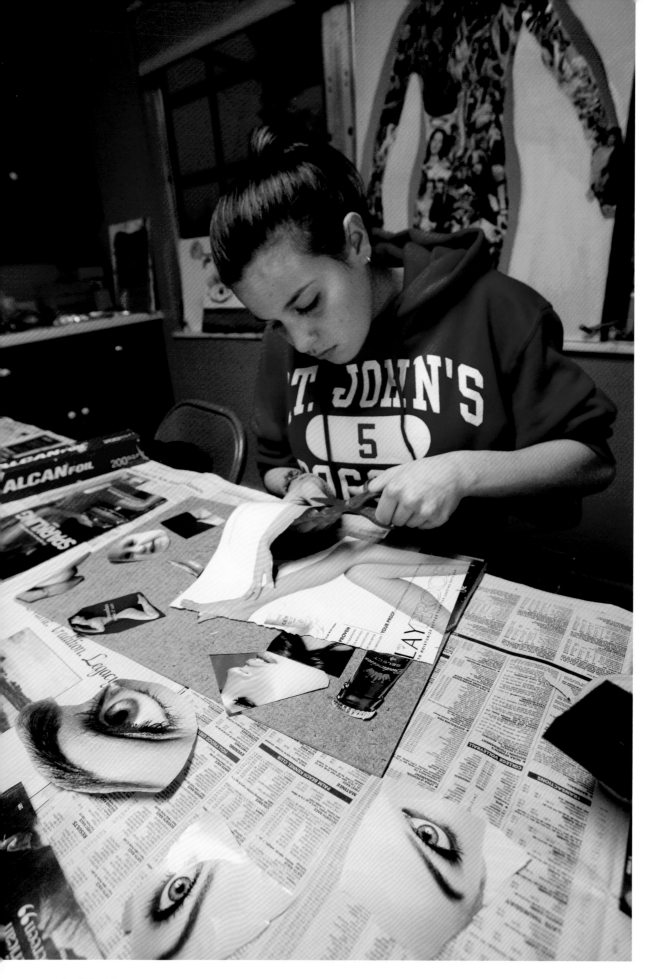

Patricia, 16, makes a collage. Patients use magazine images in art therapy to process their feelings about themselves, society, and their families. They often cut out body parts to express a sense of fragmentation.

Melissa has progressed dramatically while in treatment. She is now allowed to leave Renfrew for outings and is learning how to drive and budget an allowance.

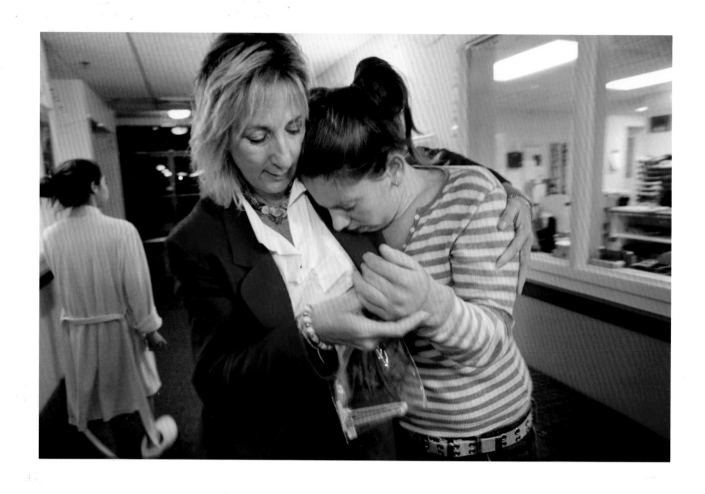

Catherine, 24, breaks down after checking out her razor to shave her legs and underarms for the first time in weeks. Though most residents can get their "sharps" each evening, Catherine's use is restricted because she is a recovering cutter. Nurse Wendy will supervise her shaving.

DR. MICHAEL STROBER

The Path from Illness to Recovery

The biomedical sciences have made remarkable strides in the past two decades in understanding the origins of mental illness and in developing more effective and safer therapies for alleviating the suffering it brings. Understanding of eating disorders has grown impressively during this period of research, but it remains incomplete; sadly, it cannot be said at this moment that the effects of our therapies are robust or dramatic.

Like other disturbances that simultaneously affect mind and body, eating disorders are complex, maladaptive behaviors, precipitating out of a mix of psychological and biological vulnerabilities. That they are not readily explained as the mere consequence of extreme dieting is self-evident. Why can we be certain of this? First, the large majority of persons with anorexia nervosa manifest significant levels of anxiety many years prior to the onset of dieting and weight preoccupation. Second, the profound changes in perception of body size and in attitudes regarding eating and weight are indisputably different from what is observed in the course of continuous dieting. And third, rarely does even the most determined effort at dieting progress to anorexia nervosa.

It isn't that culture is irrelevant; after all, as a principal conveyor belt of ideas, its role in shaping icons of beauty and preferred body shape is easily appreciated. But eating disorders affect a comparatively small minority of the population. How, then, do we reasonably account for the fact that most young women prefer a thin frame, engage frequently in extended periods of dieting to lose weight, and often see themselves overweight when they are not, yet only a small minority (an even smaller proportion of young men) veer off into the irrational, blindly compulsive, life-

DR. MICHAEL STROBER, Ph.D., A.B.P.P., is the Franklin Mint Professor of Eating Disorders and professor of psychiatry at the Semel Institute for Neuroscience & Human Behavior, David Geffen School of Medicine at UCLA, and director of the Eating Disorders Program at the Stewart and Lynda Resnick UCLA Neuropsychiatric Hospital. In addition to his long-term psychotherapy practice with both adolescent and adult patients, he is editor in chief of *International Journal of Eating Disorders,* as well as the author of *Just a Little Too Thin: How to Pull Your Child Back from the Brink of an Eating Disorder.* Dr. Strober is a founding fellow of the Academy for Eating Disorders and past president of the Eating Disorders Research Society and is the 2005 recipient of the Price Foundation Award for Research Excellence from the National Eating Disorders Association.

threatening starvation that is the hallmark of anorexia nervosa? In any culture, there are predisposing psychological and genetic profiles that confer susceptibility to extremes of behavior and that such factors play a role in the "dieting disease" is well supported by scientific evidence. Simply put, anorexia nervosa is a severe, disabling, potentially chronic, and sometimes fatal mental disorder.

The stories in this book have surely triggered a cascade of deep emotion and thought; they are gripping, poignant, bewildering, heart wrenching, incomprehensible, inspiring, sickening, disturbing, repellent, touching, infuriating, and so much more. That such a diversity of emotion follows examination of the life history of persons with anorexia nervosa is not unexpected. Anyone who has been touched by this disease—patients, family members, friends, therapists, passive observers—will, in time, be swept up in its arresting image and powerful energy. How can anyone of sound mind welcome or accept such a corrosive, debilitating existence? How can a person capable of rational dialogue in most matters become so hopelessly deluded, so utterly unhinged, when faced with discussion of the senselessness of their style of eating and the alarming degree of their malnutrition?

Indeed, the contradictions that shadow this illness can only be decoded when it is accepted that anorexia nervosa arises from psychological vulnerability, and that the illness somehow makes life for the sufferer seem bearable, strange as this may sound. But consider, for the moment, that one important vulnerability that research has uncovered is in the realm of temperament; specifically, an extreme personal disposition marked by continuous self-doubt, fear of change, general worry and apprehension, need for absolute perfection, inhibited emotion, and highly regimented behavior—proclivities that render the transition to adolescence and adulthood fraught with challenge and fright. Causes of the initial weight loss are invariably innocent: slimming for summer swimwear, illness, athletic competition, and so forth, but for these rigid, self-doubting young girls, the routine and dedication that dieting requires and the loss of weight that signals its success rapidly become valued affirmation of discipline, perfection, and regimentation. And at the very same time, increasing weight loss and the preoccupation with it promotes both mental and physical avoidance of change by suppressing those aspects of adolescent growth and development that are feared.

This is, to be sure, a simplified sketch of an infinitely more complex psychological and biological process. The point is, anorexia nervosa is motivated by vulnerabilities and fears that most patients do not fully comprehend at the beginning.

For some, the period of suffering is relatively brief; for most, it lingers. In still other cases, anorexia nervosa can harden into "a way of life," so to speak, not because it is preferred (people do not wish this upon themselves), but because the predisposing deficits in coping and personal temperament render aspects of living too emotionally painful for the person to endure. The misinformed dismiss such chronic suffering as mere weakness of character or malingering; the truth is very different. As for identifying who will recover quickly, when recovering can be expected, or if the illness will prove chronic or fatal—here our science remains little developed.

What, then, can we say about the course and eventual outcome of those who develop anorexia nervosa? Can treatment help? Is recovery truly possible, or does one always suffer from the illness? The latter is often asserted, but there is no truth to this at all.

In fact, the majority who develop anorexia nervosa will, over time, grow healthier, both emotionally and physically. Thus, once a person develops anorexia nervosa, it is uncommon for him or her to remain severely ill, that is malnourished, continuously throughout adult life; this is seen only in some 3 to 5 percent. At the same time, the illness is associated with significantly increased risk for premature death. For some, death is the result of suicide, in others organ failure resulting directly from chronic malnutrition.

While it is accurate to say that the majority of people with anorexia nervosa will improve over time, exactly how many recover fully remains, surprisingly enough, little studied. The estimates that do exist vary because the approaches that have been used by researchers for assessing and defining recovery have lacked consistency and well-conducted research is still limited. Even so, a conservative estimate puts the figure between 50 and 70 percent, which means a not insignificant minority of persons will manifest less severe but noteworthy symptoms of illness for long stretches of time. By the same token, the time it takes for recovery to take hold is generally several years, which underscores the tenacity of the disease process.

In sum, contrary to what many people assume, recovery from anorexia nervosa is not rare. But just the same, the illness is a protracted one and initiation of intensive treatment beginning as early as possible after signs emerge is of crucial importance.

And what can be said of the type of treatment needed for persons who not only seem so oblivious to their plight, but whose immediate response to a treatment offered is ungraspable hostility? Clearly, it is a treatment that must be delivered by therapists of considerable skill, who comprehend the many facets of this illness, who are able to use the language of science with utmost sensitivity to convey understanding of the paradox of anorexia nervosa and the personal sensitivities from which it springs, and who are able to assure patient and family that they will be guided through this treatment with steady and firm hands.

We still have much to learn about the treatment of anorexia nervosa—how to involve parents in the refeeding process, how to integrate psychological work with the family and the patient, the potential role of certain medications, and the unique effects of specific types of interventions. But it is undeniable that patients can benefit from treatment. It is also painfully evident that such treatment must start early and be sustained until each of the critical objectives of treatment is achieved. The road to be traveled will be a challenging one, following unpredictable twists and turns. But patients must come to know and accept that change, though difficult, is ultimately rich with the excitement of new possibilities.

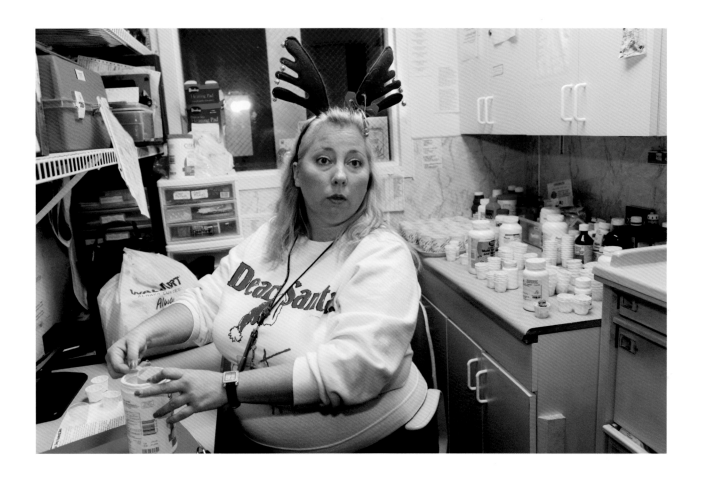

Nurse Kandi prepares the patients' medications on the day before Christmas.

Lucie, 14, from Plantation, Florida, said her eating disorder symptoms, restricting and over-exercising, were exacerbated by her competitive swimming and her family's focus on "healthy eating."

Tina, 35, from Bonifay, Florida, had to leave treatment prematurely when her insurance coverage ran out.

ALISA

I think I'm doing very well. For the most part I have been symptom-free. There have been a couple of slips, but I've been able to pull myself right back out. I'm following up with my outpatient team, which consists of a nutritionist, a therapist, a psychiatrist, and a primary care physician. It takes up just about all of my time. It's something I have to be aware of 24 hours a day.

While I left Renfrew last time feeling optimistic, I don't think I was 100 percent sure as to what direction I was going in. I did well for about a month. Then I started to deteriorate. Shelly was leaving. It was her last night and we'd gone out to dinner. I tried to have a normal meal, but I had a very difficult time and wound up purging. I became very symptomatic for a period of three months. I became really ill. I would eliminate one food, then another, until it got to the point where I just about eliminated everything. The only thing I would consume was lettuce and mustard, and an occasional protein, maybe a few bites of cottage cheese. I took off almost 30 pounds in a month and a half. Three months after leaving Renfrew, I finally hit rock bottom.

I was devoting every hour of my day to the eating disorder: restricting, counting calories. I had gotten to a point where I wasn't sleeping. I used to stay up until four o'clock in the morning exercising, trying on clothes over and over again, weighing myself or even occasionally bingeing and purging. It continued to the point where it became completely debilitating. I couldn't hold a job. I could barely get out of bed.

Even when I was sleeping, I was having nightmares about gaining weight. I just couldn't function. I couldn't be a mother, I couldn't be a friend. I couldn't pay a bill. I would go through periods where I would binge and purge 15, 20 times a day. I wouldn't even leave the house. Usually after one of those cycles I would wind up hospitalized. I spent the majority of December in medical hospitals for malnutrition, very low potassium, and electrolyte imbalance. I now have severe involuntary reflux; it's very difficult to keep anything down.

My life was completely out of control. The house was a disaster: dishes always in the sink, clothes on the floor. There were things shoved in the kitchen drawers that should have been in the bathroom. My license was suspended because of a ticket that I hadn't taken care of. My company car had to go back. When my mother came to my house, she couldn't understand how somebody who was so intelligent and so well educated and had achieved so much had sunk so low. I had gotten my MBA with honors. I had

RIGHT Alisa with her father, Jerry, 63, at her family's Hanukkah party in Lake Worth, Florida. Now in recovery after her second residential stay at Renfrew, Alisa has improved her relationship with her family.

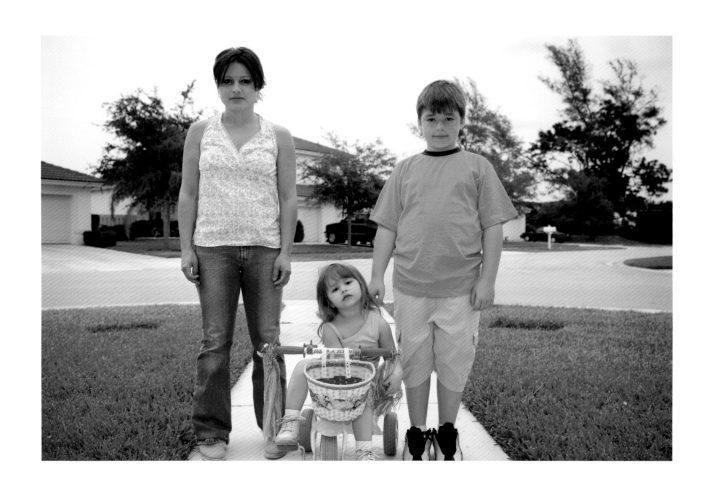

I have to teach my children the "right" way to do it. I have to set an example.

I love you so much *I want to be "your" mommy.

two beautiful children. I had gotten District Rep of the Year in pharmaceutical sales for the previous year. And now I was on disability. I couldn't even fold clothes.

I had dug a hole that was so deep that I just couldn't get out. I was feeling so hopeless. There was no life beyond the eating disorder. Every day I woke up to see how much more weight I had lost. I thought, If I have to go to my grave doing this, then that's exactly what I'll do. Right around Christmas I was taking Diurex, a prescription-strength diuretic, and I took an overdose. I had gotten to a point where I just didn't want to live. I think I used the diuretics because I didn't want it to look like I had committed suicide. I felt that if I took the diuretics, it would deplete my potassium so I could induce a heart attack and I would die of that. I felt that it would be easier for people to adjust to the idea that I had died accidentally—maybe as a result of the eating disorder, but not deliberately hurting myself.

The day I took the diuretics, I had woken up and had consumed my usual bowl of lettuce and my sugar-free candy. I remember going to therapy and crying, feeling very desperate. All I could think about was my time at Renfrew and how I left there feeling all optimistic with all these wonderful ideas. When I was there I could list 50 reasons why I wanted to recover. And on that day, I couldn't recall even one. I guess I felt that tomorrow would be a good morning to not wake up. And then I took the hydrochlorothiazide. After I had taken it and lay down to sleep, I remembered that the kids were coming home at six o'clock the next morning. I couldn't have them find me like that. So I had to call my ex-husband and tell him not to bring the children home the following morning. When he asked why, I just said, "Please don't bring the children home." He called my father and they called 911.

At the time, I felt that the only thing worse than a suicide attempt was an unsuccessful suicide attempt, because now I had to deal with the shame and the embarrassment, and I was even more depressed. My primary care physician would not release me from the hospital until I went back to Renfrew, and that's how I wound up back there. The second time I was at Renfrew for almost three months.

The first time I was at Renfrew, I was a positive voice in the community, and it appeared as if I was doing really well. While it looked good, I was pretty much a mess behind closed doors. I sounded very eloquent and very in touch, but I really wasn't. My first experience, I got along with everyone. I respected my treatment team and they reciprocated. The second time was very different. I went head-to-head with my team and many of the residents. I was crying every single day, saying, "You're not listening to me, you don't understand."

But one day I had an awakening. All of a sudden, I wasn't on the inside looking out, but on the outside looking in. For weeks, I watched the way I felt. I felt abandoned, I felt neglected, I felt that I wasn't being heard. I immediately went to the symptoms, and it was the first time that I ever saw the correlation between the two. And from there on, I took a different approach. This time I think I'm better able to use the tools.

LEFT, ABOVE Alisa and her two children outside their home in South Florida. They have moved six times in the last two years.
LEFT, BELOW Alisa's journal entry.

It impacted the children when I deteriorated between the first time I was at Renfrew and the second time. It's impossible to carry on appropriately when you're that deep in the disorder. I always thought I was a multitasker. But one thing that always suffers is your relationships with people. And as a mother, my relationship with my children was really, really affected.

My son watched his mother take off 40 pounds, and it was very scary to him. He knows a lot more than I wish he did. He harbors a lot of resentment, and for a period of time, he was overeating. He's always been very skinny, and while I was at Renfrew the second time, he packed on about 20 pounds. He was hiding candy under his pillow. He would eat double, triple the amount that he ordinarily would, and a couple of times he lashed out and said, "If you think I'm going on a diet like you, I'm not. There's nothing wrong with being fat." My hands are tied, because I can't say anything. I don't use the word "fat" around my kids and we don't talk diet or nutritional content.

My daughter went through this phase where she would come home from school and say, "I'm not going to eat lunch anymore, Mommy." I panicked: "What do you mean, you're not going to eat lunch?" "I just don't want to get big." What really hurt me was when we were eating dinner and she said, "I don't want to eat dinner, Mommy, because I don't want to get big like Grandpa Jerry." I was speechless. She's only 3.

At Renfrew, you almost become desensitized to what normal looks like. When I would go back [for outpatient appointments], I was embarrassed because everyone was so thin and I felt like I looked so heavy. When I spoke to Shelly on the phone and she told me how much weight she had lost, I was very embarrassed. The same day, I had gone to an appointment and felt proud about the weight I had put on. And just a few hours later, I was ashamed and felt really bad. Recovery is very hard. But at the end of each day, I feel so accomplished. I ate what I was supposed to and I didn't purge.

I think I have finally figured out how to live simply and be content. I don't think about tomorrow. I don't think about yesterday. I just want to get through today.

RIGHT, ABOVE Alisa makes a casserole in her kitchen. A year after her suicide attempt and subsequent second treatment at Renfrew, she is maintaining a stable recovery. RIGHT, BELOW Alisa declares her recovery in her final journal entry.

Sept 26, 2005

This week its been 6
months since I left Pinefree,
and, while I've said this
many times before, this time
I mean it. This time
something is different. I'm
not going back into treatment.
This time I speak my
truth.

BRITTANY

When I got out of Renfrew, I got back into the swing of my anorexia. I dropped 15 pounds in two weeks. My mother was looking for other treatment centers but insurance didn't want to cover those. My dad was like a prison guard figure in my life. I knew he could force me to eat. I wasn't going to do it on my own and Mom's not strong enough to make me do it. Basically, I needed jail. At Renfrew, there was structure, but I took advantage of the system. My dad wouldn't have let this happen, so I thought the best idea was to move to New York, where he lives. He would watch me eat breakfast, lunch, and dinner every day. But eventually he gave me more freedom, which sent me haywire.

I ended up losing enough weight that I had to go into a psych ward. They were very strict. They threatened feeding tubes and medication. They said I would have to be in the center for as long as it took, and it wouldn't be like Renfrew. They scared me into thinking I would be in an institution for many years where I would have no friends and everything would be their way, not my way. I was scared enough to not want to starve again.

I ended up moving back to my mom's house. I was abusing laxatives and exercising profusely. My mom's symptoms were worsening, because if there's someone near her who is getting skinnier than her, she wants to starve herself again. I started thinking bad thoughts. We were just twirling around each other. I'd be at a high and be healthy, and she'd be at a low. And then I'd start to get unhealthy and she'd see that and start to get healthy. But that line kind of straightened out. Now that we started going to therapy together we realize how silly that was.

I struggle every day. When I have a good day, I'll look in the mirror and I think I look good. If it's a bad day, I have thoughts that I'm not good enough, that I need to lose weight. Right now, I'm pretty happy. I got a job at Burger King. It's probably bad for my eating disorder, but I like serving other people. To see food and not have to eat it will help me at home to not go into total binge mode and just eat everything I see.

I started playing hockey again. Scouts started coming to the rinks where I played and said I was one of the best girl hockey players they've seen and that I should go to college for it. Whenever I'm playing hockey, I don't even think about my eating disorder. I think about what I have to do to beat this team. I know that I have to stay in shape. But I don't think to myself, I have to get skinnier. I think I have to get more speed.

RIGHT, ABOVE Brittany, in front of her house in Cape Coral, Florida, 11 months after her discharge from Renfrew. She was still struggling with eating disorder symptoms and laxative abuse. RIGHT, BELOW A doodle from Brittany's notebook.

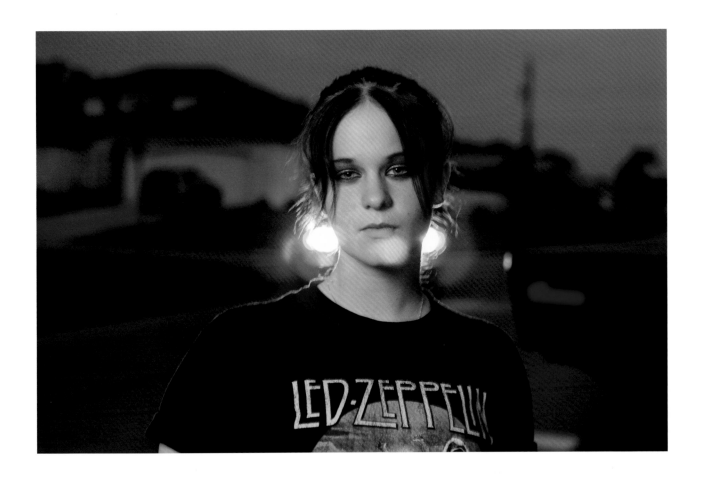

Think of
Lindsey lohan
and mark~kate
Olsen +
all the other girls
skinnier than
you

Ana + Mia Days

	Mon	Tues	Wed	Thurs	Fri	Sat	Sun
12/13/04 — 12/19/04							1
12/20/04 — 12/26/04							2
12/27/04 — 1/2/05							3
1/3/05 — 1/9/05							4

☺ = Ana! ☺ = mia!

☹ = neither

ABOVE After her discharge from Renfrew, Brittany made a chart of her eating disorder activities in her journal. "Ana" is short for anorexia and "Mia" for bulimia. RIGHT A page from Brittany's notebook in which she writes a letter to Ana asking her to come back.

Dear Ana,

Hey hows it going? I hope your on you way real soon, i need you here with me right now! Today 12/7/04 was especially bad. I ateso fucking much!!! And I know that I gained weight. I want to be able to fit into my size 3 (tyte brand) pants, and then to my cacky old navy pant that I wore on the first day of hell, I mean renfrew. Then ill be in katie's size in no time! And I can picture it, when the boys come up to visit, I should be 10-20 more pounds lighter! And they will go home and tell everybody how thin ive gotten and that im back in my anorexia stage! Oh my god its fool proof! And everyone will be worried about me again, and ill get presents, and people will say im too thin! I would give anything for that! But it will happen, ive got like 20 - 25 more days to loose the weight! Ok, so ill have to say good-bye to life for a month ½ or so, but when I come back to earth, my life will be perfect! Everyone will love me so much!

POLLY

It's always been interesting to come back home to Johnson City and walk into my mother's house. She has a beautiful house. But you walk into the foyer, and right there is the scale. Here are these antique pieces, a chandelier, the stained glass. And then there is this cold, white-and-metal scale. Right there on the hardwood floor next to an oriental rug. It's like, welcome to my home. Step on the scale and let's make sure you measure up. Even when I got back from Renfrew, the scale was right there. It kind of blew my mind.

I left Renfrew a year and a half ago. It wasn't the best leaving, what with the whole drama of me getting kicked out and the way Shelly and Kailee turned on me. I have not kept in touch with Kailee. Shelly and I have spoken a few times, but we did not maintain a relationship.

When I first got out of Renfrew, my nerves were shot. I was already so full of shame that I don't think food had a chance even before I started eating. I threw up in the airport. When I saw my mother, I just burst into tears. She gave me a hug and told me she loved me. All I kept saying was, "I'm sorry I fucked up. I'm sorry I disappointed you." And she just kept telling me that it's over. We're just gonna move from here and we'll make it.

The last time I had been in my house in Johnson City was when I had tried to kill myself in my bathroom. My family had cleaned up the mess, but there was still evidence. The blood got into the grout of the tiles and some of it didn't come out. I hated the house because my family had ransacked it. I'm a very private person. They read every one of my journals and went through my artwork. They took all my pills, even down to my vitamins. I just felt violated. It was like I'd been stripped naked. My mother said she was desperate because her daughter was lying in the ICU almost dead and she was looking for anything possible to try to save me.

I went to visit an aunt who I had not seen in 26 years. She had struggled with anorexia and knew that it was gonna be difficult for me when I first got home, so she invited me to come to Chattanooga. I fell in love with the city. I knew then that I would never come back to Johnson City to live. That was a part of my past.

RIGHT Polly in her mother's home in Johnson City, Tennessee, 18 months after leaving Renfrew. She has relocated to Chattanooga, where she is pursuing a career in photography.

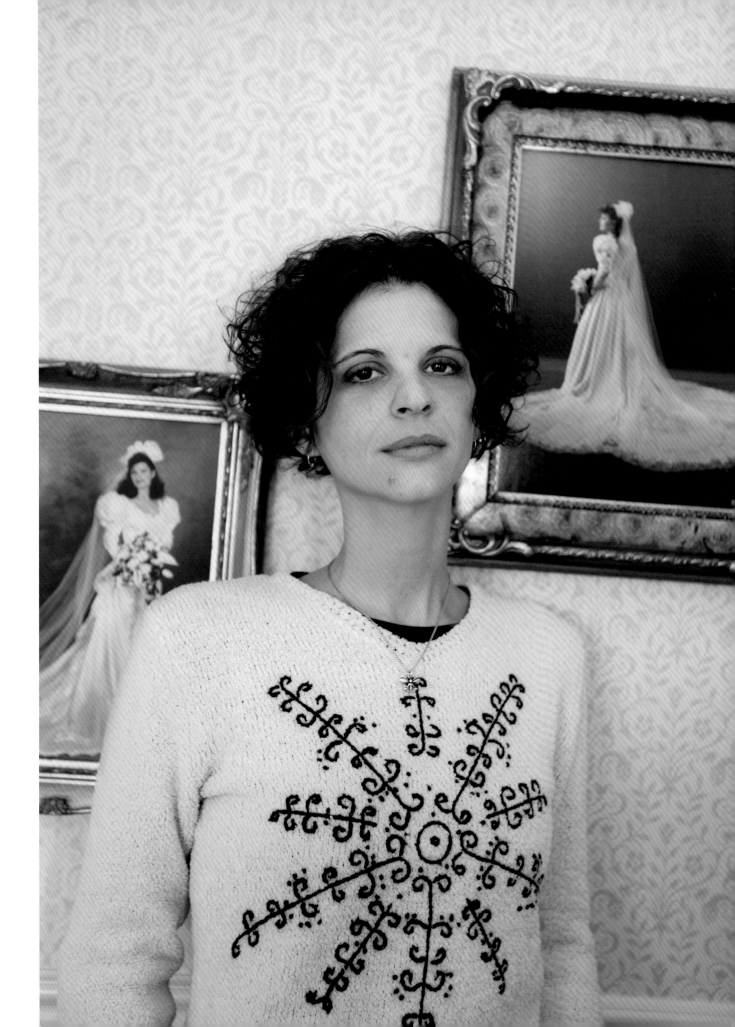

At Renfrew they told me I would never recover without going into a hospital setting with very strict rules, and that pissed me off. So the rebel part of me was like, Fuck them, I'm not gonna let them win. I will prove them wrong.

I'm a completely different person than I was a year and a half ago. In Chattanooga, there's a great program for people with eating disorders. When I first moved there, I participated in the Intensive Outpatient program twice a week. The great thing about it is that once you've gone through it, you can continue going. To this day, if I need a little bit of a boost, I'll go for a day.

I've definitely had relapses in the last year and a half. It took a good year before I would even go to restaurants. I would get stuff to go, but I didn't want people to see me eating. A relapse for me is flat-out not eating, until I get to the point where I'm gonna pass out. It still blows my mind how easy it is. It just takes one day of going without food and the next thing you know, it's been days and you haven't eaten. You start to weigh yourself, five, six, seven times a day. You make trips back to your house for no other reason but to weigh yourself.

I think that I will have the anorexia with me for the rest of my life. The difference is making the decision not to listen to it. I will still sometimes look at myself in the mirror and think that I need to lose weight, but I catch myself. There's times when I look at my watch and I haven't had anything to eat in five hours. And that voice will go, "Hmm, you've already gone five hours. Let's see if you can go two more hours." And instead of listening to that, it's like, No, I need to eat. It's making the decision to not let it control me.

Until just a few months ago, every time I looked at myself in the mirror, I was fat. I got really sick recently and lost a lot of weight—not on purpose. My weight got down extremely low—lower than when I was in Renfrew. And at that moment, I hated the way I looked. I can remember picking up the phone and calling my mother. I was crying. I told her I looked horrible, like a skeleton. And she was so happy to hear me say that, because that was the first time in my life that I had ever said that I was too thin.

Over the last few months, I had gastritis and stomach ulcers. I had diarrhea 15 times a day. My migraines started coming back very heavily. I have something they call intercostal inflammation. I had some pericardial effusion, where fluid builds up in the sac that holds the heart. I have osteopenia. The doctors said that my bones were like those of a 65-year-old. So that's a consequence that I will have to deal with for the rest of my life. The doctors don't really know what made me so sick. But I feel that if my eating disorder did not bring this on, it definitely didn't help. I put my body through hell for 9 years.

RIGHT Polly weighs the pros and cons of anorexia in her journal.

What My Anorexia
Gives Me:

Power
Comfort
Control
Sense of Success
Pride
* A High
Goal to Shoot For
* Numbness
Focus
Distraction
A Way Out
Need to be Right
An Excuse

why am I having such a hard time choosing between the two?

It's driving me nuts!

What is Anorexia
Costing Me?

Relationships
Career
School
Health
My Life
Sleep
Freedom
Friends
Family
Ability to Concentrate
Money
Warmth
Strength
Integrity

She had us do these lists during "Anorexic Eating Patterns"

Friday 11:50pm 12-17-04

I had a big eye opener. I always lose a bit of hair when I shower. I tried to put it on the side of the tub and throw it out. Well, my drain wasn't working well so I unscrewed it. You would not believe what I got out of it. I pulled out I swear enough hair to cover at least half my head. I was mortified. I mean completely mortified. It still is somewhat clogged which means that there is more ~~it's~~ hair down there. That right ~~there~~ turns my stomach. Logically, like a fucking slap in the face, that tells me to eat. I HAVE TO EAT TO KEEP MY HAIR!! I HAVE TO EAT TO KEEP MY HAIR!! I HAVE TO EAT TO KEEP MY HAIR!! I hope I can never forget cleaning that drain. What motivation to eat.

LEFT Polly writes in her journal during a relapse following her discharge from Renfrew. ABOVE A collage Polly made in Chattanooga, Tennessee. She says that lips are important symbols because they are the gateway for food. Eyes represent her concern about how others see her and how she sees herself.

At Renfrew, I was on a lot of medicine. We would have med rounds where we'd meet with the doctor and discuss meds. Was this working or not working? And a bunch of us would laugh about it and be like, Okay, now this time you tell her that you need more Neurontin and let's see what happens. It never failed. By the time I left, I was on the max amount of Klonopin they will allow you to be on. The max amount of Neurontin. The max amount of Seroquel. The max recommended amount of Zoloft. The max amount of Vistaril. I took 30, 40 pills a day.

When I moved to Chattanooga, I got a new doctor. I was filling out the paperwork and she asked, "Are these all the meds that you've taken in your lifetime?" And I was like, "No, these are the meds that I'm on right now." She just about fell out of her chair. We had to do a very slow tapering process to get me off the meds.

My mother is still very much into dieting. All she's talking about right now is how fat she is. A week ago, she was telling me that she was gonna make a lifestyle change. It was not gonna be a diet, it was gonna be a lifestyle change. And she said, "I'm just so fat." It's hard for me to hear that. I try to avoid talking about food and calories. So we're on the phone and she said, "I want your support." I said, "Of course I'll support you if you want to live a healthier lifestyle." And she said, "I'm going to call you every day and tell you what I had to eat. And you tell me if I did good or if I did bad and how many calories I had and how many fat grams."

I said, "Mom, I don't think that would be very healthy for me. We've had this conversation before. Food, dieting, calories, fat grams—that does not need to be a conversation that we have. We have so many other things in life to talk about." And she goes, "Well, I'm gonna tell you what I had anyway." She's not gonna change. You open my mother's fridge and everything's low calorie, reduced fat, fat free, whatever. It's no different from when I was a kid.

I have spent my entire life trying to live up to expectations that other people had set for me. When I left Renfrew, my life completely changed careerwise. Before, I was in the business world and made great money and bought my first home before I was 30. But I was miserable with what I was doing. Photography had always been an interest ever since I was a kid. It never occurred to me to go to photography school because that just wasn't acceptable. At Renfrew, a lot of the girls liked having their picture taken, so I got into it and had fun with it. Now I want to get my master's in photography.

I'm learning to live in the present. I would love to one day be married and have a family. If it happens, that would be nice. And if it doesn't, I'm okay with that, too. I just want to be happy. Before, when I was really sick with anorexia, I didn't think I had anything worth living for. But now I've got too much I still want to do. I look forward to the rest of my life.

RIGHT, ABOVE Polly at her father's farm, where she spent time during much of her childhood, Boones Creek, Tennessee. She still struggles with periodic weight loss and purging. RIGHT, BELOW Polly reflects on her recovery process in a journal entry.

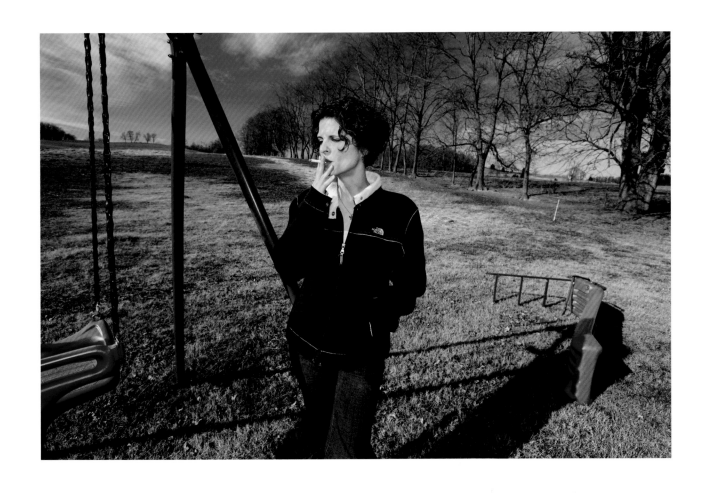

On Friday, April 23, 2004, I faced death and realized I could not fight anymore just yet. I almost died! I wanted to die and was disappointed when I didn't. Thank goodness I didn't. Renfrew got me started on the road to recovery. I still have so far to go. I wish it would just go away, but I know I have to fight.

SHELLY

Since I left Renfrew almost a year ago, I have no appetite. I don't eat a lot, but I don't feel like I'm restricting. It scares me because I don't want to lose weight, but then a part of me is like, Yeah, I am losing weight. My eating disorder definitely isn't gone. My biggest problem is depression and anxiety. I didn't think it would be this bad one year later, but it is.

After Renfrew, I lived with my mom. She's very supportive, and I got a nursing job and really liked getting out there and doing something with my day. At the same time, it was stressful. Any kind of responsibility makes me stress, and when I get stressed, I start eating less. Maybe I didn't devote enough time to recovery when I came back from Renfrew. I should have talked to my therapist and my nutritionist and made more frequent appointments. I guess I blew it off.

Sometimes, when I meet new people, I want them to know that I used to be a lot skinnier, that I had more control. My boss and a few people I work with would talk about their weight and the diets they're on, and what can I say? I can't say, "Oh, I know how to lose weight." So I thought I'd show them. I do that a lot. I'm working on it, because who really cares how skinny a person can be?

When I got back, I was having major anxiety and I was pushing for Klonopin. Of course my psychiatrist wouldn't give it to me, so I was pissed. I was having major anxiety and I tried other coping skills. Nothing worked. After a few months, it became obvious that I couldn't function without it. I was freaking out to the point where I couldn't leave my house. I couldn't drive. I couldn't work. I couldn't be in stores. I was crying all the time. Finally, I said I'd had enough. I was going to kill myself or get relief, so she gave me some Valium. Eventually, I got Klonopin.

Seven months ago, I started getting suicidal, and one day I went into my psychiatrist's office and said, "My mom thinks I should do electric shock therapy." And she said, "Actually, I was thinking that myself." I was completely shocked. In nursing school, I had watched E.C.T. [electroconvulsive therapy] being done, and it's not pretty. But I got so tired of waiting for meds to work that I just said, "Okay, if it will make me feel better."

I don't remember any of the treatment, but I remember it felt like crap. It makes you feel horrible, dizzy. I felt like I was dying, like I was going to have a seizure all the time. And then, after the sixth treatment,

RIGHT Shelly, in front of her mother's home in Salt Lake City, Utah, one year after leaving treatment at Renfrew. She lost 17 pounds after discharge and underwent electric shock therapy to treat her depression.

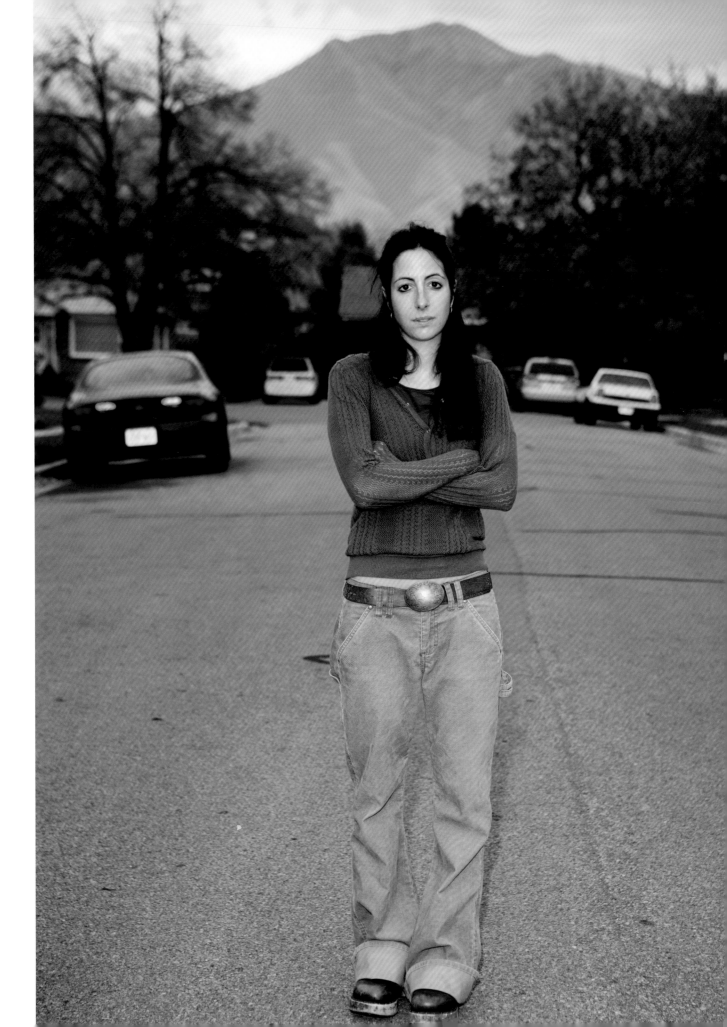

I started feeling great. My moods started improving and I started smiling. After eight treatments, I went home. I felt my normal self and was a lot happier. I was doing more. I was eating better. I was going out with friends. But sometimes it only lasts a certain amount of time and you need maintenance E.C.T. and medication. That's what I'm doing now and it sucks. I'm afraid that it might give me brain damage. I'm scared that it's going to make me a different person because I don't feel like myself. I quit my job two weeks ago because I don't know how long this E.C.T. crap is going to go on for, and I can't drive. My memory is gone. And I don't see my moods improving this time around.

I think out of every treatment center that I've been in, Renfrew has been the best. It was definitely worth it. The fact that I went there and stayed that long helped a lot. But I don't want to go back. I don't like being controlled and having people tell me what to do, handing me my medicine, telling me when to eat, what to eat. I don't like that.

I don't think I've dealt with all my issues. I have all these other symptoms and problems and thoughts to avoid what I really need to work on. I'm totally pissed off at my depression and anxiety. I really think it's just a chemical imbalance, and having my head shocked every fucking week is making it worse. I used to be so on top of it and so with it, and now I'm just scared of everything. I wish I could be normal.

Hoyt and I got back together. At first, we were just friends, but we hung out almost every day and did everything together. I knew it was going to turn into something more because it always does. Then one day we started talking about us and our future and how much we loved each other, so we got back together. Many times I've given Hoyt the option to leave because of all the crap I've dragged him through and probably will continue to drag him through. If he keeps coming back he must really love me, and I really love him. We can't stay away from each other. He knows the most about what goes on with me. And he doesn't even know all of it.

When I put on some more weight, the feelings of wanting to be intimate came back, but at the same time it was difficult because I was a lot heavier. So it was like, Holy shit, now I'm fat and I'm supposed to be intimate. It's still not where it could be. Hoyt's very patient with me because I'm still very timid with very set boundaries in that area.

Hoyt and I were going for a drive one day, up to my favorite canyon. We always sit up there and just talk. We got in the car and he put in the first song we ever danced to, and I'm like, He never plays this song. He was all nervous. And when we were sitting up there, all of a sudden he got down on one knee and said some stuff and proposed. And I said yes. I only want to lose 10 more pounds for the wedding. I'm just kidding.

It's hard to plan our wedding. We can't have it unless Hoyt has a job that has insurance, because I can't lose my Medicaid. I hope I don't kill myself and leave Hoyt here. I think that's one thing that

RIGHT, ABOVE Shelly and Hoyt, 29, shop for groceries in Salt Lake City, Utah. RIGHT, BELOW From Shelly's journal.

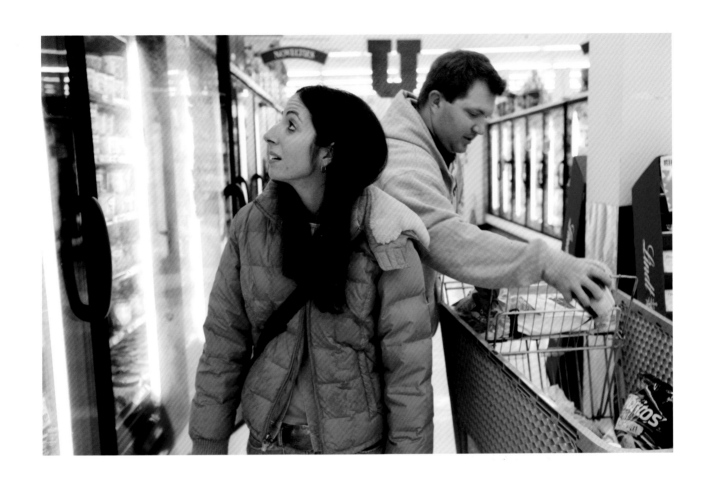

I'm desperate to be normal again. I want
to be my old self again.
 genuinely
Fun, crazy Shelly who was happy and loved life
instead of obsessed with food

I don't know - I'm just going back to my carrots,
rice cakes, and crackers. Eating is way too complicated.

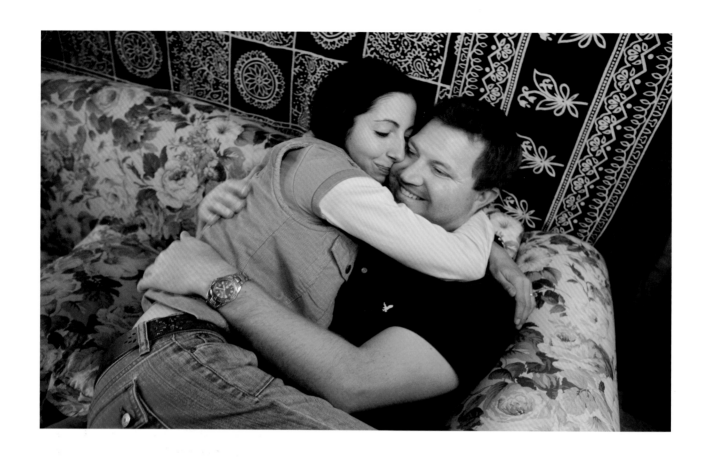

Wow - what a night. Died my hair
and got back together W Hoyt. Way
Cool, but I'm scared of sex, but I need
to get over that. Everyone does
it, no big deal right.

makes me not do it, because I do have hope that one day I'll be normal, whatever that is. I already like our life that we have together right now. We already have fun. We already love each other and we support each other, and I think that's one of the big reasons why I've stayed around.

Alisa is going to be one of my bridesmaids. We're really good friends. She kept in touch with me when she was doing poorly, just to say hi and I'll talk to you when I get better. We had made a promise to each other that if we were doing poorly we wouldn't talk to each other or bring the other one down. But whenever I need to talk to somebody about something related to eating that nobody else would understand, or if I just need to bitch about food, I can call Alisa. And she can do the same with me.

It's kind of embarrassing to describe my day now. I get up really early, like 4:30, and just sit there and think and freak out a little bit. I hate knowing that Hoyt's going to have to leave and that I'm going to be alone. I just hate it. So I watch the news and Hoyt will get ready for work, and we'll have some coffee and he'll leave. And then I just sit here all day long and watch TV. Sometimes I run errands if I absolutely have to. Sometimes I go to my mom's house. When Hoyt comes home, we usually go out to dinner and then we just hang out for the rest of the night together. It's really boring. I just don't feel like going out. It's too anxiety-provoking.

Today I was feeling really suicidal because I couldn't calm down. I just wanted everything to stop for a minute. I was so tired of my eating disorder consuming every thought that I thought it would be easier to just take a whole bunch of pills and just turn it off. Sometimes I get really close to doing that. I don't know if Hoyt knows about it. I told my mom the other day. They think it's something that just passes through my head, and really it's there all the time. Sometimes it gets so strong I can't be by myself because I'm scared. This summer I had a stockpile of pills, and I gave them to my therapist. And today I'm giving a whole bunch of pills to my psychiatrist because I can't have them here. It would be too easy.

I don't want to die. As much as I say I want to die, I really don't want to. Deep down inside, I know I have a lot to offer and I'm a pretty good person and there's stuff I can accomplish. Part of me says, You want to die, kill yourself. But then another part of me is like, Hell, no. You love your family and your friends and there's stuff you want to accomplish. Fight it, because you don't want to die. It is weird to be suicidal and planning a wedding. It's like, couldn't you make up your mind?

LEFT, ABOVE Shelly and Hoyt in their apartment in Salt Lake City, Utah. They have been together on and off for 9 years and are now engaged to be married. LEFT, BELOW Shelly's journal entry.

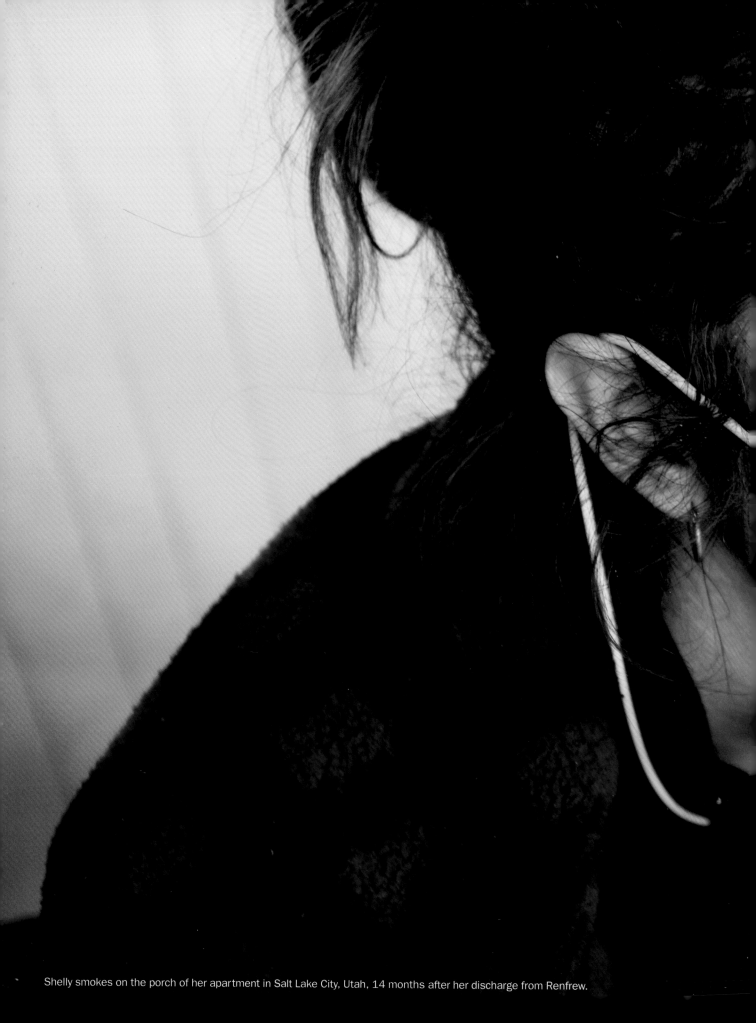

Shelly smokes on the porch of her apartment in Salt Lake City, Utah, 14 months after her discharge from Renfrew.

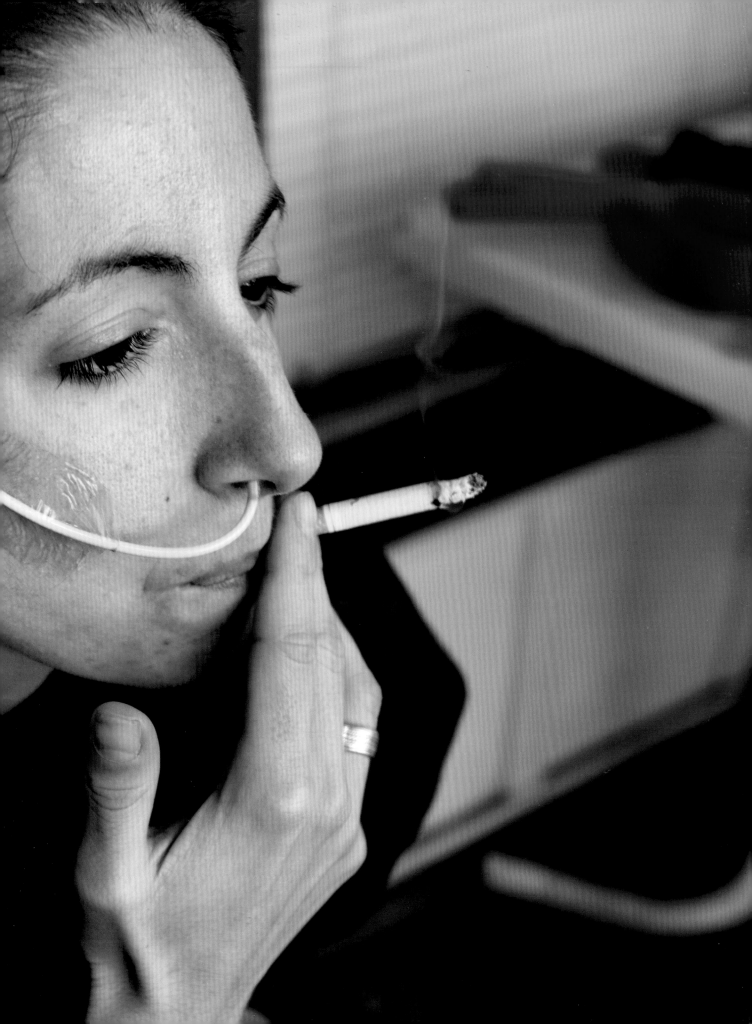

Resources

If you or someone you know is suffering from an eating disorder, it's important to seek help immediately. The following organizations offer information on the symptoms, causes, and treatment of eating disorders; toll-free hotlines; reference materials; and referrals to treatment providers.

Academy for Eating Disorders (AED)
www.aedweb.org
60 Revere Drive, Suite 500
Northbrook, IL 60062
Tel: 847-498-4274
The AED is an international professional organization that promotes excellence in research, treatment, and prevention of eating disorders. The AED Web site offers information on eating disorders and their treatment, as well as access to AED members.

Eating Disorders Coalition for Research, Policy & Action (EDC)
www.eatingdisorderscoalition.org
611 Pennsylvania Avenue SE, #423
Washington, DC 20003
Tel: 202-543-9570
The EDC is a cooperative of professional and advocacy-based organizations committed to advancing the federal recognition of eating disorders as a public health priority. The EDC Web site offers information on eating disorder policy matters as well as ways to get involved in your community and in Washington, D.C., to end discrimination against people with eating disorders.

Eating Disorder Referral and Information Center (EDRIC)
www.edreferral.com
The EDRIC provides information and treatment resources for all forms of eating disorders. The EDRIC Web site offers a comprehensive, searchable database of treatment centers and private practitioners specializing in eating disorders, both in the United States and internationally.

Gürze Books
www.bulimia.com
5145 B Avenida Encinas
Carlsbad, CA 92008
Tel: 760-434-7533
Toll-free: 800-756-7533
The Gürze Books Web site offers information about eating disorders, plus related topics such as body image and obesity. It also offers books and videos at discounted prices, free articles, newsletters, and links to eating disorder treatment facilities, organizations, and Web sites.

National Centre for Eating Disorders (UK)
www.eating-disorders.org.uk
54 New Road
Esher, Surrey KT10 9NU
Tel: + 0845 838 2040
The National Centre for Eating Disorders provides solutions to problems, including anorexia and bulimia, as well as compulsive eating and dieting. The NCFED Web site provides information on eating disorders as well as access to its nationwide network of counselors specialized in the management of eating and weight problems.

National Eating Disorders Association (NEDA)
www.edap.org
603 Stewart Street, Suite 803
Seattle, WA 98101
Toll-Free Helpline: 800-931-2237
NEDA is the largest nonprofit organization in the United States working to prevent eating disorders. The NEDA Web site offers information on eating disorders as well as a searchable database of more than 700 treatment providers throughout the United States and Canada. The NEDA toll-free Information and Referral Helpline also offers information and treatment referrals to callers.

National Eating Disorder Information Centre (Canada)
www.nedic.ca
ES 7-421, 200 Elizabeth Street
Toronto, Ontario M5G 2C4
Tel: 416-340-4156
Toll-Free Helpline: 866-633-4220
The NEDIC provides information and resources on eating disorders and food and weight preoccupation. The NEDIC Web site also offers a searchable directory of Canadian eating disorder treatment providers.

National Institute of Mental Health Eating Disorders fact sheet
www.nimh.nih.gov/publicat/eatingdisorders.cfm
National Institute of Mental Health
6001 Executive Blvd.
Rm 8184, MSC 9663
Bethesda, MD 20892

Tel: 301-443-4513
Toll-free: 866-615-6464
The National Institute of Mental Health Eating Disorders fact sheet, available online or by mail, is a detailed booklet that describes symptoms, causes, and treatments of eating disorders, with information on getting help and coping.

National Women's Health Information Center (NWHIC)
www.womenshealth.gov
8270 Willow Oaks Corporate Drive
Fairfax, VA 22031
Toll-free: 800-994-9662
The NWHIC is a service of the U.S. Department of Health and Human Services' Office on Women's Health that works to improve the health and well-being of women and girls in the United States. The NWHIC Web site and call center offer free women's health information on more than 800 topics, including eating disorders.

Something Fishy
www.something-fishy.org
Something Fishy is dedicated to raising awareness and providing support to people with eating disorders and their loved ones. The Something Fishy Web site offers information on eating disorders, a searchable directory of eating disorder treatment providers, and online support groups.

Acknowledgments

This book would not have been possible with-out the generous collaboration of the women in these pictures. I have been inspired by their candor and courage. I am also indebted to the many other women who allowed themselves to be photographed in the process, or equally important, chose not to be, but permitted the intrusion of cameras in their treatment.

I want to particularly acknowledge Shelly, Polly, Alisa, and Brittany, who worked with me over a multiyear period and shared their lives in the film as well as in this book. They and their families bravely made public their private lives and painful struggles.

The staff of the Renfrew Center went beyond the call of duty to accommodate my film and photographic projects. I am especially indebted to Renfrew president Sam Menaged, for saying yes, and clinical director Gayle Brooks, for working out issues and logistics on a daily basis. Therapist Adam Friedman was an indispensable ambassador for my work with patients and staff. Valti Bryan was a singular presence and a friend to this project. I regret she was unable to see the result before her untimely passing. She is greatly missed. I am thankful for the Renfrew nurses, therapists, and administrators, too numerous to name, whose assistance made the photography possible.

This book was a by-product of the access and trust created from six months of fieldwork on the documentary film. Producer R. J. Cutler's unwavering belief that my vision as a still photographer could translate into that of a director is the reason there is a film. Sheila Nevins and Lisa Heller from HBO stood behind the project from the beginning with creative guidance, moral support, and financial backing. Their knowledge of the process and trust in me as a filmmaker gave me a charmed introduction to the documentary world. I am also indebted to cinematographer Amanda Micheli, my creative partner on the film and an integral part of the relationships we established with the patients. As a still photographer, I thought I needed to be alone to achieve intimate access and document private, emotional situations. My incredible

crew of Amanda, soundwomen Judy Karp and Claudia Katayanagi, and associate producer Isabel Vega showed me otherwise. I was also fortunate to work with the fantastically talented editor Kate Amend.

On the book side, I was proud to collaborate with the team that has been my support structure since the beginning of my career. Charles Melcher has produced all of my books, and I am honored by his commitment to my work and the service of his sharp eye and keen intellect. He has believed in my photography and ensured its ability to reach a wide audi-ence. For that reach, I am equally indebted to my editor, Sarah Malarkey, at Chronicle Books, also the publisher of *Girl Culture* and the new edition of *Fast Forward*.

Curator Trudy Wilner Stack generously helped me edit the photography for the book and exhi-bition. The curator of *Girl Culture* while at the Center for Creative Photography, she has been pivotal to my career for the last 10 years. Gerd Ludwig was also essential in the picture editing process and is as devoted a friend and photographic mentor as anyone could wish for. I am thankful to Laura Hubber, the text editor of my first two books and a friend since college, for coediting this text as well.

Joan Jacobs Brumberg, David Herzog, and Michael Strober brought much-needed expertise, clarity, and context to this enigmatic illness. I am grateful for their insightful work.

Rob Giampietro and Kevin Smith are gifted designers whose emotional and aesthetic intelligence shaped the content. Corinna da Fonseca-Wollheim painstakingly worked with me to edit my voluminous interviews. Megan Worman shepherded this book from beginning to end with care and skill.

My photo assistant Alana Goldstein helped me every step of the way, from assisting on shoots through the production of the book and exhibition. I am thankful for her smarts, fine work, and dedication. Richard Maier guides me through the digital age with his gift for imagery, technology, and color correction. In my studio,

thanks also to Rebecca Drobis, Eleonora Ghioldi, and Mimi Ko.

Canon supports my photography with state-of-the-art equipment. This project was my first foray into digital photography and introduced me to a world of detail and resolution that pushed my work in a new direction. I am grateful to David Metz and Steven Inglima of the professional division for their generous sponsorship of this book.

I very much appreciate the support and partnership of Fran Lobpries and Tara Kirk and the Women's Museum in Dallas, Texas for organizing the *Thin* traveling exhibition.

Christina Scalet at *Time* opened the door to Renfrew with my first assignment there. Geoffrey Gilmore, John Cooper, and Caroline Libresco gave the film a wonderful premiere at the Sundance Film Festival. Thank you to Peter MacGill of the Pace/MacGill Gallery and David Fahey of Fahey/Klein for being advocates in the fine-art world. Erin Cosgrove, John Driscoll, Laurence Dumortier, Linda Lichter, Gloria Phares, and Jonathan Shikora gave counsel and support along the way. I am also appreciative of Bill Stockland, Maureen Martel, Jessica Manzi of HBO, Chris Libby of BWR, Chris Dougherty and *People* magazine, and the VII Photo Agency.

My female-focused work of the last 10 years has been made possible by one unique man. My husband, Frank Evers, is my best editor and advisor, and his professional and creative help is indispensable to my work. On a per-sonal level, he makes possible the prolonged absences from my family that documentary work demands. He creates stability in the face of geographical movement and taught me that the coexistence of work and family can make me a better artist and mother. My son Noah follows his father's example in his unrelenting support. My second son, Gabriel, was born at the end of the *Thin* journey and literally allowed me to finish this book between contractions in my last month of pregnancy. Documentary work requires the commitment, love, and sacrifice of an entire family, and for that embarrassment of riches, I am deeply grateful.

Library of Congress Cataloging-in-Publication
Data available.

ISBN-10: 0-8118-5633-X
ISBN-13: 978-0-8118-5633-1

Manufactured in China

This book was produced by

 **MELCHER
MEDIA**

124 West 13th Street
New York, NY 10011
www.melcher.com

Melcher Media staff:
Publisher: Charles Melcher
Associate Publisher: Bonnie Eldon
Editor in Chief: Duncan Bock
Project Editor: Megan Worman
Assistant Editor: Lindsey Stanberry
Production Director: Andrea Hirsh

Distributed in Canada by Raincoast Books
9050 Shaughnessy Street
Vancouver, British Columbia V6P 6E5

10 9 8 7 6 5 4 3 2 1

Chronicle Books, LLC
85 Second Street
San Francisco, California 94105
www.chroniclebooks.com

COVER Shelly near her home in Salt
Lake City, Utah, 6 months after leaving
treatment at Renfrew.

ENDPAPERS Shelly's refrigerator in
the apartment she shares with her fiancé.

PAGE 8 Ata, 26, from New York City, walks
on Deerfield Beach several months after
discharge from the Renfrew Center.

Credits
Photographs edited with
Trudy Wilner Stack

Interviews edited with Corinna da
Fonseca-Wollheim and Laura Hubber

Designed by Giampietro+Smith
Typeset in Franklin Gothic

Thin title design by Robin Cottle
and Stephen Kirklys

Assistant Editor for Lauren Greenfield:
Alana Goldstein

Scans and photographic printing:
Richard Maier

Thin Film
HBO documentary directed by
Lauren Greenfield. Produced by Lauren
Greenfield, R. J. Cutler, Amanda Micheli,
and Ted Skillman. Premiering on HBO
and available on DVD, November 2006.

Thin Traveling Exhibition
The traveling exhibition of Lauren Greenfield's
Thin was curated by the artist and Trudy
Wilner Stack and organized by The Women's
Museum: An Institute for the Future in Dallas,
Texas. The Women's Museum, a Smithsonian
Affiliate, is the only comprehensive American
women's history museum in the nation. The
national tour of *Thin* will begin at The Women's
Museum, February 22–April 22, 2007.

For more information about *Thin,*
visit www.thindocumentary.com

For more information about Lauren Greenfield,
visit www.laurengreenfield.com

Gallery Representation
Pace/MacGill, New York;
Fahey/Klein, Los Angeles

Technical Information
The photographs in this book were taken
with the Canon EOS-1Ds Mark II Digital
camera, the Canon EOS-1v camera, the EF
16-35mm f/2.8L and EF 24-70mm f/2.8L
lenses, and the Speedlite 580 EX flash.

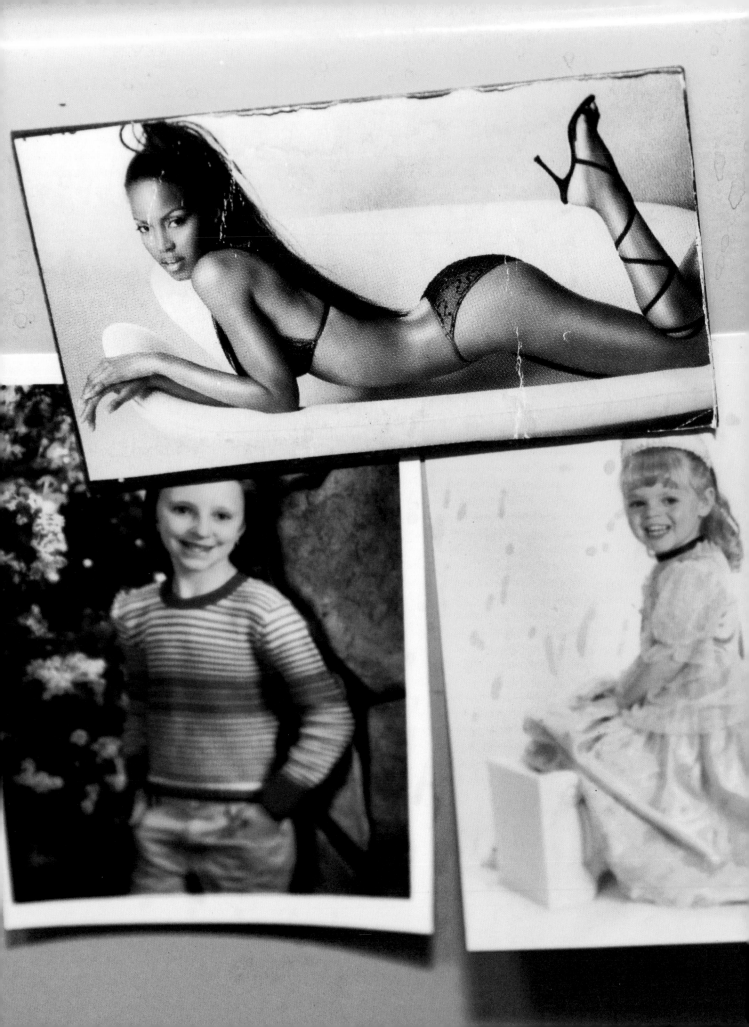